MODERN ART AND THE DEATH OF A CULTURE

This illuminating, disturbing, highly original book shows how modern art reflects a whole culture—a dying culture. Dr Rookmaaker outlines the various steps, the decisive choices that have been made, which have led to the modern movement. But the steps have not been made in isolation from society generally. They depend on a whole world-view, particularly on the values and presuppositions of the Enlightenment, the Age of Reason, which have made our culture what it is today.

With his analysis of both well-known and lesser-known works of art, his broad understanding of contemporary cultures and sub-cultures, pop and op, happenings and hippies, jazz and beat, protest and revolution, Dr Rookmaaker builds up a message for our times which may be devastating, but is also profoundly helpful and positive. He sees above all the tremendous potential and relevance of Christian attitudes, to man, to society, to freedom, to the whole of reality, as the basis for a way ahead in the future.

MODERN ART AND THE DEATH OF A CULTURE

H. R. Rookmaaker

Professor in History of Art, Free University, Amsterdam

INTER-VARSITY PRESS

INTER-VARSITY PRESS

Inter-Varsity Fellowship
39 Bedford Square, London WC1B 3EY

Inter-Varsity Christian Fellowship
Box F, Downers Grove, Illinois 60515

First Edition September 1970
Reprinted July 1971

INTERNATIONAL STANDARD BOOK NUMBERS:

UK EDITIONS:
Casebound 0 85110 617 X
Paperback 0 85110 568 8

USA EDITION:
0 87784 888 2
Library of Congress catalog card number: 73–130658

Printed and Bound in England by
Hazell Watson & Viney Ltd., Aylesbury, Bucks

CONTENTS

ILLUSTRATIONS

INTRODUCTION

Something is happening here
But you don't know what it is,
Do you, Mister Jones?

Bob Dylan, *Ballad of a Thin Man*

WE LIVE at a time of great change, of protest and revolution. We are aware that something radical is happening around us, but it is not always easy to see just what it is.

We are aware too of a tremendous change that has come over the arts in the twentieth century. Why? What are the forces behind the change? What does modern art really mean?

My aim in this book is to show the relationship between the great cultural revolution of our time and the general spirit of the age—an age which, as we shall see, would seem to be drawing to a close. To do so, we must first go back to look at the art of an age before our own began. Then we shall examine the new forces that have made the modern world what it is, and see the various decisive steps by which art has developed as it works out these new forces.

The aim of the illustrations is simply to illustrate: they are essential to an understanding of the text, and there has been no attempt to include others purely for decoration where they are not needed. Most of my examples are from painting: as an art historian this is the field I know best. But I shall not be excluding the other arts, although they will not be getting the amount of space they deserve. In any case, I feel that the visual arts are in fact the most important today (with an almost religious aura to them), so I will not have bypassed the really significant issues.

This book has also been written with the needs of younger artists in mind, particularly Christian artists. I am very aware that the issues at stake are not just cultural and intellectual but spiritual. What is involved is a whole way of thinking that leaves out of account, and so largely negates, vital aspects of our

humanity and our understanding of reality. Christians today must understand the spirit of the age. They must realize that the protesters and revolutionaries are often fighting against the same evils of society as they are themselves. But they must also see the inadequacy of all answers that do not tackle the root of the problem.

My closing chapter has particularly in mind Christian artists for whom the problems, spiritual and artistic, are often overwhelming. How should we react as Christians to the pressures around us? What does it mean to trust Christ at such a time as our own? In the battle against the spirit of our age, how can we use the weapons that have been given to us, our humanity, our understanding, our emotions, our artistry—and, of course, the written revelation of God?

But whatever our starting-point, whether we are Christians or not, artists or not, it is my hope that this book will help us understand the attitudes, problems and concerns of the times in which we live.

Chapter one

THE MESSAGE IN THE MEDIUM

Through art we can know another's
view of the universe.

Marcel Proust, *Maxims*

THE AIM of this book is to discuss modern art, its meaning and its relation to the contemporary cultural scene at large. But modern art did not just happen. It came as a result of a deep reversal of spiritual values in the Age of Reason, a movement that in the course of a little more than two centuries changed the world. If we want to understand how new modern art is, and why it carries the sort of message it does, we have to confront it with the art of the period before the great change began.

For that reason I want to go back in this chapter to discuss some specific works of 'old art'. It is not my intention to give a complete historical survey; quite the contrary. My aim is to analyse briefly some particular works in order to see their meaning, their content, their spiritual message. In doing so, too, a fact emerges which is common to them all, and vital for an understanding of the particular role in society which art, and painting especially, has been called upon to play. I have chosen works that represent the major historical movements that contributed to the culture of the period before the Enlightenment. The works belong to the great tradition that began in the later middle ages, and ended during the nineteenth century—the period when the new world emerged and modern art slowly took shape.

The icon

To illustrate what I want to say, I have chosen, first, a Madonna by Duccio, painted about 1300. I could have chosen many other paintings of the Madonna. Each would have some particular

feature of its own and, of course, the paintings vary in quality. But all of them, or almost all, are alike in the points that I want to discuss.

The painting is on wood, and is quite small. As we look at it, we can ask ourselves what the artist meant when he was painting it. Or we can ask what people wanted the artist to create, for he did not stand alone as a creative artist, but was closely tied to his community. What does the painting mean?

Is it supposed to be a picture of something that could have been seen at Bethlehem in AD I, a reconstruction of the sort of photo-

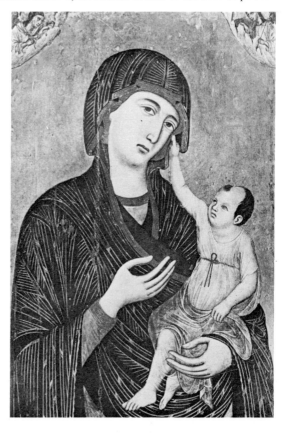

Duccio, *Madonna with Child*
Museo dell' Opera del Duomo, Siena

graph that would have been taken if they had had a camera? If we look at the picture—and perhaps even more if we look at representations of other biblical scenes—we shall soon see that this is not the case. Mediaeval man did not really think that the air in Bethlehem was golden! And he might even have realized that fashion had changed since then. He might well depict his Madonna in rich attire even though he knew that she was poor, as the Gospel writers tell us (if he did not read the Bible for himself, the priest would have told him). So it is not AD 1. What is it supposed to be, then? A scene in heaven? But mediaeval man was theologically well informed, and he would not have tolerated the thought that Christ would still be a baby in heaven. There is nothing to suggest that it is supposed to be set in the future. But neither does it seem to represent a specific scene on earth. So what does it mean?

Well, let us see what the picture itself says. It tells us obviously about the Madonna, called the 'Mother of God'—that alone would be good enough reason to depict Christ as a baby. The Madonna is looking at us, and seems interested in us, even if in rather an aloof way. She is obviously no ordinary person—not even the greatest blasphemer could make a pin-up girl out of her, nor would the picture make an advertisement for child care. She is more than human, yet still human. This is what the picture tells us. It is a sermon on Mary, if you like. In a deep and truly religious sense, the picture was a 'poster' telling people to 'go to Mary with all their troubles'.

In the Roman Catholic churches that have given Mary an exalted position these pictures are universal. The oldest are from before AD 500, the latest probably yesterday. They do not tell about a reality of historical importance, nor of a historical event— even though the picture is in fact related to an event such as the birth of Christ. No, these pictures talk about a reality claimed for this very moment, a reality that is to be believed and cannot be seen, that Mary, the 'Mother of God', can help you if you pray to her.

Such pictures we could call icons. They depicted something felt to be of supreme importance, and sometimes even the picture itself was considered holy. They stood for something super-natural, something above and beyond ordinary human experi-

ence, and were loaded with religious meaning. The painting was thus much more than a simple picture, a memory of an important event, and very much more than a portrayal of something as humanly important as motherhood. They represented Mary, the Madonna, 'Our Lady'!

But there is more to it than the subject-matter alone. The artistic qualities have a part to play. The last thing the painters of these icons did was to take the subject just as an excuse for making a fine composition. Of course, if they were going to paint a picture of the Madonna, they wanted it to be as beautiful as possible: if one loves somebody, one never wants less. But the picture had more to say than just 'Madonna'. One can follow almost all the different stages in Mariology just by looking at these paintings. For instance, in the fourteenth century one sees a new type emerge, the Madonna of Humility, where we see the Madonna sitting on a cushion on the ground, often offering her breast to the child. This is a marked change from the Madonna as Queen that we see in the earlier periods, and specifically in Romanesque times. Later, after the fourteenth century, the portrayal becomes more natural, with more attention to details like the hair, the chair, the background that often becomes a landscape. And in the Baroque period she sits on clouds, high above us mortals, often accompanied by adoring saints—they are setting us an example, the painting tells us. So the important thing is that it is precisely the artistic qualities of the composition that pass on the message—not just what we know or think about the Madonna ourselves.

Beyond history

Though I have begun with a painting of a Madonna, I might just as well have chosen another theme, a Crucifixion, or an Adoration of the Magi, or a Resurrection, for instance. In all these I could equally have stressed that the artist was not concerned with historical events as such, and certainly not with archaeological accuracy, but with dogma, with a credal statement in a well-defined, traditional, compositional scheme. The styles might change, and with them the theological overtones, but the basic ideas remain.

Many things did change. The Counter-reformation came, as a

Roman Catholic reaction to the Protestant Reformation. The forms of piety, the subjective feelings in worship, the 'propaganda' of the Catholic church, the points of emphasis, all these changed, while retaining the same basic ideas. One thing that was new was an emphasis on the greatness of the martyrs. Rubens, as one of the greatest painters within this stream, painted some of the most convincing ones. His 'Martyrdom of St Livinus' will illustrate what I mean.

The saint is in the left-hand corner, in all his clerical attire, his arms outstretched, calling to God, giving himself to Him. Just

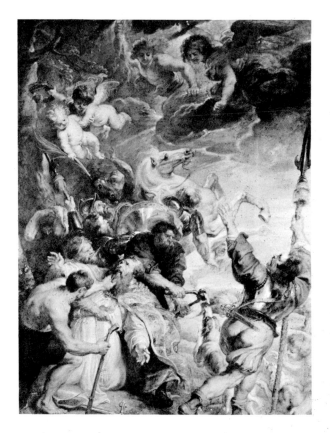

Rubens, *Martyrdom of St Livinus*
Musées Royaux des Beaux-Arts de Belgique, Brussels

before, he had been standing before his judges, telling them that he could not recant even if they would otherwise put him to death, for there was an absolute, deeper and higher than anything else, a truth that man may never deny. The judges themselves stood for another absolute, one that gave them the conviction that Livinus was dangerous. He had accepted the condemnation. His tongue was to be cut out. This is what we see. He calls to God, and look, the heavens are open, angels come carrying wreaths to crown the martyr, and others bring the sword of God's wrath. But it is not just a vision of a highly exalted mind: the soldiers see it too, and flee. The horses stagger. The painting speaks of an open sky, a world that is not closed within itself: God and His hosts are there too. Truth has meaning.

Historical scenes, scenes from the Bible, for instance, were no problem to mediaeval man. He meant his picture to be a symbol of a truth deeper than the eye can see. But, with the Renaissance, art began to have greater pictorial realism, and this raised a problem. What will the artist depict, what he knows to be true, or what the eye would have seen at that particular time and place? Let us take as an example Christ on the way to Emmaus. We know from the biblical story that there were three men on the road, and two of them did not yet know that the third was Christ Himself. What must the artist show? What he knows, or what the casual passer-by might have seen? Either way he is at variance with the biblical truth.

This problem is always present in one way or another in the portrayal of biblical narrative. The picture can be made historically exact (as in the nineteenth century), attempting to reconstruct what a camera would have recorded. But that would reduce the event to something of no more than historical interest. Or it can give the true, timeless message, but often only by losing the historical truth of the fact. And true Christianity is firmly based on historical facts. The fact that God led His chosen people out of Egypt is a historical event to which the whole Old Testament refers again and again. It is equally vital for Christianity that the event of the resurrection of Christ is recognized as really having happened in history. Otherwise, says Paul, 'your faith is in vain'.

This dilemma led many seventeenth-century painters in the

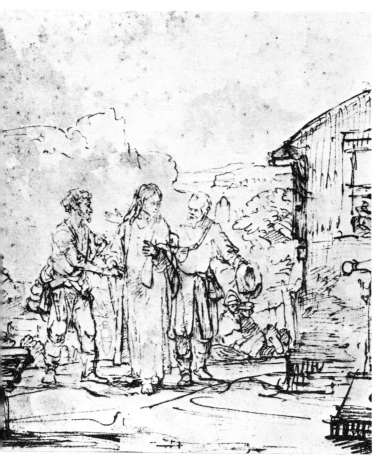

Rembrandt, *Christ on the Road to Emmaus*
Vienna, Coll. Dr J. Winter

countries of the Reformation, in Holland, for instance, to abandon painting biblical scenes entirely. Only Rembrandt really tried to overcome the problem. His drawing of Christ on the way to Emmaus shows his answer perhaps best of all. When we look at the drawing, at first glance there is nothing special about it. Three men are standing together near a house. Yet we gather that the middle one is most important. He has made this apparent

by pictorial means, by making the side of the house dark, thus creating a rhythm, man-Christ-man-house, with the downbeat on Christ and the house. He also makes Christ stand out as important by the way he has placed Him between the two disciples. Then Rembrandt draws some trees in the distance in such a way that, although there is no halo, yet there is a suggestion of one. In this way the drawing is natural, and yet it is much more than just three men on a road. It brings out the fact which he wanted to get across.

Painting is more than art alone

In discussing the Madonna with which we began, I made it clear that such a painting is much more than just decoration, or a memory of an event, or a didactic statement about the structure of a situation. The painting is loaded with religious meaning. It is crucial that we understand this. For in this way we can understand why in the course of Western European history painting has very often been much more than just decoration or something that people enjoy looking at. It has often been more loaded than is justified by its being art. It has been taken to be of deeper significance than tapestry, for instance (even when tapestry was pictorial), or ceramics, or often even than sculpture. And this was not only because of its subject-matter, but more often than not simply because it made visible a particular view on life and the world, expressed deeply-felt values and truths, through the way the theme and the subject-matter were handled. Modern art cannot be understood if we do not take this into account. Many works would be senseless, real junk, but for the fact that, being art, they are exhibited because they have a message of almost religious importance, interpreting man and his world—yes, perhaps even as junk.

We called the Madonnas we were talking about icons. So we may call this extra value that is often found in Western painting its iconic quality. Perhaps the strangeness of modern painting has some connection with this, for the art of painting has been given too high a value, too great a task. Perhaps too that is the reason why many of the so-called 'applied arts' have escaped this type of modernity. Madonna paintings, icons, have something of the

quality of idols, and that is perhaps the mistake that has led to this specific problem. But we cannot solve the problem overnight by saying that we feel that painting should be just painting and no more. Even if we do feel that this should be the case, we can do no more than work towards it.

Two landscapes

A landscape by Jan van Goyen, possibly the greatest of all landscape painters, will illustrate how art gives an interpretation of reality. Look at the picture we reproduce here. It is as simple as can be—a calm sea, storm-clouds, some boats in the distance, and to the right boats lying alongside the harbour jetties. The furthest point is to the far left, the brightest highlight—it is very far away indeed. How has the painter managed to achieve such depth in the painting? Van Goyen was one of the greatest in this respect.

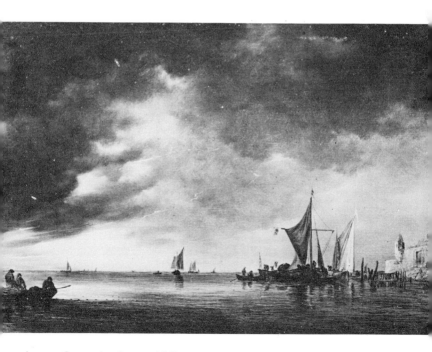

Jan van Goyen, *Landscape, 1646*
Groninger Museum voor Stad en Lande, Groningen, Holland

The cloud formation helps, of course, with its peculiar kind of perspective effect. Then we look at the water: there are light strokes alternating with dark ones. On the dark strip towards the front there is a small boat that makes a kind of silhouette against the lighter strip 'behind' it. Yet we must realize that this 'behind' is achieved precisely by making the dark stand out against the light—an effect called a repoussoir, a method of helping to make clear the structure of the reality we see by creating depth. When we see the tone becoming lighter and weaker, when for instance a boat is further away, this is known as aerial perspective.

For it is important to realize that this is no superficial painting. The artist is very much aware of what he is doing. We realize this better if we try to analyse the composition. We read a picture from left to right. (This is probably related to the way we write; Japanese art, for instance, 'reads' from right to left.) So, to use musical terminology, the introduction is in the little rowing boat on the left. Through it we are brought into the first theme: the far distance out to sea. Then there is a bridge in the boat that is exactly in the middle of the picture. The second theme, the right half of the painting, could be called 'Boats in a Harbour'. It is, as such, much nearer and more complex than the first theme. The coda is to be found in the walls of the town that can be seen at the extreme right.

It is typical that this composition can be read on the surface in such a musical way. This is not just by chance. Many pictures by van Goyen and by many other painters of the seventeenth century can be 'read' like this. We realize in this way too that the painter has brought together in his picture many different things that belong to the sea, or rather to an inland sea or lake. It gives a concentrated view, and analyses the structure of its reality. It is not just a view from a particular point. A study of Jan van Goyen will show that he never painted a view from a particular position. There is no photographic quality in his painting.

Yet we feel that it is so real. The simplicity of the painting is its greatness and artistry. It is so real that many people today bypass the picture, thinking that it simply copies nature. Yet it never does. The paint is laid very thin, and in almost only one brownish colour, so that the whole design is realized in fine differences of tone. Note too how the clouds underline the whole two-theme

quality of the composition—something that is very different from what is natural. How can it be so real, then? Those who think that a painting must be a copy of nature to be realistic are mistaken: art never copies nature, but always portrays reality in a human way. That means that this painting does not copy nature as a camera would, but depicts a human experience, a human understanding, an insight and emotion into what the truth about reality is. It speaks in an artistic way about reality, as have all paintings ever made. This one speaks about clouds, bad weather coming, the sea, water, boats, work and rest. It does not copy, it is about something that is of human relevance. In a way one can say that the painting gives a particular view on reality, a philosophy. But it is of course given not in words, even less in arguments, but in its own artistic way. It is the same way in which the Roman Catholic painter expressed a theological understanding of Mary and her role in religious life.

This painting, then, seems to be so natural that some people (by a most common mistake, a legacy of the nineteenth century, as we shall see) think it copies nature as a camera does; but in fact it presents a philosophy of reality that is very true and very deep. Where does this insight come from?

The answer becomes clear when we compare the art of van Goyen, working in Holland, with some of his Belgian (Flemish) contemporaries. Holland was deeply influenced by the Protestant Reformation. Belgium was very much in the Roman Catholic world of the Counter-reformation. There is no doubt that the two attitudes to reality, to the physical as well as to the spiritual world, were a result of the deep influence of the two faiths on their whole culture and thought-patterns.

There is probably nothing more typical of a truly Protestant vision of reality than the painting by van Goyen we have been discussing. What is important is that he was painting out of a culture that had been re-orientated according to the Bible. Even if we know that van Goyen was a Catholic himself, and however shallow or deep his own personal faith may have been, yet the fact remains that he was acting and thinking along the lines of a biblical view of nature.

Perhaps this is an illustration of the way in which a biblical Christianity can act as 'salt' in society. It is really a secondary

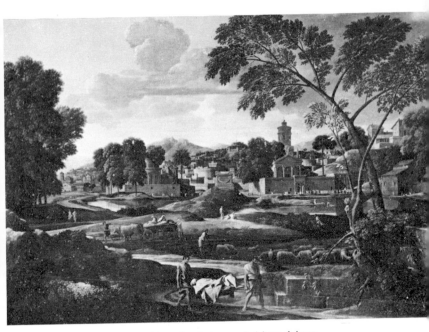

Poussin, *The Body of Phocion being carried from Athens*
The Earl of Plymouth, Oakley Park, Shropshire, England

fruit of the gospel. Individuals become Christians by accepting Jesus Christ as their Saviour and Lord. The fact that He comes to indwell them by His Spirit means that they will be bearing the 'fruit' of the Spirit in their lives. This, working in and through the world, leads to the 'secondary' fruits in culture, the consensus of Christian, biblical attitudes—to work, to money, to nature, to the whole of reaiity—which deeply influence the whole nation. And it is these which are reflected in the nation's art.

The landscape artists of the classical tradition, humanist in inspiration, depicted quite another world: a more lofty, ideal world, a setting fit for great human deeds, heroic acts, deep thoughts, surpassing the mean, everyday world. Poussin, the great French painter who lived most of his life in Rome, is perhaps the best example of a man with such a vision. Claude Lorrain is another.

A work of Poussin, his picture of the burial of Phocion, will

illustrate what I mean. This is a beautifully constructed land-scape, with a clear composition. We see a wonderful classical city in the near distance—Athens as Poussin dreamt it might have been. Phocion, a great man, a Stoic like Poussin himself, is being buried. The painting has a nostalgic mood: death is there even in the classicist's paradise.

Poussin painted a world as it should or might have been: a world inhabited with gods—in a deep sense allegorical figures—or heroes, ideal human beings from a lofty and poetic past. He painted more than the eye can see, he painted a norm, a wish, a vision of mankind. His art is imbued with a philosophy of life and of the cosmos, ordered and well defined, deeply human while yet more than human.

Yet it is not a Christian vision. The difference between this and van Goyen's picture is striking: van Goyen sings his song in praise of the beauty of the world here and now, the world God created, the fullness of reality in which we live—if we only open our eyes. Poussin dreams of an earthly paradise, with great men, a high humanity—but, alas, a fragile and easily-broken one, as if it is a dream that will never be fulfilled. Van Goyen knows that the world is not without its storm-clouds, that it is not unspoilt: but basically he loves the world in which he lives.

Two world-views

Jan Steen was van Goyen's son-in-law. His art can be compared with that of Rubens, living not so far away but in a totally different culture: the differences can be understood for the most part only as the differences between their Reformation and Counter-reformation cultural background, even though Steen was himself a Catholic.

Look at his St Nicholas Eve, for instance, which pictures a typical Dutch festival. On the morning of 6 December the children get presents, presumably from St Nicholas (or 'Santa Claus'), who has sent his servant down the chimney to put the presents in shoes put out for the purpose. But naughty children only get a brush. Now look at the story Jan Steen paints for us: the mother is asking the little girl what she has got; a girl holds up a shoe with a brush her brother has been given, teasing him, while

his younger brother calls his mother's attention. Near the fireplace we see an older boy holding a small child, singing a 'thank-you' song together with another boy. Father or grandfather sits in the middle of the commotion enjoying the feast, while grandma in the background has something put aside for the boy that has been given the brush. Steen has understood life perfectly, the psychology of a grandmother, the commotion and differences in attitude of the members of the family. And he has also not forgotten to give a rich picture of the many different kinds of special dishes belonging to the feast, piled to left and right.

Even if you had a quick eye for things it would have taken time to see and understand all that was going on if you went into a Dutch room in the seventeenth century. One simply cannot take it all in at a glance because of all the noise and commotion. Yet Jan Steen has succeeded in producing a very clear picture of it, because of his intimate understanding of it, and because of his gifts of composition. The scene would have been virtually an impossible one to photograph. The result would have been either a dull line of people sitting side by side or a chaos of quite 'unreadable' forms. Or the people would have had to have been posed, making the whole thing into a tableau. Yet Steen's picture has nothing forced or artificially posed about it.

Look how he 'makes' space, by placing the people clearly one behind the other, and by the lines that, for instance, go through the heads of the child, the father and the grandmother, or the one that starts at the mother's head to go on through the father and sister. The whole story of the small boy crying as he is teased by the others is brought out by the line that goes straight 'through' this space. And how is the commotion realized? Through lines forming Vs, for example starting at the small shoe in the middle foreground: the line that is indicated by the stick held up by the little boy and the line that follows from the handle of the little girl's bucket to her face and that of her sister. And look at the diagonal that follows the arm of the boy by the fireplace, goes along the head of the mother and the strong orange colour in the little girl's bucket over to the left hand corner. All these very cleverly inter-related lines 'make' the picture. This is no snapshot. It is a true human understanding of real family life, realized in an artistic way.

Jan Steen, *St Nicholas Eve,* Rijksmuseum, Amsterdam

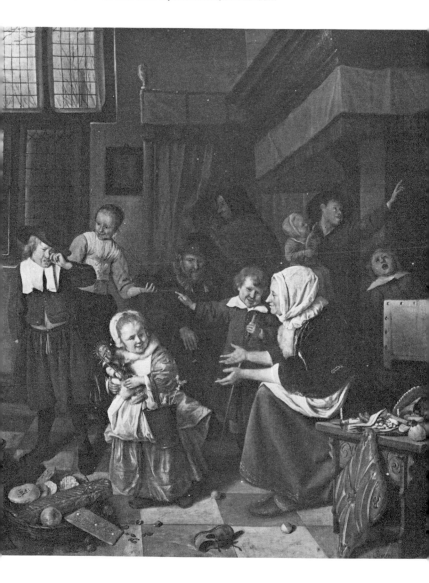

One is not normally concerned, when looking at pictures like this one, to think in terms of world-views, or philosophies. It all seems so natural, so open and free. And it really is open, free and natural, real in a very deep sense. One more readily raises questions of world-view and philosophy when looking at a strange picture, one that seems unnatural. I am reminded, for instance, of the discussions that have centred around El Greco. Yet we must realize that the naturalness, the full humanity of such pictures as Jan Steen's, is not just a chance product. It must be controlled by a true insight into reality, an insight that must have a deep foundation, one that really leads to the opening up of reality. The very normality of the picture is founded in a deep understanding, a 'philosophy'. This understanding comes, as I have said, from the Reformation, which means from the Bible's view of life. It is an understanding that leads life back to the foundation of biblical Christianity, Jesus Christ Himself. It is an insight drawn from the well of life, from the Scriptures. Such things do not come cheaply.

We must look at one more picture in this section, Titian's 'Venus and Music'. He painted several versions. Titian's world

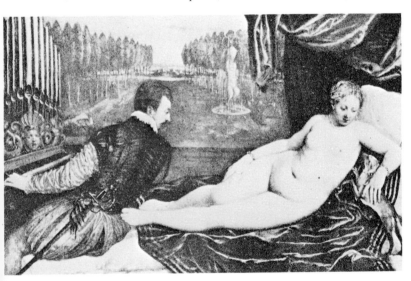

Titian, *Venus and Music,* Prado, Madrid

was a Roman Catholic one. His contacts with the King and court of Spain connected him with the Counter-reformation. Yet, as so often, Roman Catholicism went together with Humanism, the third force beside the Reformation and the Counter-reformation that contributed to the great European civilization of the seventeenth century. Humanism, this basic force that emerged with the Renaissance, took its starting-point in man. It is man's insight, man's power, that would rebuild the world. At times it was non-Christian, even anti-Christian, but as a whole the Humanists, because they were not deeply concerned with the church, compromised with the church—which after all could become somewhat dangerous, with its inquisition. As the Roman Catholic world awakened out of its slumber with the Counter-reformation, Humanism was put in its place—a secondary place: it could cater for worldly activities and insight, not be concerned with religion . . .

So Titian painted both altar-pieces and many works with a marked Humanist tendency. This painting of 'Venus and Music' is one of them. To understand it one must ask oneself: who is Venus? Nobody worshipped Venus in a religious way, of course, or believed she really existed. No, the old pagan gods of antiquity were revived to be used as allegorical figures, figures through which invisible yet real concepts could be symbolized and visualized by means of painting. Mars stood for war, Hercules often for the human soul, Mercury for trade, and Flora for the world of flowers. Venus was the goddess of love and beauty. The sixteenth- and seventeenth-century conception of the world was in many respects a mixture: it combined the old scholastic philosophy, itself a synthesis of pagan Greek philosophy and Christian theology, with the re-discovery of late Greek and Roman thinking as well as the renewed insights into biblical truth of the Reformation. It was a world in which it was possible to speak of the reality of such concepts as beauty or love. They were realities outside man, and man in his life and work had to reflect them, to realize them by working according to them. Love and beauty were not just man's feelings and man's subjective taste; they were really there: if he did not follow them, hate and ugliness would be the result.

So we must be careful to understand that the woman on the

couch in this picture is not a real woman, which would make the picture somewhat strange, if not of questionable propriety! In a way there is no woman in the room with the musician at all. Titian makes it clear through his composition that she is of a different kind, living in a different realm. There is a jump in space between the feet of the Venus and the back of the musician. The organist looks back at her as he draws his inspiration from love and beauty. So the title of the painting is rightly 'Venus and Music' as music is inspired by love and beauty. This mixing of allegorical figures with real ones was typical of the Venetian painters of the sixteenth century.

Venus is reclining. We often find reclining nudes in sixteenth-and seventeenth-century painting, and very often their position symbolizes inspiration. In a picture by Rubens, a man looks at a reclining nude: Cimon is being inspired by her beauty and thus changed from rogue to gentleman—a story from Boccaccio with neo-platonic overtones. We can see her too as Danae in a famous painting by Rembrandt in the Hermitage in Leningrad: the woman is a portrait of his young wife, and he speaks of her as inspiring him—mixing in a peculiar way allegory (in the form of an ancient myth) and reality.

The fact that these pictures show more than the eye sees means that they acquire a meaning that goes beyond a photographic representation. They speak of human insight and understanding, of human values and truth— human in the sense that they belong to man, not necessarily in the sense that they are invented by man.

So, from the Madonna on, paintings give a philosophy of the world and of life. They are more than decorations or simply pleasant to look at. They have a message, and, what is vital to notice, a message realized by artistic means. The picture gets across what it wants to say, not just through its title, but by its own built-in qualities of artistry and method.

Chapter two

THE ROOTS OF CONTEMPORARY CULTURE

When Man throws God right out of the window
It ain't so much a case of
He don't believe in nothing,
But more a case that he
Believes in anything and everything . . .

Flaming Youth, *The Planets, Ark Two*

AT THIS STAGE in the historical development we have been tracing there is a picture missing. For our next picture we would naturally have looked to see what the great Christian movement which had its starting-point in the Reformation went on to express in its art. We may acknowledge the deep influence of Calvinist Christianity on the culture and art of the seventeenth century, particularly in Holland. But otherwise we draw a virtual blank. Protestantism as such did not foster the arts. Why?

For the only apparent explanation we must look rather further back. At the time of the beginnings of the Reformation the main spiritual and cultural forces in Europe were a Roman Catholicism in decay and the lively and growing Humanism of the Renaissance. But, perhaps less obvious, but no less important, there was also a mystical stream. The whole cultural scene changed according to the content and strength of the different spiritual streams. The Reformation came as a challenge to the authority of the Roman Catholic church, which up to that time had forced many to pay at least lip service to its doctrines. Soon we see Roman Catholicism trying to renew and reinforce itself with the Counter-reformation. Humanism became more openly worldly and secular, though it thereby lost some of its strength and influence on the course of events (in fact, a kind of crisis can be seen here, expressing itself in the mannerist art of Pontormo, Giulio Romano and Pellegrino Tibaldi). The mystical stream was expressed in the movement loosely labelled Anabaptist, which included a variety of viewpoints, Christian and anarchistic, pacifist and militant.

The sixteenth-century battle between the Reformation and

the mystical movements was won, by and large, by the Re-
formation, but it did not emerge completely unscathed. A
secondary stream of mysticism went along with the Reformation,
tingeing its efforts and thinking, sometimes more strongly,
sometimes almost not at all.

This accounts for the differences in the subsequent develop-
ment within the Reformed camp. Puritanism is not a unified
movement. It took from the Reformation its profound reverence
for the Scriptures as a base for all theological thinking and daily
living. But through mystical streams it was often tinged by a kind
of subjectivism and a tendency to look for holiness in a legalistic
and spiritualized way in an effort to keep clear of all worldly and
fleshly pursuits.

It is hard to give a full picture of the Puritan movement. There
was certainly much biblical wisdom, but again and again the
mystical undercurrent came to the surface. For instance, Morgan
Llwyd is a typical example of one who held radical Puritan
views.[1] He combined a scepticism about outward forms of
religion, a strong antipathy to dogmatism about church order and
ordinances, and a marked tendency to evangelical antinom-
ianism, a false idea of freedom from the law.

This mystical stream often depreciated everything outside
the 'spiritual', the 'religious' in the more narrow sense. It must
have had a stronger influence than we often assume, as only in
this way can we understand why psalm-singing, which was
originally very lively, cheerful and attractive (Queen Elizabeth
once called the psalms 'Geneva gigs'!) was abandoned for a very
slow and almost unmusical way of singing—the sort of thing
against which Isaac Watts later protested, and which was only
superseded by the vigorous hymn-singing of the Wesleyans.

Yet music was to some extent still acceptable to them. The
other arts fared worse. We can only conclude that the Calvinistic
and Puritan movement (at least from the seventeenth century on)
had virtually no appreciation for the fine arts, due to a mystic
influence that held that the arts were in themselves worldly,
unholy and that a Christian should never participate in them.

Only in this way can we account for the fact that the real

[1] *A Goodly Heritage* (Banner of Truth Trust, London, 1959), pp. 53 ff.

Puritan or Calvinist movement did not produce its own style of painting. As we have seen, Dutch painting in the first half of the seventeenth century was strongly influenced by Calvinist Christian thinking. We mentioned Rembrandt, who was certainly searching to achieve in his art a true portrayal of the biblical message. But can Rembrandt be called either a Calvinist or a Puritan?

In the second half of the seventeenth century in Holland the Humanist stream gained in strength, and a Humanist-classical style, imported from France and Italy, began to take over. In England before the time of Cromwell the court art of van Dyck and kindred spirits made any developments from the side of the more Puritan stream of thought and feeling almost impossible —and later it never had much of a chance.[2] When the chances did come, much later, in the eighteenth century with the revival of faith with the Wesleys, or with the nineteenth-century revivals, the Protestant stream was no longer interested in the arts at all.

We cannot say that Christianity had no influence at all. On the contrary: it had a great influence on public morality, concern for the poor and oppressed, and generally speaking on people's way of life. What we shall call the bourgeois mentality in a later section of this book is often in fact a secularized form of Christian ethics, even though morality may have become no more than moralism and legalism. But on the other hand the fact that most Christians did not take part in the arts and the general trends of culture to any extent allowed them to become completely secular, and in the long run even contrary to Christianity. However that may be, it is the reason why in this book we have to deal with developments outside the realm of Christianity if we are to understand what is going on today.

Christianity and culture

Today it is well known that within evangelical Christian circles there is little interest in the arts. As a change becomes apparent, as

[2] F. Antal in his writings on Hogarth discusses this lack of a real English school of painting before Hogarth's time, apart from portraiture, and ascribes it to the strong influence of Puritanism in the cultural atmosphere.

the younger generation born and raised within these circles comes to understand the importance of the arts, all kinds of problems and tensions arise. Any sort of critical way of thinking is almost completely lacking. There is no artistic insight, nothing to point to, no answer to the relevant questions of the rising generation. Many want to be artists in a Christian sense—but have to find the answers for themselves. How should they go about it? What does it mean? Many have turned away from Christianity or, more tragically, from Christ, as they have come to feel that, if this vital aspect of human life is outside religion or faith, then something basic must be defective in the faith. In different ways they have to join in spiritual battle against the spirit of the age which is expressed so very strongly in the arts—and many succumb.

It is only too possible of course to take the same Puritan position today: keep away from the arts, they are worldly, they are secular and unholy. But that is no answer. It misses the point. For one thing, it ignores the fact that the arts are particularly strong protagonists for a new non-Christian way of thinking. It could well be that the arts are indeed 'avant-garde'—in the sense that they are ahead of the rest in the quest for a non-Christian way of spirituality. Why? Because for so long Christians have taken no part in artistic discussion or activity.

But this is to anticipate the argument of later chapters. At this stage it may be helpful to show in broad outline the different attitudes there have been in the past to the relationship between Christianity and culture. By 'Christianity' I mean something very general: a cultural and spiritual stream that has historical connections with biblical faith and religion. Christianity is not a normative term, but rather a loosely meant framework, to differentiate it from Mohammedanism, paganism or the world of the Eastern religions.

Christianity and culture can, of course, mean two things: what attitude the Christian should have to the surrounding (non-Christian or secular) culture; or what kind of a culture will be the result of the Christian's way of life. The two answers are in practice closely bound together, and as in the following discussion it will be clear what is meant, we have not tried to be systematic in this respect.

Some major diverging answers to the question of the Christian's attitude to culture have been given in history. They were discussed in H. Richard Niebuhr's *Christ and Culture* (1952), whose main approach I follow here.

Gnosticism and mysticism

It was gnosticism that was in many ways the influence behind the mysticism of later ages. It was the view that lay behind some of the letters of John and Paul to the early church, which were written with the express purpose of warning the Christians against it. Without going into detail at all, we can say that the gnostics made a synthesis of biblical thought with that of neo-platonism and pagan mystery religions. One of the main ideas involved was that the material world is wholly bad. So salvation means escape from this world, getting nearer to God who reigns above this world. And not only is the material world bad, but so are all our worldly passions.

The early mystics were akin in many ways. They were concerned not just in mortifying their sinful nature but the body itself, the physical, the material. So, they said, we must flee this world—and they did so, with austere asceticism, trying to climb towards God, whose reign is in the world of grace, beyond the material, in the spiritual realm.

So the life of faith consists in fleeing sin, living in the spirit, seeking to be holy. These words certainly sound biblical, but gnosticism gave them a very specific tinge. This life is of no value. The material is sinful. Life is no more than a time of trial, and the true goal can be reached only by those who have worked themselves up towards God by their own holiness, by conquering all fleshly desires.

It is important to understand these basic ideas of mysticism, for our own century, and particularly the arts of our century, are strongly mystical in spirit. Mysticism has also often been Christian, meaning that Christians have looked in this direction for their way of salvation. But the Bible gives no grounds whatsoever for such a view; quite the contrary, for the apostles fought it strongly in their letters. But as most 'Christian' mystics de-

preciate the Bible for a more subjective experience this argument
often fails to reach them.

In the visual arts in the middle ages mystical tendencies can be
seen at work in the art of the fourteenth century in Germany, also
in the extreme, spiritual, 'fleshless' beauty of the Madonnas, and
in the extreme portrayal of Christ's suffering on the cross (as in
Grünewald, for instance). A more practical and less extreme
mysticism was very strong in the Netherlands in the fifteenth
century amongst the Brethren of the Common Life, whose major
literary work was Thomas à Kempis's *The Imitation of Christ*. In
the visual arts we see its subdued and inward way of expression in
the works of Geertgen of St John and other Dutch artists (who
were of considerable influence in the formation of the Dutch
character).

As I have already shown, mysticism's influence on Calvinism,
expressing itself in an extreme, passive, almost fatalistic view of
election, was mainly responsible for the lack of real interest in the
arts. It introduced a kind of spirituality that often kept Calvinism
from realizing one of its main principles, that faith is not just a
matter of 'religion', of the soul, with its salvation in heaven, but a
salvation of the whole person, a way of life and thought affecting
all aspects of human life.

A dualism of nature and grace

Another answer to the problem of the relation of Christianity and
culture was worked out in the mediaeval theology, or rather
philosophy, of men such as Thomas of Aquinas—what has come
to be known as Scholasticism. As a complete Roman Catholic
system of thought, it was to have a lasting influence on all
Christian thinking, and its attitude to the world in which we live
is one of the most subtle and dangerous enemies of true biblical
thinking, even today.

Basic to it is its dualism: this world is good, but yet has an auton-
omy of its own. The world of faith, of grace, of religion is the
higher one, a world for which we have need of God's revelation.
This is where our aims and affections should be set. But the
lower world, the world of men, the world of 'nature', can be
understood by reason, and here in fact reason reigns. It is as such

non-religious, secular. Here there is no difference between the Christian and the non-Christian, as both act according to the natural laws of thought and action.

Being biblical scholars, and trying to find a unity in their original duality, these men often softened their principles in practice. In the middle ages, when the Roman church was overwhelmingly powerful, they tried to get the secular world into their power in order to prevent autonomous 'nature' from becoming non-Christian and truly autonomous, emancipated from Christianity. Yet this is just what did happen in the Renaissance, with the birth of Humanism.

We often hear people say in discussions about the sciences and the arts that these cannot be Christian—even devout Christians say so sometimes. We must be careful to distinguish what they mean to say. Often it does in fact mean that these realms of 'worldly' pursuit, belonging to our human nature and not sinful as such, are just human, that is, apart, outside of the realm of grace, of God's work and revelation. The only claim God has in this realm of human endeavour is in the field of ethics; so painting is simply painting, whoever does it, but the Christian must show his Christianity by avoiding immorality of any sort.

This of course raises all sorts of questions about the attitude of Christian artists to their work. But I will forbear from commenting at this stage, as I shall be attempting to formulate a rather different answer in a later chapter of this book.

The Reformation attitude

Christians have sought in all sorts of ways for an answer to the question of how a Christian should live and act in his daily life and in his academic and creative endeavours. Augustine, later Calvin and in his wake the Calvinists and Puritans, though sometimes hindered by the mystical influences we have been discussing, looked for the answer in a more directly biblical way.

I used the phrase 'how a Christian should live and act' rather than 'a Christian's attitude to culture' advisedly. For we can easily slip into the mistake of making Christianity and culture two distinct entities quite separate from each other. Then, if we find we are in difficulties in resolving the two, the mistake may well be

that we are trying to bring together two different things which we have separated artificially. Culture is the result of man's creative activity within God-given structures. So it can never be something apart from our faith. All our work is ultimately directed by our answer to the question of who—or what—our God is, and where for us the ultimate source of all reality and life lies. So our resulting 'culture' can never be something separate from our 'faith'. This is just as true for those that do not acknowledge the true God, the Creator: their cultural activity is coloured by their basic non-Christian faith. For the Christian the problem remains of how we have to deal with the culture around us, often the fruit of a non-Christian point of departure. But then this is dealt with at length and depth in the Bible itself: it is even one of its main concerns, and bound up with its teaching on sin, redemption and sanctification.

It is basic to thinking about culture in the tradition of the Calvinist Reformation that there is no duality between a higher and a lower, between grace and nature. This world is God's world. He created it, He sustains it, He is interested in it. He called the work of His hands good in the very beginning. Nothing is excluded. Everything, from the lowest atom or animal life to the highest doxology, everything belongs to Him. Nothing can exist outside of Him, and all things have a meaning only in relation to Him.

Yet there is a sharp division—not between a realm that God deals with and another that is more or less autonomous, not between a higher and a lower, but between the kingdom, the rule, the realm of God and the kingdom of darkness. Man, in the Fall, brought sin and, consequently, a curse into the world. And so there is a duality, between good and bad, right and wrong, beautiful and ugly. In his sinfulness man wanted to be like God, to be autonomous. And sin, bringing with it decay, sickness and ultimately death, is still in the world, marring God's wonderful creation. This is the true division. It goes through all mankind, affecting every human being; two opposite ways, one as God wants, the other against His will. So, as Paul said, nothing is sinful, neither eating and drinking nor any kind of activity whatsoever, if done with thanksgiving. But all things are sinful if done in disobedience to God's will and Word. The first and second

commandments express this basic division within mankind. Nobody is excluded. And so too the fact that Jesus Christ died to take upon Himself the sin of mankind is not just something for the 'soul'. The whole cosmos is to be redeemed, to be 'bought back', for all things are under the curse of sin and evil. His saving grace, His offer of new life in all its fullness, for He is the Way, the Truth and the Life, excludes no aspect of human reality.

Seen in this way all of life and reality is related to God—and all our thinking, work, action, feeling is in a way 'religion'. Religion in the narrow sense, prayer, the devotional, is only a part of the life of faith. The Bible makes it clear that we shall not try to turn all human life into the devotional in the sense that Christians have often made a division between direct, conscious devotion, or worship, and 'natural' life. The Roman Catholic ideas outlined in the last section were not just theory, but common practice. Sincere and committed Christians have often struggled with this duality in their desire to bring everything under God's dominion. It was what led some to become hermits or monks, as they wanted to give their whole life to God. But it is not just the soul, the religious in the narrow sense that belongs to God—it is the fullness of life. Nothing is excluded. That is why we pray 'Thy kingdom come'. We ask for God's rule to be acknowledged and extended in this life, in this world, 'on earth as it is in heaven'.

To make this full relationship with God clear, including both the devotional and all other aspects of daily life, we may use the Old Testament term 'covenant'. As the Old Testament covenant was for the Jewish people, those who were circumcised, so the New Testament covenant is for all those that call on Jesus as their Lord and Saviour, those who are baptised. Within the covenant there is no division between a higher and a lower, no part of life that God would not be interested in. Though we sleep, or plough, or solve mathematical problems—all activities in which we do not think consciously of God, and our 'faith' seems to be non-active—yet we are never outside God's covenant. We can never be out of His world, and He never forsakes us.

We see that God makes this abundantly clear in the Old Testament. He did not want His people to turn everything into 'religion', into 'cult'. So He told the Israelites that they could slaughter everywhere, though it was only in the temple that it

would be done as an offering. He told them they could feast with the offering of thanksgiving in the temple, though not for more than three days. And He also told them that it was good to put a fence round a roof to stop people from falling off. He was anxious to give them good advice in many matters that were not simply cultic, but yet belonged to His dominion. He wanted His people to live, as He was the God of life, life in the full sense, in all human realms. He showed that nothing was excluded, neither stealing nor judging, trading nor property, sexuality nor eating and drinking. His commandments were not simply religious or ethical, they were basic principles of life, though including of course both worship and ethics.

God in His wisdom knew that if His children took to other gods they were not only wrong in their faith and worship, but that all life was in principle threatened, sex, politics, daily happiness. We read about the results of leaving the true God in the Old Testament historical books and prophets—and in the New Testament too. And if they were reluctant to listen to the prophets, God told them that He would come with His judgment, which again was not only in matters of faith, salvation or the after-life, but also in this life, in their political freedom, their possessions and well-being.

So without going into more detail, these great biblical principles of the Reformation gave an answer not only to the question of what a Christian's attitude to culture should be, but also to the question of what a Christian's attitude to a non-Christian culture should be, the very practical problem of how we are to live in a world that is full of sin and ungodliness. Where things are loving, good, right and true, where things are according to God's law and His will for creation, there is no problem. The Christian will appreciate and actively enjoy and enter into all the good things God has made. But where they have been spoilt or warped by sin, then the Christian must show by his life, his words, his action, his creativity what God really intended them to be. He has been made new in Christ, been given a new quality of life which is in harmony with God's original intention for man. He has been given the power of God Himself by the Holy Spirit, who will help him to work out his new life into the world around him. He is the 'salt of the earth', keeping society from corruption, and giving savour to every aspect of life.

Before the Enlightenment

The relation of Christianity to culture can in many respects be seen as what we might call a secondary blessing. Most people, simply by being human, long for true humanity, for righteousness, love and goodness; if Christians are showing these things, the primary fruits of the gospel, in their lives, this will have a great influence in itself. In this way even in a sinful world—even in a world where Christians too are still far from being without sin—a 'consensus' can develop, a general cultural pattern which will include an insight into what is best and right, an understanding of what is truly human. I would call it a secondary blessing of Christianity because it influences not only the true Christians, those who have trusted in Jesus Christ, but also people who do not want to be Christians themselves. In fact even those who are living sinful lives accept the standards of the consensus.

Something like this happened in the seventeenth century. The consensus was to a large extent the fruit of the Reformation. Also it influenced the Roman Catholic church to review its teaching and (perhaps more important) its practices. Because of this the power of Humanism was contained for a time. Though Humanism was certainly a contributory factor in the seventeenth-century consensus, it was a minor force, and to a certain extent christianized.

We must realize that to seventeenth-century man there was no doubt about the reality of the things in Scripture. Even those who were not Christians still acknowledged the facts. Marlowe was somewhat earlier, but his play *Dr Faustus* is typical. Here is a man who has sold his soul to the devil; when hell is very near, he cries out: 'See see where Christ's blood streams in the firmament. One drop would save my soul, half a drop, ah my Christ.' He does not repent and is not saved, but he knew, though an unbeliever, where redemption was to be found. And Marlowe was not a Christian; and he knew. The same sort of thing happens again and again: the philosopher Descartes found by his famous 'method' the way for mankind to find human certainty—which meant that biblical realities were cast out. But when he made his great discovery and formulated his *cogito, ergo sum*—he made a pilgrimage to the Virgin Mary to thank her! The world-view of

seventeenth-century man was a traditionally Christian one (and mainly a biblical one), even though many of the people themselves were not Christians.

The greatness and fullness of seventeenth-century culture, its art and science and depth of understanding, its wealth and power, were not the result only of human endeavour—as if Christians made these things their main aim. No, they were by-products of basic Christian attitudes, and in the final analysis blessings and gifts from God. Jesus Himself told us to look first for the kingdom of God, and all these things would be given to us. And all these things, the great culture of the seventeenth century, were given after European man returned to God. God promised His people (for instance in Deuteronomy 28) that, if they were willing to walk in His ways, He would make them outstanding among the nations, and give them a leading role in the world. And this was not only true for ancient Israel, it is still true today. The blessings listed in that chapter were the natural results of walking in the ways God had designed individuals and societies to live.

How did seventeenth-century man understand the world around him? Of course there were many interpretations and opinions, but the basic core, the consensus, was something like this. There is a triune God who created heaven and earth, the whole cosmos. In this cosmos there are angels and devils, and there are men, animals, plants and material things. But there is more, much more than the eye can see. There are principles and norms or laws, and therefore we can speak of good and evil, right or wrong. The world has a structure, given by God, in which all things are in a specific order. All things have meaning in this structured order of things. Creation is harmonious and good, even if polluted by man's sin. Within this ordered universe man too has his specific place: he may be the crown of creation, but he is not the centre of it.

This description is in no way complete, of course. It was a very rich understanding of the world and of man and his life. Yet seventeenth-century people were really no better than we are: they were sinful and often stupid. For instance,[3] their attitude to

[3] See the helpful book by Basil Willey, *The Seventeenth Century Background* (Penguin Books, Harmondsworth, 1962), in the discussion of Glanville.

'witches' was the last thing we would want to defend, though it was an attitude only possible within such a world view. And above all seventeenth-century man was no different from the Israelites of the Old Testament: when it came to it they forgot that their wisdom and greatness were gifts from God. They did as Moses said the Jews would do,[4] 'Jeshurun waxed fat, and kicked . . . he forsook God who made him, and scoffed at the Rock of his salvation.'

Christianity grew weaker in the same way. There were increasingly people who said they believed in God, but no longer acted on His promises. They tried to be moral in their own strength. And they failed. And Humanism grew in influence.

This might seem a somewhat negative way of introducing the great movement which has come to be known as the Enlightenment. But it is a crucial point in our story. For the Enlightenment was to change the world. It is a period in which we today are still living, though at its end. Its aims have been fulfilled. The world is different. What started in the philosopher's study is now in the hearts and minds of the whole western world. It is essential for us to understand it in outline if we are to appreciate either art today or the whole position of man today which our art expresses.

Science

Before discussing the main themes of the Enlightenment in more general terms, we must first concentrate on one key area— science—in which it is essential to compare what was to come with what had already gone before.[5]

When Christianity was preached in Europe, culture and spirituality were changed very deeply. If we realize what the simple conclusion of understanding Genesis 1 means to man's outlook on reality and his endeavour to understand it, this will be immediately clear. Genesis 1 says that God created the world and that there is no being that has not been created. This has given man a freedom for research formerly unknown. To the heathen, whether Greek or Germanic, the gods gave order to reality.

[4] Deuteronomy 32: 15.
[5] See too R. Hooykaas, *Natural Law and Divine Miracle: The Principle of Uniformity in Geology, Biology and Theology* (Leiden, 1963), esp. pp. 209 ff.

Ionian natural philosophy, for instance, began something that might have developed into a scientific philosophy similar to that of the eighteenth century; but there were objections from the majority of the Greeks who were afraid of such impiety.

Take lightning, for instance. What is it? The wrath of the highest god? His tool and weapon? Can we investigate it? We had better not, as that could be sacrilegious—and dangerous. The heathen gods, being part of the cosmos and its regulating principles, made it at the same time impossible to analyse these principles open-mindedly. But as soon as we come to know the true God, who is not part of the cosmos but its Creator, then everything is open for investigation, for everything has been created by Him. So only on this basis is there freedom for science.

What is more, in contrast to the ancient scientists who were always in danger of being accused of going against the 'divine' order, this Christian freedom did not need to go against the understanding that God reigns over the cosmos. Science proceeds from the assumption of causality. We ask what made a thing happen like that when we make an experiment. There is no event without a cause, no cause without a result. If we see a stone moving, the question is what made it move. And we always try to find a natural cause, a cause within the created order of reality. But again, this does not exclude God, nor explain God away.

Elijah, for instance, prayed to God for rain. But he knew, as man has always known, that there can be no rain without clouds. So he sends his servant up the hill to see whether the clouds were coming. Praying for rain and understanding the basic rule of causality do not conflict. Why should it be a problem that Jesus walked on the water? If Jesus was God, and so Lord of creation, there is no reason to query whether He could. This is not contradicting science. It keeps the world open to God, who as Creator can work in His creation. This is the basic assumption of all prayer, and at the heart of biblical teaching: that God has created *and* sustains the world; that He is interested in His creation, and does not let things go 'by chance'. He looks after man, His creature.

It is a pity that it took a long time before these principles were realized. Perhaps it had been mystical ideas about the relationship of Christianity to the world that had previously kept men

from being really interested in matters of science (and historical circumstances such as the barbarian invasions cannot be ignored). So it was only in the sixteenth century, after the Reformation, that science really began its fantastic development. Of course, Humanism played its part. But it must be said that it capitalized on the freedom in looking at the world which Christianity brought. Many of the scientists of the seventeenth century were in fact devout Christians, and never found their activity minimizing their faith.

The Age of Reason

What happened, then, with the eighteenth-century Enlightenment? As with all periods of deep and many-sided changes, it was a time of conflict and contradictory aims and ideas. Yet, as we have seen, it is essential to an understanding of what was to follow to understand its basic principles. For they were principles which still very much affect us today.

In a way the Enlightenment was the resurgence of the principles of Humanism, gaining new strength as the impetus of true Christianity after the Reformation lost momentum or retreated into a mysticism that left the world to its own devices. The old pseudo-Christian view of the two provinces in human life, faith and nature, which was revived at this time in a neo-scholastic theology among both Catholics and Protestants, made it easier initially for Humanism to gain ground. The inevitable result was only apparent later as faith became something set apart from the real problems of culture, something of no more than private importance, with no influence on the things that really matter. And so, in the long run, the place of Christianity became problematical and many lost their faith.

The first principles of this new cultural movement known as the Age of Reason were developed in France and England by philosophers such as Descartes, Hobbes, Locke, Hume, and the French Encyclopedists such as Diderot. The first three wanted to retain their Christianity. Descartes made his pilgrimage to the Virgin Mary. Locke wrote a much-used book in 1695 called *The Reasonableness of Christianity* (for he would accept revelation only so long as it was reasonable). Indeed, their basic starting-point

was found in reason. I doubt everything, said Descartes, but one thing I know for certain, that I am, because I think. So God was made unnecessary, left out of account. However gently, He was pushed out of the door. For personal life, for heaven and redemption, He might be useful, but in the discussion of matters of science, politics, the big issues of the organization of the world, man must start with reason.

We can understand their intention. Reason, or, as they called it in the eighteenth century, common sense, is something that all men have in common. And they all live in the same world using the same senses. If we start from this, we can get rid of all the seemingly subjective discussions on matters of religion. And, after all—in this they were true Humanists—man is good, and in starting from his reason and perception things will go better; a better, more human world can be made, a world in which man will be tolerant of his neighbour rather than persecute him.

In pushing God out of the door of their reasoning, the result may well have been a radical scepticism of everything. But they avoided this either by sheer humanistic optimism or by keeping detached from the ultimate questions man is inclined to ask.[6] What they did not avoid was an increasing change of emphasis from what was reasonable to what was rational. The rationalist's reason is like an idol; it is like King Midas's fulfilled wish: everything it touches changes and dies, even if it glitters and sparkles. The Reformation had never asked man to accept faith as a leap in the dark: for the Bible itself points to facts. Faith and rationality do not exclude each other. But rationalism is something different: it means that there is nothing more in the world but what the senses can perceive and reason apprehend. There is nothing but scientific fact—or fancy. And God? God is amenable neither to sense-perception nor to reason. So God is left out . . .

Starting in every human endeavour with man changed virtually everything, though it took a long time before all the consequences were seen or realized—perhaps only today are we beginning to see it in all its depth and breadth. In the older framework, man had his place in a large universe. There were

[6] *Cf.* H. J. Blackham (Ed.), *Objections to Humanism* (Penguin Books, Harmondsworth, 1965), p. 62.

principles, ideas outside man, just as there were angels, devils and other forces. In philosophy man's endeavour was in the field of ontology, the theory of being: how is the world structured, what is the place of man in it? But now the primary problem was that of epistemology, the theory of knowledge: how can we know, how do we get true knowledge? Locke wrote an *Essay concerning human understanding* (1690), Hume an *Inquiry concerning human understanding* (1739 and 1748), while Kant made epistemology the cornerstone of his philosophy. Again and again the main point is this: we as man stand before a big 'X' called the universe, and the only way to come to any understanding of it is to use our senses (seeing, hearing, weighing, measuring) and to use our reason to coordinate the sensations or perceptions we have had. So the ideas outside man are no longer of any reality nor of any validity as normative principles.

Of course, starting with man and his reason meant that not only God (who is He—an idea too?) but also many other elements were excluded from man's world-view. Angels, devils, they are probably only old superstitions. At least one thing is sure, we cannot prove their existence: have you ever *seen* an angel? They did not stop to ask whether many people in biblical times had seen angels either—they were not a common everyday experience in the sense of being frequently seen or heard—but then belief in biblical times was not based solely on statistical evidence.

Then the principles, norms and laws themselves also disappeared. If we have agreed upon the principle that we shall not ask God for guidance nor accept His commandments, and if we say only things experienced or reasonable are true, well then, why not steal? The fact that God gave a commandment is irrelevant. So Hobbes constructed his 'social contract': man in the beginning of history, having found that stealing is a nuisance and a hindrance to all human endeavour, decided that it was reasonable that man should not steal. This is fine, of course, but what if man (or a group of men) decided, by a majority vote tomorrow, that in the present situation it is now more reasonable to steal? The principle of the Enlightenment excludes the possibility of true norms or basic principles. So good and evil have to be put aside as part of real reality—they can at best be con-

sidered subjective human evaluations of behaviour.

But in a way man also disappears. Diderot wrote in the famous *Encyclopedia* (1752–72) under the entry 'Man' that he 'seems to stand above the other animals' . . . Man is really only an animal— who can *see* any basic difference? If we read on, and appreciate the spirit in which sentences like these were written, it comes down to this: there is no basic difference between man, animals, plants and things. This was a credal statement, of course, avowedly anti-Christian, but a faith without any sort of proof. So the sciences were called in to provide the proof and give it a solid base. Science accepted the new task, and, with the theory of evolution, would seem to have 'proved' it finally, for in examining the possible mechanism of evolutionary change there would seem no need for a God behind natural reality, no need for a Creator. Science became scientism. Evolution was from its very beginning evolutionism, more than just a scientific theory, but rather a philosophy with its own anti-Christian or at least non-Christian dogmas. In this way human existence was equated with natural, biological or physical reality, and the new science tried to give this view a foundation in facts. But they were naturalistic facts alone, from which, following the principle of uniformity, everything beyond the natural, everything which cannot be perceived by the senses, everything beyond the rationalist's reason, is excluded.

So man became 'natural', and lost his particular place in the cosmos. He lost his humanity. What does that mean? If man is just another animal, for instance, then what is 'love'? After a long development the answer came out loud and clear: Libido. Lust. Love is *really* only sex. All that seems to be more is 'in fact' sublimation, a nice kind of façade to hide the real drives. Sex one can see and experience. But love?

We must always be on our guard when we hear the word 'really' used like this. More often than not it means that an essential quality is removed! For the new science, which we should call mechanistic science, became a kind of 'revelation', the only way to get true knowledge. All things are *really* only natural things, animals, plants, non-living matter. There are no basic differences to the scientific eye. Science has become the revelation of the new world, and man clings superstitiously to the

word scientific as true to reality. But it is a reduced reality.

The nineteenth century—and ours too—has laboured to work the new principles out. The result has been a *démasqué* in which many things held sacred or deep are brought down to what they *really* are: sex, lust, power, the survival of the fittest, an instinct or will to live. Life itself, instead of the varied and deep meaning it had in biblical language—man's full being, his true humanity, his work, dreams and aims, so that Christ Himself was able to say that He is the Life—life became nothing more than biological life, the beating heart and sexual urges and quest for food and drink. We can understand the man who, standing at the end of this development, asked recently in one of the underground papers, 'Is there a life before death?'

Man in the box

Science had been the way to acquire insight into the structure of reality, into the way this world is built, to find out the greatness of God's creation. But now it was elevated by the rationalist into the tool to know all truth, the foundation of all knowledge. But the world was no longer open to a transcendent God. It had become a closed box, and man was caught in that box. The content of the box was the only true reality allowed by the men of the Age of Reason, the things that can be understood by rationalist reason and mechanistic science, together with the dream of the new world they had begun to build. What we have already called 'scientism' was this faith in reason, with science as a kind of revelation. The world they were building was a fulfilled technocracy, scientistic truth put into practice.

It took a long time before all this was fully worked out. Maybe it never will be, completely and fully, for real reality, that which is more than naturalistic nature, cannot be ignored. It took a long time before the scientific methods that were used with such great success in the natural sciences and technology were applied to other fields of human endeavour, to economics, sociology, and soon too, through Freud and others, to psychology. Then man is really caught in the box, an object determined by natural laws to be studied by science with scientific methods—and nothing more. Scientism was almost a new religion: man was *really* no different

from animals, plants and things. And Darwin seemed to give the final proof, by providing the mechanism of natural selection, of the evolutionary vision of what man really is and could become.[7]

The world in which we live is built upon these principles. They still hold man in their grip. Scientism is still the way man hopes to make a better world. It is, and will be, a technocratic world, as technocracy, which includes man, too, is at its heart. Man is no longer a human being who buys things: no, he is a consumer. He has become a little wheel in the big machine, a unit in social statistics, an electronic oscillation in the computer.

We shall be seeing later what this means when we discuss modern art. But in thinking of the process by which man has become what Marcuse has called 'one-dimensional man', there is one thing we must never forget. Man will always remain human, for he cannot change his own basic created being, whatever he thinks of himself. He can never get away from his place that was assigned to him in the fullness of the created universe. This means that man can never be happy with the fact that he is 'caught in the box'. He knows that he is *really* more than an atom—or a rabbit. And so he wants to escape from the box, even if the principles of his own philosophy deny him the possibility of doing so. He can but protest against the dehumanization of present-day society, the establishment. . . .

The existentialists in our century have been the philosophers who have thought deeply about this human condition. And they have told man to jump out of the box—following such great men of the nineteenth century as Kierkegaard, the romanticists or some of the great artists such as Baudelaire or the cubist painters. They have said to man: get out of the box, you are more than matter, more than the naturalistic sciences can tell you. You are really human if you transcend your human condition, your fate of being in the box. Of course, this reality is above reality, it has to be irrational, for rationalism is the main principle of the box— and irrationality means unreasonable, undiscussable, being understood neither by reason nor by science.

[7] R. T. Clark and J. D. Bales, *Why Scientists Accept Evolution* (Baker Book House, Grand Rapids, Michigan, 1966).

For many reasons[8] art has been assigned the role of the revelation of this existential, irrational order which is above technocracy and apart from technocracy. But before showing how this has worked out we must wait until we have advanced so far in our argument. At this stage we must turn to the development of modern art, and the genesis of its basic principles. We must turn from the background, the principles of the Enlightenment, to their consequences.

[8] I have discussed them in an essay 'The Artist as a Prophet' in a booklet published by L'Abri Fellowship under the title *Art and the Public Today*, 1968.

Chapter three

THE FIRST STEP TO MODERN ART

Impaled on my wall my eyes can dimly see
the pattern of my life and the puzzle that is me.
From the moment of my birth till the instant of my death
there are patterns I must follow just as I must breathe each breath
like a rat in a maze the path before me lies
and the pattern never alters—until the rat dies.

Paul Simon, *Patterns*

THE ENLIGHTENMENT may have begun as a philosophical movement, but deep spiritual problems related to religious truth were also very much at stake. Its influence was not only on the minds but also on the hearts of men, it affected their sensitivity and emotions, it really changed their life in all its aspects. The eighteenth century was the beginning of a revolution of life and society that has not yet come to an end. The denial to God of the place that He deserves as Creator and Lawgiver has had many repercussions. And as man's understanding of himself and his world has changed, so inevitably has his art.

The Enlightenment involved raising the epistemological question: *how can we know* the world and its governing principles? This had considerable implications for art. The problem for the artist was now what to paint, what to see. What could he see, how could he achieve any sort of artistic understanding of the world, of humanity, of what he wanted to paint? In a way intellectual questions came to hinder his vision.

Nothing but the facts

One of the first to appreciate these things deeply was Goya, whom many would call the first modern artist. So deeply in fact did he understand them that he produced an etching with the title 'The Dream of Reason Produces Monsters'. He has depicted man, in war, in daily life, as monstrous. He has depicted the irrationality of this seemingly rational world. It must be stressed that he always avoids showing any sort of normative principle at work. People are fighting in the street: it is a fact, people are

Goya, *The Dream of Reason Produces Monsters,* etching, Prado, Madrid

Goya, *The Execution of Spaniards by the French, 3 May 1808*
Prado, Madrid

fighting in the street—but he does not show us heroes fighting for right against cruel oppressors. In one very well-known painting he shows an execution: men are being shot by a firing squad. It is terrible. Yet the modernity of the picture lies precisely in the fact that we do not see heroes who have fought for the liberty of their country giving their lives, nor revolutionaries rightly condemned by the forces of law and order. No, these are simply men being shot, and others doing the shooting. The sky is closed. This is quite different from the martyrdom by Rubens we have already discussed, with angels coming to bring the true confessor of the faith his heavenly reward. No, the sole facts are the things that we can see—the things we see are *really* the only facts there are. And Goya shows us no more than that.

Goya painted his mistress, the Duchess of Alba, in two versions,

a naked and a clothed Maya. She is lying on a couch, following the well-known formula originated by the Venetians of the sixteenth century (which we discussed in connection with 'Venus and Music'). Who is the nude on the couch? Venus? No, she is simply a beautiful woman, portrayed from her head down to her feet. There can be no more Venuses, for the old ideas are dead, and Venus was killed in the eighteenth century. There is no longer any such thing as 'ideas' like this, principles external to man, as we have seen. Now there is only man's subjective reasoning from his perceptions, from the sensations he has in seeing things. So we can no longer paint a Venus, but we can *see* the beauty of a woman, and *experience* desire in looking at her. Venus, of course, could stand up (we have quite a few paintings of a standing Venus), but could not be clothed. Clothes would make her into a different allegory, the representation of another idea, a Juno, or Flora, or Diana. Venus's nudity is an attribute by which we recognize her. But a real woman of course can be clothed, and so we can have a portrait of the same lady as in the nude Maya, but now clothed. It may have been that Goya made these two companion pictures to show that Venus was dead. The only thing left was his sensibility as a man before his mistress.

Goya, *The Clothed Maya*, Prado, Madrid

Delacroix, the great artist of the first half of the nineteenth century in France, wrestled very consciously with this same problem. We can read about it in his diary. He tells us how he would like to have painted like Rubens, or Titian, or Rembrandt, but that he despaired of ever being able to do so. The women of Rubens are marvellous, exactly right as Venus or Fame—but how could he ever paint them? He never had such models in his studio. Delacroix could do no more than paint the model, that is, make a portrait of her—as he did of Mademoiselle Rose in a small painting now in the Louvre, a study never intended to be on display. When he was painting his great works, works for exhibition, and wanted them to be meaningful and important, he started from his visual experience in his studies, and then stylized, generalized, idealized in order to achieve something that could be compared to the great works of the Baroque painters. He stylized, but without having a true basis for doing so. He had no foundation for his art but the great tradition of painting. Hence there was always the haunting question: how could they do it? How did they achieve it? How can we make something that is more than we can see?

Delacroix's answer in a way was the same as that given by his main supporter, the art critic Baudelaire: it is through imagination that we must do it. It is an answer typical of romanticism. It is perhaps an affirmation of humanity not fully 'caught in the box'. Romanticism was the first major revolt against the rationalism of the eighteenth century. It exalted the irrational, the strange, the mysterious. It was a movement of more importance in literature than in painting, and I do not intend to spend further time on it now. In any case, my aim is not to try to write a history of art! But I shall be returning to the painting of William Blake in a later section.

Landscape and reality

It was also in the romantic period that landscape painting became of great importance. The study of landscape was parallel to the observations of science. I say the study of landscape, as there is a marked change here from the seventeenth-century type of landscape as created by Jan van Goyen or (perhaps of greater

importance for England and France) by his contemporary Claude Lorrain. Constable was the first to make scientific studies in painting clouds, and many of his landscapes picture actual places. Turner too began as a 'topographical' watercolour-painter. Later he frequently made precise studies of natural phenomena, such as particular weather conditions. His 'Rain, Steam and Speed', depicting a train crossing a bridge over the Thames in London, is justly famous as the first rendering of a type of weather condition in this way. Turner painted what he *saw*.

There is here a certain kind of duality. On the one hand Turner was a romantic, painting man's vision and feelings, free from a slavish, 'scientific' copying of nature, expressing the non-rational and 'spiritual' in man. On the other hand he did paint exactly what he saw, nature as it can be experienced by the

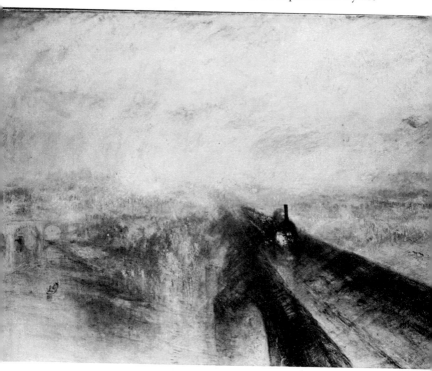

Turner, *Rain, Steam and Speed*
National Gallery, London, reproduced by courtesy of the Trustees

senses. He wanted to paint like a Claude Lorrain, just as Delacroix was trying to work in the tradition of the great Baroque painters. Yet he is different from the examples he admired so greatly because of this inbuilt tension—what we have come to know as the Romantic. Lorrain painted a lyrical version of a Humanist ideal landscape, a vision of the structure of the countryside around Rome. Insofar as it was Humanist idealism, dreaming of a greater past, a human possibility, it prefigures the art of men like Turner. But there is this other side to Turner, his naturalism, and the tension between these two sides makes up his Romanticism.

The duality we noted in Delacroix, who made studies from nature in order to be able then to idealize, is also to be found to a certain extent in Constable. His well-known twofold painting of 'The Haywain' is very typical of this. First he made the rough painting, to keep as close as possible to the direct sensation of nature in all its freshness and colour, its 'light, dews and breezes', as he called it; then he painted the more finished picture, which was much more in line with the great landscape tradition. It is not really relevant to discuss which one is the true Constable, and whether he made the second one only to please the public. Both pictures are truly Constable. They typify the epistemological problem, the question of the true source of knowledge, which the landscape painters were having to face because of the new naturalistic spirit of the age. The sketch is from nature, the second painting tries to retain what made the old art from before the Age of Reason great. The first pointed more to the future, the second to the past. Yet there was good reason why these painters were reluctant to give themselves immediately and wholeheartedly to the directly-from-nature approach. We have no difficulty in understanding it when we see the problems art has run into since. These painters realized the importance of the 'human' in older painting, and were hesitant to lose it. But at the same time they had to start from what they saw directly from their immediate sensations.

So in many ways these painters still belonged to the great tradition; yet the germs that were to destroy that tradition were already active. The same duality was found in Corot, who, in his early days, also painted two pictures of which one was painted

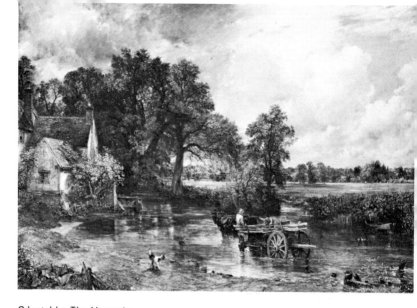

Constable, *The Haywain*

directly on the spot and the other idealized according to the principles of Claude Lorrain. That the second is the lesser is understandable: it really simply follows Lorrain, according to the vision of another age that cannot be copied just at random, while the first is more in line with the understanding of nature in the thinking of his own day. Yet we must honour his hesitation.

The death of themes

It was not only in method but also in subject-matter that art changed deeply. Even a noted traditionalist, the great painter Ingres, working according to the principle of Raphael, did not paint a reclining Venus but his 'Great Odalisque'. An odalisque is the favourite concubine of a great Oriental ruler—and so what we see is not Venus, an allegory of love and beauty, but a kind of ideal female, even if she is only there for sexual gratification, and even if love is understood in the sense of lust. Ingres has placed his ideal woman in a faraway world, to make the painting acceptable. Yet, in one sense, she is a real woman, and in no way a

goddess. In another sense she has already lost something of her humanity, being no more than an object of lust.

The final blow was given by Courbet—the final blow against the old pre-eighteenth-century principles of choosing subject-matter. Let us reconsider those basic ideas for a moment. The great facts of history, biblical scenes, myths taken from the Graeco-Roman world, were depicted not for their own sake, nor for their special interest as history, but as examples to illustrate (in a deep sense) human truths. Hercules was a kind of allegory of the human soul; the great deeds of a man like Alexander the Great showed the greatness of man and his heroism; biblical scenes were chosen to preach Christian truths.

But the old principles were gone. Now, in a rationalist, scientific age, there were no laws, no norms, exterior to man at all. They were 'man-made', inherent in man himself. The neo-classical or romantic historical pictures already show the loss of meaning: they were often large reconstructions of a scene so many years ago, a kind of blown-up photograph of what the painter thought it would have been like.

An example of this is David's famous 'Battle of the Romans and the Sabines' of 1799. Of course there is no denying its quality, nor the fact that it reveals strong compositional elements. Yet everything is painted with painstaking precision in archaeological detail, and, as these classicists erroneously thought that the heroes of those days fought naked, in some ways one cannot escape the feeling that the whole thing is a sort of great, strange nudist camp! True, there was a deeper layer to the picture, in its aim of trying to express the strong contemporary desire for peace: note the Sabine woman trying to separate the two armies. But we do not learn about this from the picture itself; we can only know about it from other sources, then see it in the picture. For the painting itself conveys nothing but a kind of archaeological and rather idealistic understanding of something that happened somewhere in Roman history.

Later historical paintings were to go even further in the same direction. If we look in the catalogues of the salons, the large annual exhibitions in Paris, or the exhibitions at the Royal Academy in London, we see that the paintings were described in long, precise titles, with a note added about the story that the

picture depicted. These had become necessary as the incidents painted were often rather minor and of no consequence whatsoever. Just because they were so 'photographic' their content was often not at all clear. In a seventeenth-century picture the meaning was usually clear even if we do not know the picture's title. (Who would misunderstand a 'Susanna and the Elders' despite never having read the apocryphal story?) But now the main general theme and meaning of the picture was often sadly not apparent from the picture itself.

Courbet, as I have said, dealt the final blow to the old idea of choosing subject-matter. He faced up to the consequences of the fact that previous principles had become empty and without any sort of basis for the deep appreciation of reality. Instead of trying to cling to a dead tradition as the historical painters did, he said he wanted to paint only what he could see. I have never seen an

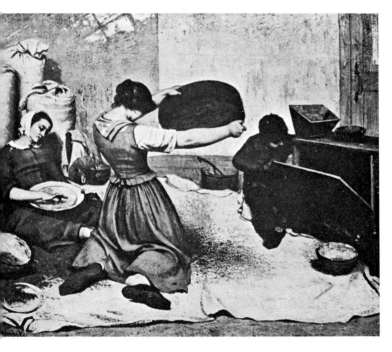

Courbet, *Girls Winnowing*, Musée de Nantes, France

angel, he said, so I shall not paint one. He painted peasant girls at work, or stonebreakers, or people coming back from the market. And the public was shocked. For he made these pictures just as large as the 'important', 'high', fashionable, historical paintings, and people realized that what his work was saying was, 'Look, this is really just as important, perhaps even more true, and surely just as human and deep.'

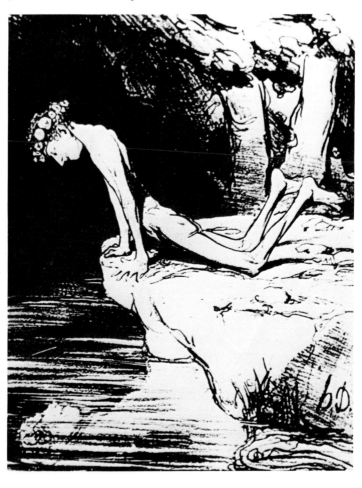

Daumier. *Narcissus,* lithograph

For us, living so much later, it is often difficult to realize how revolutionary and new his work was. Its message is less in the handling of the artistic tools, the style, as in the subject-matter, or rather in the lack of a theme. These are the things one can see, his works cried out, and that is the only thing that can be called true or important.

And so the first step towards modern art was taken. Themes in the old sense had become obsolete. In the art to come they had no further role to play.

Naturalistic reality

There were two other men working in the same direction, Daumier and Manet. With Daumier, it was his lithographs rather than his paintings which were crucial. In a series depicting the old Greek and Roman myths, such as Oedipus, or Odysseus, he showed what they would have been 'in reality'. Penelope was an old haggard woman, sentimentally looking at a worn portrait of her husband who had been away for many years. Narcissus, who died as his eye was fascinated by his own beauty as he looked at his reflection in the water, . . . what else could he have been but a starving idiot, grinning at his own hollow cheeks? Who could ever paint these themes seriously again? No painter of any merit ever did . . .

Manet completed the work of Courbet and Daumier, and in finalizing the first step to modern art prepared the way for the next step. His 'Picnic on the Grass' and 'Olympia' (1864) are particularly famous. The former starts from the idyllic beauty of a humanist poem by Giorgione, his Pastoral Concerto (in the Louvre), in which we see musicians attended by their muse and, to the left, the nymph of the well, lower deities, personifications even: all this Manet has translated into the rather dubious picnic of some men (dressed) and women (nude—or rather, undressed). The latter showed the consequences of the direction already taken by Goya. The painting shows a nude woman on a couch. To Titian she had been Venus, to Goya a mistress. But Manet might have argued: what man is going to paint his own mistress and so display her to the world? Where *in reality*, that is in the world in which we live, can we see an unclothed woman on a couch

otherwise? Surely only in a brothel? And so he painted a prostitute, looking at us out of the picture quite unabashed. And when we realize that she was a character of some notoriety—rather like Christine Keeler a few years ago in Britain—we can understand that the people of the time were shocked. They were shocked not only perhaps because she was who she was—and certainly not because the painting was poor, for, as people realized, it was painted magnificently—but because human values were at stake, and Venus was now not only dead, but well and truly buried . . .

Another initial step to modern art

Modern art is very complex. It is a fruit of the Enlightenment; it expresses the consequences of its basic principles. What is at stake is man's insight and knowledge of reality. But we must also account for another aspect of our age, the reaction against rationalism and naturalistic science. It is a reaction, and yet dependent on what it is reacting against: it makes sense only because it does in fact acknowledge the truth (or at least the inevitability) of naturalism and naturalistic science.

This reaction came very early. It was already there in the eighteenth century. In the nineteenth century it soon became a side-line, as it was the art of the Salon (with which we shall deal in a later section) and the development from Goya to Manet we have already discussed which predominated. Only at the end of the century did this movement come to the fore again in the form of symbolism and art nouveau.

The rationalist movement of the Enlightenment initially expressed itself mainly in classicism and in a renewed interest in historical painting. In France there was the work of David, while in England there were no really great artists but quite a number of painters and sculptors working in this line, such as Copley, Benjamin West, Flaxman, Haydon. The main artists here in fact were the great portrait painters such as Reynolds and Gainsborough, whose art served the nobility and gentry of England, the ruling class that as such was not yet deeply touched by the new spirit. But they were far less out of touch than the French court, which was less involved with the realities of life and took much

less interest in the problems of the majority of the people—and who through their frivolity and lack of real concern added fuel to the fire of the up-and-coming rationalist and revolutionary movement.

Yet it is in this same England that the reaction against the spirit of the Age of Reason found early expression in the works of poets and writers such as Young, Gray, Walpole (Castle of Otranto), the novels of terror and other pre- or early-romantic genres. Among the painters were Fuseli and William Blake.

William Blake was a mystic who thought the greatest enemies of his time and his country were reasoning, the philosophy of Locke and the science of Newton. He was afraid of their systems, and in an almost anarchistic way looked for the freedom of man. He related their work to the industrial revolution, the deadening effects of which he prophesied in many books. He mourns the fact that the machine would dominate the mind as well as the body, until it makes out of the man at the machine another machine, without intelligence and, finally, no more than an animal. He wrote that 'A Machine is not a Man nor a Work of Art; it is destructive of Humanity and of Art; the world Machination'.[1] He also reacted strongly against the rigid sexual morality, the already growing 'Victorian' bourgeois prudishness that we shall discuss later in this chapter, and preached free love, and the virtues of acting on our impulses, rather than repression.

His own answer to these problems was a kind of mysticism, based on Swedenborg, neo-platonist and gnostic ideas, that had as its basic teaching the importance of the spiritual—that there are other spiritual beings, and that the world is greater than is acknowledged by the rationalistic or scientific view of reality. He expressed his theories in very involved prophecies, inventing new mythological figures with names like Los, Enitharmon and Golganooza. In fact he is thinking about the realities of the world he lived in in a mythologizing way: Los is the symbol of the age of iron, Enitharmon of textiles, and Golganooza stands for London. The main concern again and again is that the forces of evil are 'petrifying all the human imagination into rock and sand'. He speaks of Satan, whose work is 'eternal Death with Mills and

[1] Quoted from J. Bronowski, *William Blake* (Pelican Books, Harmondsworth, 1954), p. 131.

Blake, Title Page of *Songs of Innocence*
British Museum, London, reproduced by courtesy of the Trustees

Ovens and Cauldrons'. Deeply inbuilt into all his work is the 'hatred of reason and restraint, which has no other function than to limit and destroy energy, the only source of good. Man, he says, can only attain salvation by the full development of his impulses, and all restraint on them whether by law, religion or moral code is wrong'.[2]

The interesting thing is that Blake printed his own books, writing them and illustrating them in a completely original and new way. His style is wildly imaginative, fantastic and yet real, depicting the great realities that are more than the eye can see or logic can reason about. The curved lines, the letters that turn into plants (such as on the front page of his *Songs of Innocence* of 1789) are especially typical, and show graphically his irrational, sweeping way of thinking.

William Blake had a few followers but not many. But in his reaction against rationalism, his search for the spiritual and the mystical, for imagination and liberty, for sexual freedom, he brought together many elements that would and did appeal to young artists in later periods, both in the 1890s and again in our own time with its psychedelic art.

Idealized escapism

There is another art that is called romantic, the art of a John Martin and of many other landscape and genre painters. Today they are not valued particularly highly, although, to say the least, many of them were accomplished artists technically, and achieved works with a merit, style and atmosphere of their own.

One example here will serve better than a list of names. It is a painting by Klombeck from the school of the well-known Dutch landscape painter B. C. Koekkoek. What is romantic in this landscape? There is nothing wild or dangerous, nothing heroic or extravagant. It is, quite to the contrary, peaceful, restful, rustic, with a kind of contentment and almost sentimental poetry. There are the woods, the old oak tree, the stream and little waterfall (you can almost hear the water), the peasant folk with their cattle, and the beauty and golden sunshine of a fine summer's day. There is

[2] From an article on Blake by A. Blunt in the *Journal of the Warburg and Courtauld Institutes*, VI, 1943.

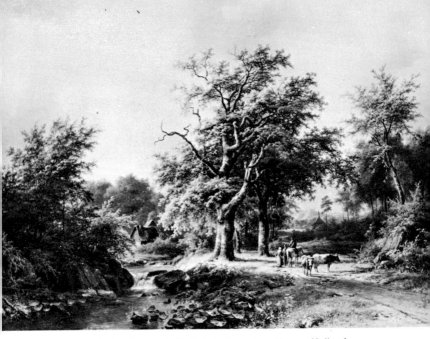

Klombeck, *Landscape*, Coll. P. A. Scheen, The Hague, Holland

nothing of the agitation and problems of the larger world with its ever-changing culture, its revolution and counter-revolution. It is the world of contented people living away from the turmoil amidst the beauties of the world that remained untouched by the new industrialization. It is the world 'at its best', in its almost eternal (even if almost secular) bliss.

This vision is the world of the restoration that came over Europe after the turmoil of the revolution and the Napoleonic wars. It is a restoration that idealized the 'old world', longed for it, and hoped to find it in the simplicity of rural, rustic life. We may call it early Victorian, or Biedermeyer, or simply romantic. It was a kind of escapism—to use a word coined by the fiercely committed generations of our own times. They looked back, and found their inspiration in the art of the past, in seventeenth-century Dutch landscape art (Ruysdael and Hobbema), perhaps too in artists such as George Morland and other minor masters of the late eighteenth century. Where it differs from seventeenth-century art, and resembles the late eighteenth century, is in the idealization, the remoteness from life, the placid dream.

Here we see the bourgeois spirit at its best—and its limitations. We shall be looking in a moment at another rather more negative aspect of the bourgeois spirit. But first we must see how Christian art reacted to the anti-Christian or non-Christian forces let loose by the Age of Reason.

Christian art ?

What happened to 'Christian art', or, better, to art depicting biblical stories or subjects related to the Christian faith, in the aftermath of the Enlightenment? Two facts stand out before any discussion of actual works. First, orthodox evangelical groups are conspicuously absent, in spite of the great awakening of the eighteenth and early nineteenth centuries, for the newly revived evangelicalism was often marred by an unbiblical anti-intellectual and anti-cultural outlook (of which we have already seen the background in an earlier chapter). Second, the 'spirit of the age' was not really Christian in a biblical sense at all. Perhaps one of the most tragic aspects of the nineteenth century lies in the fact that so very few Christians really did see the deep de-Christianizing influences of the Enlightenment. In Holland there was Groen van Prinsterer, who wrote his *Unbelief and Revolution* in the middle of the century—a book which is still a key one in showing the revolution in its real depth. As a whole people did not wake up to the deep ideas at work before Darwin's *Origin of Species* was published. Many compromised, and others were concerned wholly with doctrinal orthodoxy and evangelism, failing to meet the enemy in his own field.

The main art of that period was to be found in the bourgeois art already briefly referred to, the art exhibited at the Paris Salons, comparable to the art of the Royal Academy in England. Here too in the course of the century we see the old themes lose their meaning, together with the values of a time now irrevocably past. This academic art had the façade of old art, but in reality it was very naturalistic: its historical pieces became increasingly either sentimental stories or rather idealized genre pieces. Kings and other great men were shown in their daily all too common reality. Salon art reflected the bourgeois spirit: it tried to cover up the fact that the old values had lost their hold. At the same time

Cabanel, *Phèdre*, Musée Fabre, Montpellier, France

its basic outlook on reality was positivist, painting only what was as photographically precise as the eye can see. In fact there is not really so great a distance between the line of Manet and that of the Salon artists in basic principles; it was the bourgeois spirit of the latter that made the difference.

Christian painting, in the sense indicated above, belonged almost completely to the stream of Salon art. Most of the painters in this line were liberal Roman Catholics (and liberal Protestants in Britain). They took the point of view of the average man of the nineteenth century: they stood in the line of development that started with the Enlightenment, but with the principles mellowed, and professing at the same time a Christianity which was also watered down and not held with any great conviction.

Leys was a painter from Antwerp. He painted in the town hall there, around the middle of the century, a series of wall paintings very typical of the period. They are very precise renderings of often not very important historical events, and one can very rarely understand them without reading the text that

explains what is intended. They are paintings which are more illustrations from a history book than depictions of important human issues. As far as his religious work was concerned, he painted no biblical stories to my knowledge. His picture of people in the sixteenth century praying in front of a crucifix is typical of this type of work. The people are as precisely reconstructed as possible. Considerable study of contemporary fashions and so on was involved. We see people moving from left to right, and a girl kneeling, with as background a particular well-known place near an Antwerp church where there is a large sculpture of a group at the crucifixion. We can see some glimpses of statues of the apostles which stand near the entrance to the little garden in which the sculpture stands, but we do not see the sculpture itself, which stands several yards to the right, outside the picture. We presume it is there, but do not see it in the picture.

So what do we see? People from a past period, full of faith, reverent, praying—but we do not see the object of faith, the crucified Christ. This is typical. The whole scene is designed to

Leys, *Women Praying at a Crucifix near St James in Antwerp*
Town Hall, Antwerp

create an atmosphere of the golden times of the past, when people were still full of faith—it is all very beautiful and fine. But the focus is on the faithful men and women, not on the content of their faith. The crucifix, Christ Himself, has been left outside the picture-frame.

This was done again and again by nineteenth-century painters. By removing Christ, or Mary, or other Christian themes from the picture itself, leaving them outside the picture-frame, it is as if Christ Himself, and the reality of the things Christians believed in, were placed outside the world. We could almost say that we see within the picture-frame a part at least of the contemporary view of the world and man, and as God and Christ were spiritually set aside in the eighteenth century, so were they too in the painting of the time. Yet they were there, not in reality but by implication. To borrow a term from mathematics: Christ was extrapolated. He was put outside the framework (in a double sense) of man's endeavour.

There are two more pictures that we must look at: first, one by Ciseri, an Italian painter famous in his time. His large 'Ecce Homo' in the Pitti Palace museum in Florence, painted in 1864, is one of the best works of the kind we are discussing. The question is, what does the painting mean? What does it tell us? Is it about Christ's importance, or about His suffering, or His Passion? But Christ is seen half from behind, and is not particularly drawn to our attention. The soldier standing beside Him seems more important in a way, even though we cannot say that the painter really meant him to be the real centre of attention. Is it tne throne in front, painted so precisely that it looks like a reconstruction? It may seem strange, but if a group of people looks at the picture, there is very soon a discussion about whether the reconstruction of the details of the throne and the palace and the city is adequate and true. To some degree it is, but the column, for instance, with the spiral relief on it is an anachronism; it was only around AD 100 that the Romans began to build these, and then only a few, in the great capitals of Rome and Constantinople.

But what *is* important in the picture? Pilate's wife going sadly away? Or Pilate himself? He is standing in the middle, after all. But we see only his back. What can the meaning of the picture be? We are not talking about what you (or your aunt) feels to be

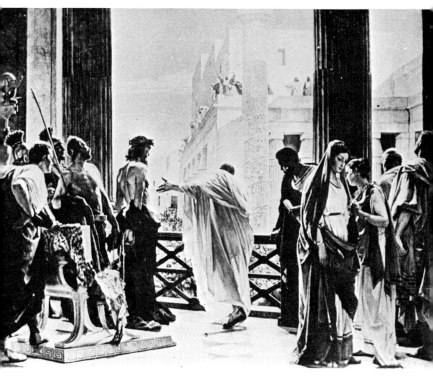

Ciseri, *Ecce Homo*, Palazzo Pitti Gallery, Florence

important in the Passion, or what one might have felt if present, but what interpretation the artist gives of the scene. Our thoughts, perhaps induced by the picture, are probably sentimental, for there is no 'sermon' in the painting to react to. It gives no more than a photographic record, in which everything has equal weight and validity—shoes, columns, hair, clothes, everything. It does not interpret history, nor can we 'see' human meaning and content. In fact, as figures seen from behind are often used in painting to create a sense of space, and as Pilate has very much this effect in the painting, one is tempted to say that the only real meaning in the picture is space, the space around the figures and things. Is it a Christian picture in a true sense? It would certainly not seem to be: I sometimes even feel that it is doing away with true Christian content, avoiding any idea of 'testimony', recording no more than a historical fact in a naturalistic way.

The problem which we have already discussed in a previous chapter comes to us here in all its force: if we paint events 'as they would have been seen', they may well be interesting as history, but lose their true content, for there is no sense of their being things of importance for all history and for all mankind. But if they are not painted as being 'historically true' the factuality on which Christianity is founded is lost, for, as we have seen, 'if Christ has not been raised, . . . your faith is in vain'.

The problem lies somewhere in the words 'historically true'. The nineteenth century developed new methods and new aims for historiography: they wanted to know 'how things really were', which means what could have been seen, or measured (the number of people), or described precisely (dates, geography, etc.). Men continued to look for truth, but the concept of truth itself had changed. For instance, the genealogy in Matthew 1 could never have been written by a modern historian. It would not seem to be wholly accurate historically when compared with the Old Testament. It looks wrong to modern man. But to Matthew and his contemporaries it was true—after all, he had written his Gospel to convince people of the truth of Christ! Their truth was deeper and more comprehensive, and so more truly historical, including all the facts, than that of modern man with his limited understanding of factuality.

This conflict between modern scientific historical method and the way the Bible tells its true story is to be found in the modern 'demythologizing' of the Bible. Bultmann has said that in our modern technological age we cannot believe the things the Bible presents as real. That would mean a sacrifice of intellect. But I would want to say that, on the contrary, we must really listen to the Bible, and look not only at what it says but also at the methods it uses. For the biblical writers were richer and nearer to the fullness of reality than we modern men are; and not only did they write as men, but their message is God's revelation, and so their approach to 'facts' and 'reality' normative for us. We have reduced reality, and technological reality is nothing but a box limited by the scientist's approach to reality, leaving out everything that is beyond rationalistic reason and naturalistic nature. Matthew was not just interested in 'what actually happened' in the modern sense, the sense of measurable and

rationalistically controllable data. He wanted to show the meaning of history, the deeper spiritual and therefore human relationships in time and in history, the relation between the many relevant facts. And above all he wanted to show that God had something to do with it. He is interpreting history. The names he mentions are significant. Christ was born from a real human lineage in which quite a few strange and far from 'decent' people are found. The numbers of generations too are significant. God acted in history, and was preparing for the coming of Christ in this way. Matthew spoke the truth; he did not want to bypass the facts, but he did not want to see the facts only in their factuality but in their true meaning. We, in our obsession with tangible facts alone, have become the poorer.

This digression makes it clear that a painting like Ciseri's is not Christian in the biblical sense, even if the subject-matter is taken from the Bible. Yet it has content and expresses ideas. The content reflects a new way of understanding, a new idea of truth which has been engendered by the Enlightenment.

Tissot's 'Crucifixion' shows how far these painters went. It seems strange at first, but one soon realizes that the crucifixion itself is not shown at all, for we are looking through the eyes of the Crucified to the scene around the cross. Is this not almost too clever a device to get rid of Christ? The painter did not show Him; he extrapolated Him from the world he painted—and yet He is there, as the painter almost blasphemously makes his own point of view to be that of Christ.

In what way was the Protestant world expressing itself in art? For that we must turn our attention to the Pre-Raphaelite painters, and particularly to Holman Hunt. We are now in a position to understand his 'Scapegoat'. What does it mean? He went to paint the picture on the spot, by the Dead Sea, with a gun on his knees (the Bedouin could be dangerous), an umbrella over his head against the sun, trying endlessly to keep the poor animal in position. It took him some months. One cannot say it is not naturalistically true. It is. But is it biblical? Does the painting change at all if we tell each other that the scapegoat was a sacrifice, sent away into the desert yearly bearing the sins of the people of Israel? And look at Hunt's picture of Jesus in His father's workshop. The boy is stretching, and we see His shadow

Holman Hunt, *The Shadow of Death*
City Art Gallery, Manchester

against the wall in the form of a cross. Hunt took pains to paint this on the roof of his house in Jerusalem . . . but is it truly biblical? I am not wanting to criticize it just because the Bible does not mention the story but because the whole feeling of the picture would seem to be no more than sheer sentimentality: our feelings are kindled, but the painter shows us nothing of any depth or importance at all. There is no 'exegesis', no confession, no credal statement. Here is a fact, of no importance . . . and we are invited to give it meaning, within us, in our feelings (certainly not with our intelligence).

Of course, the work of these Victorian artists is of historical importance, and has a quality of its own. But it is particularly important that we should see what they were doing, for almost all 'Christian art' since has followed this line. Think of Bible illustrations, or Sunday school pictures, or reproductions on the walls of church halls. As a style it became the Christian style, until the last war, at least . . . and in some places it is still alive.

For centuries evangelical Christians have steered clear of art, and so lost their critical powers and any real understanding of the arts. It is only in this way that we can explain why Christians took this art to be Christian in spirit and so fit to illustrate our Bibles and teach our children. Christians saw the deficiencies of the liberal reconstructions of the life of Christ of Hall Caine and Renan, but failed to see that the same spirit was at work in these pictures.

Evangelicals have also underestimated the importance of art. They have thought of biblical pictures as being representations of biblical stories. But they did not see that the salt had become tasteless, that there was so much idealization, so much of a sort of pseudo-devotional sentimentality in these pictures that they are very far from the reality the Bible talks about. Could it be that the false ideas many people, non-Christians as well as Christians, have of Christ as a sentimental, rather effeminate man, soft and 'loving', never really of this world, are the result of the preaching inherent in the pictures given to children or hanging on the wall? Their theology, their message, is not that of the Bible but of nineteenth-century liberalism.

The new naturalism and the bourgeois attitude

The prophet Isaiah spoke of people whom God had to address as those who 'draw near me with their mouth, and with their lips do honour me, but have removed their heart from me, and their fear toward me is taught by the precept of men'. It was a spirit which the prophets preached against again and again. But is not that exactly the type of Christianity we have described in the last section? We could call it bourgeois. It is true that it is found at all times in history, the spirit of a Christianity which has lost the true faith and does not really trust its Lord. But in the form in which it appears around us it is really a manifestation of the bourgeois. It is interesting to note that it came into being virtually at the same time as the growth of the influence of the Enlightenment. As we have suggested already, it might even have been one of the sources of the Age of Reason.

What was the bourgeois spirit? 'Well, you know, we Christians are very nice, decent people. Please don't keep on at us with all this talk about sin in the Bible. We are much more civilized now than people were then. And anyway, it's what Christ said in the Sermon on the Mount which really matters (*He* didn't talk about sin, did He?). That's the spirit we want to live in—love and kindness and so on . . .' They never said so, but what they meant was: 'Please don't remind us of the hard facts of life, don't open our eyes to them, as then it will be impossible for us to live in peace and unity with the establishment of today. You cannot expect us to be haggard prophets, that sort of thing isn't really done. We are too good and moral and righteous . . .'

The bourgeois were people who looked for certainty and security. With their lips they might have honoured God, but in their hearts they looked for a more 'tangible' kind of foundation. They found it in money, in a career, in status, in their moral uprightness. And so morality became moralism and insurance often took the place of the assurance that God does not forsake man. They wanted their lives to be moral, true and normal, but they had no foundation for it, for true Christianity was rejected and turned into liberalism.

These very nice people lived in the Age of Reason. And of course, they looked with dismay on the new generation who were

taking to the principles of the Enlightenment. Morals were going downhill, and the old-established rules were being challenged. This was bad enough. And when the new thinkers were preaching that man was basically an animal, that his love was really only sex, then they were shocked. Human beings like animals? . . . No, that could never be. Yet, what could they do? Had they not got desires themselves? Oh no, *we* haven't got them, they told themselves. And so they began to push the fact that man has a body, and especially his sexuality, into the dark, hidden corners of life. Of course lust was beastly, and should be suppressed—maybe young men could have their fling in their youth, but that is only passing, and you must not talk about that, even if it means maintaining a double morality.

So towards the end of the eighteenth century the bourgeois world, which often coincided for various historical reasons with the middle class, began to build up the defensive attitude towards sex that later became known as Victorian.[3] We, living so much later, and following that period, can no longer really understand what it was like in pre-Victorian times—how people knew that the fact that they had bodies and sexual urges was because they were human. We can only understand the loss of it. Around 1600, for instance, people had many words for sexual intercourse, but today we can only say that people go to bed with each other or else we have to use more scientific (and therefore neutral) words. We can never fathom the depth of the loss of this, or what it has meant in the lives of many, many men and women.

Out of this grew the notion of 'romantic love', a love pure and beautiful and eternal, virgin-white and virtually sex-less. It meant the myth of the pure virgin, beautiful and truthful to the very end—but with almost no real passion—married to the ever-faithful husband, loving and caring and never looking for another woman, as his pure heart is unable to do such a thing. Reality, alas, is different: men and women are sinful, and even if one partner wants to remain faithful in marriage, only too often the other is likely to be an easy prey to temptation. Romantic love is a lie, and has proved a great deceiver. Biblical marriage is designed for men and women as they really are. It is true that for

[3] See, for an illustration of the theme of this chapter, J. H. Plumb, 'The Victorians Unbuttoned', *Horizon*, Autumn 1969.

sinful men and women the Old Testament recognizes something less than the ideal—divorce was allowed 'for the hardness of men's hearts'—but it also shows that those who have been made new in Christ can now realize what marriage was really intended to be, a union of two people become 'one flesh'.

It may seem strange that Christians fell victim to the optimistic, humanistic, 'romantic' vision of love—so much so that its last strongholds are probably within Christian circles. Perhaps it was the old ideas of Greek philosophy so popular in mediaeval times (for mediaevalism enjoyed a revival in Victorian times) with its mystical exaltation of the spirit over against the lowness or even sinfulness of the flesh, which were the cause of this. Or, more probably, perhaps it was a necessary part of this bourgeois type of moralistic Christianity.

Beside 'lily-white', romantic love there also existed another concept, the romantic concept of true passion—meaning that passionate love was irresistible and could break all barriers, of standing, age and even marriage ties. This type of love, popularized in romantic novels, is still very much with us today. It too is a lie, as many have found to their cost. But it is an idea which sinful men and women are only too ready to believe, as it gives them an excuse to pander to their desires.

So the Enlightenment changed the world. For its principles were not 'just philosophy', but had their consequences in sorrow and deception and ruined lives. Sexuality has never been the same again. On the one hand there was Victorian prudishness, on the other the reaction to it, the salaciousness of some of the romantic writers (probably stronger in France than in England), which only too easily degenerated into pornography. The former naturalness in speaking about these things was completely lost; many passages in books written before the Age of Reason are either unreadable for us today or are read almost as pornography. Who today could do what John Dowland did, write a song to be sung at a wedding, an epithalamium, with the refrain, 'Ride happy, ride happy, happy lovers'?

Reactions to realism
Beside Victorian prudishness and salaciousness the nineteenth

century also witnessed the 'positivist' trend that has been discussed in talking about Goya, Delacroix and Manet, who had no intention of being pornographic at all, but only of seeing and speaking the simple truth.

It is against this threefold background that we must understand the beginning of censorship in the nineteenth century of all kinds of art that speak about straight 'facts'. Flaubert's book *Madame Bovary* would seem to have been the first to have been brought to court (in 1857, though there had of course already been suppression of true pornography much earlier, but this is not our concern here). When we read this book, it is hard for us to understand what was considered wrong with it. Its heroine is a woman who commits adultery with different men, being married to a bore of a husband. Only in a few passages do we read anything of the sexual pleasures she indulged in, and then never does it go into detail as pornography would. In the court the book was accused of offence against public and religious morality. But the lawyer who defended Flaubert said that the scenes had a fidelity comparable to the daguerreotype (the early form of photography then current). Here we have the real problem. Things and actions were described photographically, with no reference to norms or principles at all, though the narrative did in fact end with the downfall and suicide of the woman. The woman's life was shown photographically, factually. And that was exactly what horrified Flaubert's contemporaries. They felt that human values were at stake, the more so as their own principles were based on a negative defence rather than a positive moral, as we have seen.

This way of writing was called realistic. And it was under the name of realism that Courbet had exhibited his works, and Manet's pictures of the Picnic and the Olympia had been painted. Yes, they were true to life, if life is no more than factual, no more than the things we can see and experience.

Soon the writers began to talk about 'Art for art's sake'— which meant that in creating works of art no moral ideas had to be considered at all. Art had to depict life 'as it is'. Zola, the great writer who was contemporary to the impressionists I shall be discussing in the next chapter, shocked the world again and again with his 'fidelity' to true life.

Two questions must be asked. First, was this really reality?

Second, did this have any influence on reality? There is no need to labour the answer to the first question. It was life only as it was understood by men of the 'avant garde', a view of life in line with the principles of the Enlightenment, or, as we must call it now, of positivism, the philosophy which made everything depend on scientific observation and experiment. Auguste Comte, Herbert Spencer, John Stuart Mill, these were the positivist philosophers who began to apply the spirit and methods of naturalistic science to the humanities, especially to economics and sociology. But even if it was reality as they understood it, was it true reality? We can only refer back to what we have already discussed, for it was really a very impoverished world, the closed world of 'the box' of the Age of Reason. True humanity, being much more than factuality, was left out of account.

The second question is a very important one. It is difficult to prove statistically one way or the other just how much influence the artist has on reality. For there will always be only a small gap between the artist and his public. Both are part of the same culture, which is moving 'forward'. Where to? In this case it was once again to an ever-increasing consistency with the principles of the Enlightenment. Realism, or rather naturalism, in books and in films today, for example, including all the facts of sexuality, has been prepared for, and was propelled on by, the nineteenth-century type of art we have been discussing. Since the eighteenth century there has been a constant reduction of the 'old' moral principles, a *démasqué* leaving us at the end amidst the ruins of the one-time Christian consensus.

At the same time what we have been describing in this chapter may help us to understand some elements of our times. On the one hand there is this type of realistic, open portrayal of sexual matters, while at the same time in daily life these things are still kept hidden, and a Victorian attitude remains, even if in a watered-down form. We still cannot sing Dowland's song at a wedding. And we still have not regained a full understanding of what sexuality means. Only too often it is something strange and shameful, or it is a fact, an appetite to be satisfied, something which is no more than animal. Sexuality today has sometimes become something almost a-moral, something outside morality altogether, catering to drives comparable to drinking or eating.

A final conclusion must be this: we must not be surprised if a section of the youth of today has begun to live according to the principles—or lack of them—found in films, books and on the stage. They are often protesting against the bourgeois people whose Victorian understanding of sexuality is equally a lie; who still cling to the 'old morality' yet have no true foundation for it.

Chapter four

THE SECOND STEP TO MODERN ART

Through the corridors of sleep past the shadows dark and deep
my mind dances and leaps in confusion.
I don't know what is real, I can't touch what I feel
and I hide behind the shield of my illusion;
So I continue to continue to pretend
that my life will never end
and the flowers never bend with the rainfall.

Paul Simon, *Flowers Never Bend*

Goya, Delacroix, Constable, Corot, Courbet, Daumier, Manet
had worked towards realizing some of the consequences of the
new principles of looking at reality as developed in the Age of
Reason—and art had become 'realistic'. This art had at the same
time, at least with the later artists, a certain degree of protest
inherent in it, protest against the shallowness of Salon painting,
which, in the course of time, was to become even more shallow
and vulgar in the hands of men like Gerôme and Bougueraux.

But, following this naturalistic trend further, how was it
possible to develop it? What, in fact, was there left to paint? For
the only things that are real and true are the things seen, and the
rest is façade, traditional ideas which have been emptied of
meaning.

It was here that the impressionists came in. Monet, Renoir and
their friends set out to paint what they saw, what the eye recorded.
In the late 1860s Monet painted Paris seen from a high window:
houses, water, trees, churches, people walking along the pave-
ments . . . this was Paris. In the early 1870s Renoir painted an
open-air dance, with some of his friends sitting in the foreground.
Nothing special—though all would admit that the quality of the
painting is very high, and his brushwork and use of colour are
superb. Nothing special? Look a bit closer. What are the light
spots on the jacket of the man in the foreground? Perhaps he
forgot to brush his jacket? Or he has leant against a wall and got
some whitewash on it? No, of course! They are simply 'spots' of
sunlight dappled by the leaves. And there are 'spots' of light on
the faces, too, and, most conspicuous, on the straw hat of the man
behind the first group.

We must realize that it is the first time in history that things like this had been painted. Nobody had done it before. Of course in the seventeenth-century paintings of Rembrandt, the church interiors of Emanuel de Witte and many others, spots of light had been included. But they never blurred the vision, they never made the structure of the things depicted unclear. No-one ever painted sunshine falling through leaves at random as Renoir did, or light spots on a hat as in Renoir's painting. They would have thought that this falsified reality. Even when we look at a painting of the young Guercino—his 'Elijah in the Wilderness'

Renoir, *Le Moulin de la Galette,* detail, Louvre, Paris

Monet, *Quai du Louvre, Paris*
Coll. Haags Gemeentemuseum, The Hague

for instance—or a Caravaggio, we may see dark and light passages alternating, and light is really handled in a fantastic way, but it was done in quite a different way from Renoir. They were playing with light in an early baroque way, using it to give a sense of illusion, for instance, or even to make part of the picture apparently obscure (where *has* that man's leg got to?), but it was never done in the naturalistic way of the impressionists.

These paintings were just the beginning. Now look at a later Monet, of about 1880. We should really look at a reproduction of it in colour, or, better still, look at the original. What do we see? Nothing special at first. It is not an important place. Monet just chose a 'corner of nature'. It was not the start of the regatta, or a place where a famous man was drowned, or anything. It is just a certain point of the River Seine near Paris. Subject-matter in the old sense has become obsolete.

Here I must go into a problem arising from a basic principle of

the Enlightenment. Reality, the cosmos, is an unknown X. And man can find out what it is like only by using his eyes and senses and then, with his brain, find a structure in the sensations coming from outside. Already Hume had pointed to a peculiar problem coming out of this. If I roll a billiard ball over the table against another one, the other one starts to move. Now, how does one know that this is causality? We only see what happens. The interpretation of it is another matter. If I let a knife fall 999 times, how do I know that it will fall the next time? Are there laws? We know only that it fell so many times, and statistically we may take the chance that it will do so again the next time . . . but we must admit that we never can be sure. This was a problem which positivism had run into at about the time of Monet's painting. It was in fact an epistemological problem, a question of the source of our knowledge of reality. Monet wrestles with it too, not as a philosopher, but as a painter.

So, what do we see in the picture? Monet's brush-strokes recording what he saw? In a way, no. Not *what* he saw. But he recorded what reached his eyes, the light beams that caused a sensation on his retina. The question is whether there is something behind them, a reality of things that caused the light beams. One may conjecture that there is a reality, in the same way as one is likely to take the chance that the knife will fall again, but one never knows for sure.

In the years before 1885 the impressionist group became restless and nervous. Heated discussions took place. The public were very critical, and were asking awkward questions. Everybody who was in contact with this art realized there was something at stake. What is it? they were asking themselves. Where are we heading? Are we losing painting altogether? Are our works simply becoming muddled? Is this art worthy of our galleries? This world we are depicting, is it really reality? Can we go on in this way? What must be the next step? They felt themselves unsure, for they realized that there were deep implications. Their public too were aware of it.

Only Monet seemed to be sure of himself. He simply went on, and in 1885 dared to take the great step. The decisive step. The step over the threshold, the second step towards modern art. No, one never knows whether there is a reality behind the sensation

we receive. There is no reality. Only the sensations are real.

If we look at his paintings after 1885 we see the difference. He went on in the impressionist line, more consistently than ever. He did various series of paintings depicting one spot—a row of trees by a river, Rouen cathedral—but in different conditions: in rain and snow, in the morning, in the afternoon. It could not have been more naturalistic . . . Yet this is not the impression you get when looking at these pictures. They are more like dream pictures, pictures showing a world that is immaterial, ghost-like. The colours are beautiful, and one can sense that there was a world that induced his sensations—the picture had some relationship to a real cathedral, for instance—but the reality does not seem so real.

In 1891 Kandinsky saw a painting of a haystack at a large exhibition of French painting in Moscow. He tells us how he

Monet, *Poplars at Giverny, Sunrise,* Museum of Modern Art, New York

looked at it, how magnificent he thought the painting was, the colours brilliant—but that he could not make out what kind of reality was represented. Was there a subject? He saw only colour. Only after he had consulted the catalogue did he see what was meant. A strange picture, he thought. Beautiful, yes—but what about the reality depicted? It gave him, some twenty years later, the courage to paint an abstract picture.

Renoir, in 1885, tried to steer painting back to the portrayal of reality. He had no desire to follow Monet. He wrestled with a large painting of bathing girls—not Diana and her nymphs, of course, for they were long dead and buried . . . He tried to do it in the style of Ingres, a pre-impressionist style: a painting that depicted solid things, a leg that had volume and form; a painting with structure and . . . well, did it have meaning? To his tremendous disappointment, no doubt, Renoir must have realized that his painting had not really succeeded. It seems stiff and awkward. The girls were as it were caught in action, like a still. And their solid forms were more like wood than flesh. It was so, because he did not really believe his own painting. This was not the world as he could understand it.

And so he fell back to a kind of middle way. It is strange, but the works of the later Renoir never have the impact and strength of his earlier ones before 1885. He seems to have lost something. He was never the great painter again. We can understand. Because he did not dare to follow Monet, whose step was consistent and true to principle. Because he did not want to lose hold of reality. Because he was too weak, spiritually. Yet we must understand that his weakness is his greatness. Surely it is greatness if a man stops short of the ultimate consequences of what he is doing when he sees that something of vital importance will be lost; if he takes the risk of losing the strength and consistency of his work in order not to lose something of such importance to man as reality itself? His weakness was his greatness, his greatness his weakness.

On from impressionism

1885 was a year in which many things happened that were of great consequence for the future. In immediate reaction to the

impressionist dilemma some began to think in new directions. In that year the following letter was written:

> 'To me the great artist is defined by his great intelligence, and he has feelings that are very delicate and therefore almost imperceptible translations of his understanding. Observe in the vast natural creation and see whether you cannot find laws to create all human passions in a way that, even if they are not quite equivalent, yet are clear in their effect.' [1]

[1] Letter to Schuffenecker, 14 January 1885, translated freely. See my *Synthetist Art Theories*, Genesis and nature of the ideas on art of Gauguin and his circle (Amsterdam, 1959), p. 120, and the notes with the more precise translation. For the Tahitian painting dealt with below see pp. 230 ff.

This letter was written by Gauguin. It was written from Copenhagen, where he was staying temporarily, to another painter. In it he expresses his idea that the artist should not copy nature, but use particular methods of arranging lines and colours in order to denote particular feelings. These are evoked by reality, and represent far more than simply what you see. If you see a rat (or even a spider!) you may well feel fear . . .

We are fortunate that Gauguin, because he happened not to be in Paris, wrote these letters, as they show us how he struggled to find new ways of representing reality in order to include more than the eye can see, in order not to imitate or copy but to create

Gauguin
Vision after the Sermon
National Gallery
of Scotland
Edinburgh

in a truly human way. In this same decisive year of 1885 we see him trying to overcome the extreme naturalism of the impressionists. He felt that with them the artist had become a slave of nature. Yet it took some years before he was able to realize his new approach to reality, in which the artist expresses his understanding of a human situation by the way he handles his artistic means, his lines and colours on the flat surface of the canvas.

In 1889 he painted one of the first great works that expressed his aims, the 'Vision after the Sermon', now at Edinburgh. Women from Brittany, with their simple yet deep faith, have heard a sermon on the fight between Jacob and the Angel: they *see* it in all its reality before their eyes. Yet they are not so stupid as to think that it is a real man fighting the angel there before them— they are human!—so Gauguin paints the grass red. Yet, to these women, the story of Jacob is as real as their cows; the story took place on the same level of reality as the one on which they themselves lived—so, on the same red grass, we see a real cow. The whole composition is built up by means of planes, with the very decorative effect of the women's hoods forming a linear pattern, and then the flat colours—the red, the brown of the tree, the white of the hoods.

In this sort of way Gauguin tried to give his work a more human touch, expressing feelings and knowledge and human reactions to the realities of life, while at the same time he gained a new freedom for the artist to use colours and design in a free way, overcoming the narrowness of merely copying what the eye registers. In an explicit and definite way he wanted to overcome the positivist approach to reality, with (as Gauguin said himself) its loss of all feeling 'for the mystery and the enigma of the great world in which we live'.

To reach this goal, and as it were to regain humanity in its basic, original form, he went in the 1890s to Tahiti. It was here that he painted his greatest work, the one he intended as the embodiment and legacy of his vision, 'Whence? What? Whither?' (commonly called 'Where do we come from? What are we? Where do we go to?'). In writing about it to a friend, he said that his work was a philosophical one, the subject comparable to that of the Gospels. We must 'read' the work, he said, from right to left: Where do we come from? A source, a child. What are we?

Man stands questioning. Where are we going? An old woman, a bird of death. In the background mysterious figures, in sad colours, standing near the tree of knowledge—sad as a result of that knowledge.

It is interesting to note that Gauguin painted all these works 'realistically': he did not use the themes of the past, but painted the world we have around us, the world in which we live. But he composed his work in such a way as to show a deeper meaning, a more profound, more general sense.

The art of Gauguin and his followers, as well as of those that we shall deal with later in this chapter, is aimed at synthesis, realizing freedom and humanity in art without losing the realism of the previous generation. It was an unstable equilibrium between man's freedom and his ties to natural reality. Gauguin was not able to do much more in the way of painting towards the end of his life, and so his evolution as a painter ends when this synthesis had been realized; but in his writing he goes further, and just after the turn of the century, shortly before his death, he came down unequivocally on the side of freedom. The equilibrium has been broken. The art that belongs to his new formulation was expressionism, the art of the younger generation then just starting. He wrote of it as follows:

'So what was necessary, without bypassing all the efforts already made and all the research, even scientific research, was to think in terms of complete liberation: to break windows even at the risk of cutting one's finger. From now on the next generation is independent and free from any fetters: it is up to them to try to resolve the whole problem. I do not say they will do so definitely, for art is limitless and rich in techniques of all kinds, fit to translate all the emotions of nature and man, from any individual and from any period, in joy and in sorrow.

To achieve this you will have to throw yourself into the battle, body and soul, the battle against all schools, all without distinction, not only by disparaging them, but by something else, insulting not only the official artists (the Salon artists) but also the impressionists, the neo-impressionists, the public old and new. No matter if your wife and children disown you. What does insult matter? What do wretchedness and poverty matter? In our work itself, we need a method of contradiction, we must attack the strongest abstractions, do all that was prohibited, reconstruct art without fear of exaggeration—if necessary with exaggeration; we must learn anew, and, when we have done that, learn all over again; we must conquer all

diffidence, whatever ridicule may ensue. Before an easel a painter is no slave, neither of the past, nor of the present, neither of nature, nor of his neighbour. He is himself, himself again, always himself.'[2]

The quest for reality

Quite a different way of overcoming the crisis of the impressionists was taken by Seurat. He tried to find a way of expressing things in a very orderly and organized way, almost scientifically. He applied a very involved colour theory, which led him to the pointilliste method, putting little dots of primary colour side by side to give a luminous effect. His compositions were rigid, and very studied, in an almost classical way. Yet he never painted the ancient gods or other themes from the past : he depicted the world around him, a Sunday afternoon on a Parisian island, dancing chorus girls, a circus with a clown and a woman on a horse, a model in his studio.

This last painting is very characteristic of his aims. He painted the same woman in three different poses, as if he wanted to show the fullness of the reality of humanity. Just as in previous periods painters would use the nude to represent humanity or universal principles, so Seurat wanted more than the specific and very individual, almost chance, aspect of a particular person.

This latter was more Degas' way. Degas was very close to the impressionists in his aims. He painted his nudes 'as seen through the keyhole' as he said himself, which means that he tried to come as near to the particular as possible, with no idealizing—just everyday, normal reality. By comparing the work of these two great artists one can see the marked change in direction and aim. However different Seurat's works might have been from Gauguin's in subject matter and style, yet they were quite close in the 'flat' layout of their composition and in their understanding of the emotive and expressive values of lines and colours.

Another painter, and one who knew both Gauguin, with whom he was friendly, and Seurat, whom he met just before he left Paris, was van Gogh. He had arrived in Paris in 1886, just after the decisive events that we have described, followed the

[2] *Racontars d'un Rapin*, 1902.

Seurat, *Le Chahut,* Rijksmuseum Kröller-Müller, Otterlo, Holland

LE PEINTRE IMPRESSIONNISTE, PAR CARAN D'ACHE

Caran d'Ache, Caricature of an Impressionist, from the Catalogue
of the Salon, 1889

discussions, and then, in 1888, went to the South of France. He
solved the problem posed by the impressionists in his own
original way: he did not paint what his eyes saw, but expressed
his feelings, his experience when confronted with reality. He was
not concerned about making an accurate representation of
particular trees, rock formations or houses. He painted his own
artistic, poetic, emotional reactions, his vision. Trees like flames,
mountains like waves of a great sea, everything was painted in
strong, bright colours.

Van Gogh believed in reality, but painted only his personal
reaction, hoping to reach to a deep and general truth, and
longing to bring joy to ordinary people, for he was strongly
attracted to the ideals of socialism, as were most of the impression-
ist and post-impressionist painters. In this their politics were
consistent with the aims of their art: both left-wing socialism and
their art were developing on the foundation of the basic ideas of
the Enlightenment and, in the case of politics, from the ideas of
the French Revolution.

In some ways, the greatest of this quartet was Cézanne. His
aims were most consistent and directly related to the problems
we have been dealing with. With great obstinacy he tried to
unite the conflicting principles in order to solve the impression-
ists' dilemma.

'Monet is only an eye', was Cézanne's critical comment on

impressionism—though, he added, 'a magnificent eye'. Cézanne had started as a kind of romantic painter in the tradition of Delacroix and Daumier, but he soon met the impressionists. They initiated him into their creed of painting directly from nature, of painting in bright colours, painting nothing but what the eye sees. Yet always he differed from them in that he never sought to represent the fleeting, momentary aspects of reality, but tried to make clear the structure, the lasting elements of the landscape he was representing. And slowly but steadily he worked at the development of his own ideas: our view on nature does not stop at what we see, we must add our understanding. It is as if he said to the impressionists: you have forgotten that the great principle of the Enlightenment is not only that we have to start with our perceptions, but that we have to use our reason in order to make of these perceptions a rational structure.

Cézanne was very much aware of the fact that the painter does not copy nature, but that he paints on the flat surface of his canvas an equivalent of reality. And this equivalent must convey a rationalized, human insight into the reality he sees. In this way he tried to make a new impressionistic art worthy of the art gallery, of equal standing with the great masterpieces of the past. Here he was thinking specifically of the great classical landscape painter Poussin, who also strove for rational and clear structure in his work. Cézanne wanted to restore the great tradition of Poussin, but of course without the classical themes: the first step to modern art had been taken, and could not be undone; the second was in his view disastrous and had to be overcome. So, he said, he would do what Poussin did—but from nature.

Cézanne wanted, as it were, two things at once: to paint only what the eye sees, and yet to paint the structure of reality as understood by human rationality. This led him to his slow, laborious method: by looking, looking, looking again and again he tried to *see* the structures, the rationalistic principles 'behind' the thing seen, the universal ideas that ordered what he saw. There is always this feeling of conflict inherent in his art: it is a structure—and yet only a rendering of what the eye registers. Sometimes he did not hesitate to make changes to the actual scene, removing a tree, changing the position of a building, in order to make the structure clear. He never painted the fleeting

aspects of nature, outlines blurred by rain, distant hills fading through haze, the lack of clarity of perception resulting from some chance viewpoint.

The quest for a synthesis

In discussing the art of these four great post-impressionist painters, I have deliberately left out details more suited to a history of art than to the argument of this book. My aim is to discuss the problems that resulted in the rise of modern painting. In a way, when the second step had been taken, modern art was already born. But these four tried to solve the problem, to regain the ground, to bring humanity and reality back into art.

They had to escape from the principle that there is nothing more than what the eye can see at any given moment, that there is nothing there but the individual, the specific, things just as they can be *seen*—and no more. It was a problem arising from the positivist and impressionist principle that there are no laws that govern reality, that only experimental facts can be called true and certain. So these four post-impressionists tried to depict something that is more than what the momentary, fleeting impression can make us understand. They looked for a way to find something of the true values and the lasting principles of reality, the deeper universal. This is what drove them on to overcome the consistent naturalism of the preceding period and to search for new ways of approaching reality.

So they brought together the two great principles of the modern post-Enlightenment world: the principle of starting from sense-perception in order to gain knowledge of the universe; and the other great principle of human freedom, the search for a humanist humanity. One was the principle of positivism, of science. The other was a reaction against positivism, against the optimistic idea that all nature could be conquered solely by the techniques of the laboratory, that man's happiness lay in material wealth. They re-asserted man's freedom against the narrowed-down naturalist reality of man caught in the 'box', tried to re-discover humanity over against the pressure to make man no more than an atom or an animal, but yet they retained their respect for the great achievements of their century.

It was because they achieved this synthesis that their art was probably the fullest and richest the world had seen since the seventeenth century. In bringing together the best of the two opposing streams, the more scientific positivism and the more irrational search for freedom, they remained true to reality without falling into the trap either of depicting only external, irrelevant details, or of letting the imagination run wild into fantasy or the vaguely mystical. With Seurat and Cézanne they tried to achieve the synthesis in creating a rational universal out of what can be perceived by the senses.

The harmony they achieved was an unstable one. It was soon to be broken. Neither van Gogh nor Seurat lived long enough to see it. But in the last work of Cézanne, for instance, we already see a tendency towards the abstract, the breaking down of the clear image, the failure to retain the natural in his striving for human, rational expression. And, as I have already shown, in his last writings Gauguin reached a more irrational abstraction in the name of freedom.

A new century was already beginning. But before we see where it led, we must look at a rather different movement—one which in its own way tackled the basic nineteenth-century problem we have been discussing in this chapter.

A mystic-romantic reaction

All that I have been discussing in this chapter happened in a restricted circle of artists and their friends in France. The art textbooks show the line of development of art as going from Delacroix to Courbet to Manet, then to the impressionists and the post-impressionists, and we can easily get the impression that this is a true account of nineteenth-century art. But it is not. This line, even if of great importance, is not the art nineteenth-century people themselves talked about. The mainstream of art in that period was to be found in the bourgeois art I referred to in the last chapter, the Salon art in France and the art of the Royal Academy in England.

A reaction that emerged in England against this academic sort of art led to a kind of mystic-romantic art that is called art nouveau. In its reaction against such academic, bourgeois

shallowness it tried in its own way to solve the artistic problems that were posed by the developments of the nineteenth century. In its time it was more highly rated than the post-impressionists, but in the twentieth century it lost its importance and was swept aside by the 'other' modern art. Yet it did have a deep and lasting influence on the decorative forms of our century, and the design of many household tools had their origins here—even the so-called 'streamlined' forms to be found, for instance, in door handles. Only with the psychedelic art of the 1960s did art nouveau become a real artistic source again, and then again not so much in 'gallery-art' as in posters, graphic design, fabric design and interior decoration.

It was back in August 1827 that William Blake had died. In his last years he had started to learn Italian so as to be able to read his beloved Dante in the original. Exactly nine months later, not very far from the place where he died, Dante Gabriel Rossetti was born, the son of an Italian refugee who named his son after his favourite poet. When Rossetti later went for his first year at the Academy, he obtained, almost by chance and for a very low price, a Blake manuscript that put in his hands the work of a man whose ideas would influence him throughout his whole life.

Yet Rossetti did not become an imitator or a follower of Blake in the narrow sense. Rather, through Rossetti's version of Pre-Raphaelitism, with its wavy lines, emphasis on imagination and poetic subject-matter, a more romantic than 'positivist' kind of art was introduced in England. He took a different path from his original fellow Pre-Raphaelites, from Holman Hunt, who remained a naturalist to the end, and from Millais, who became a society painter. Rossetti's friends and followers William Morris and Burne-Jones defined a style that was to influence the young generation of the 1890s, real aestheticists, enemies of positivism and its dehumanizing science, enemies of the machine age, longing for spirituality, beauty and a new way of life.

They looked, for help in their quest, to the newly-discovered Japanese art, to the mediaeval dream as exemplified by the Faery Queen and her retinue, to ancient mystic philosophies, and of course to Blake. They turned everything into poems, not only painting but also china, silverware, book design, wallpaper—and so created what has come to be known as art nouveau. They were

dreaming of a new world, aristocratic and yet anarchistic, a world of freedom, without Victorian sex repression, without the ugliness of machine-produced utility ware, a world in which beauty and not the laboratory would set values and truths. A world, in short, that was characterized perfectly, even if only in its more fashionable aspect, by Gilbert and Sullivan (in their opera *Patience* of 1881) when they described the 'very cultivated, clever young man', who would walk down Piccadilly with a poppy or a lily in his mediaeval hand:

> 'If you're anxious for to shine in the high aesthetic line as a man of culture rare,
> You must get up all the germs of the transcendental terms, and plant them everywhere.
> You must lie upon the daisies and discourse in novel phrases of your complicated state of mind,
> The meaning doesn't matter if it's only idle chatter of a transcendental kind. . . .'

Art nouveau was not confined to England. As its name implies, it was also to be found in France, and soon over the whole of Europe, having centres in Brussels, Vienna, Munich and Turin. Its masterpieces are not so much the weird and debatable paintings of men like Knopf, or even of Klimt, but rather posters by men like the Beggarstaff brothers, Bradley, Toulouse-Lautrec, Bonnard, Toorop and others, and its most typical works are found in book design, in illustrations such as those by Beardsley, in typography or in the design of furniture, utility ware or small *objets d'art*. It also involved interior design and even architecture, where its products could be strange and extreme at times, as in Gaudi's buildings or Horta's interiors. But yet there are elements in their style that prepared the way for twentieth-century industrial design (look at the handle of an Olivetti typewriter, for example).

Art nouveau has had its own development, and is not restricted only to the 1890s: you can if you want see its principles working until far into the present century, in the architecture of the rather romantic Amsterdam school, in Mendelssohn's Einstein tower, even in much of the work of Frank Lloyd Wright and Berlage, and in book illustration right up to the thirties. Its freakish elements, its extremes were discarded, but its importance

continued in its influence in renewing industrial design and giving beauty to machine products.

In revolutionizing the applied arts, art nouveau not only brought them up to date but also swept away the chaos of historical styles of the nineteenth century. It is as if that century had been afraid of applying its own principles. It was always looking nostalgically backwards to the great styles of the past. It is telling that in some ways it was 'engineer's art', the 'style-less' bridges and utility buildings that prepared the way for these renewals. It was in these that the nineteenth century was honest to itself.[3]

The inner tensions of modern times are grafted onto the history of art nouveau and its subsequent development: it began as a revolt against the all-embracing claims made in the name of science and industry, as a search for the spiritual, the truly human; and it ended by having its lasting fruits precisely in this area of industrial design. It helped to prepare the way for the great revolution in art that was to take place after the turn of the century, even though the new art was to take as its point of departure the achievements of the post-impressionists. Hence it was to be largely confined to painting and sculpture and to continue in the tradition, not of the applied arts, but of 'high art'. In this way it was, too, to take on the tradition that we have followed through in this book, that it should be 'loaded' with meaning and express a philosophy. But this is to anticipate the next chapter.

[3] See N. Pevsner, *Pioneers of Modern Design* (Museum of Modern Art, New York, 1949).

Chapter five

THE LAST STEPS TO MODERN ART

Like a bird on a wire
Like a drunk in a midnight choir
I have tried in my way to be free

Leonard Cohen, *Songs from a Room*

IT WAS as if the turn of a century really meant something. The divisions of earlier centuries are no doubt a help to students in remembering the broad outlines of the history of art: the High Renaissance 'began' in 1500, seventeenth-century art began (almost precisely!) in 1600, Rococo more or less in 1700—and nineteenth-century art in 1800. But no-one would claim for the divisions of the centuries any deeper meaning.

But the year 1900 really did mean the start of something new. In 1890 van Gogh and Seurat had already died, Gauguin was beginning to have some influence on younger painters, while Cézanne worked on almost unheeded and unknown, except by a few real connoisseurs and a small group of artists. Yet the new emerging style just after 1900 looked to these for example and inspiration, and almost wholly bypassed the rather ephemeral art nouveau, despite the fact that it had set out to renew the face of the world. Perhaps art nouveau was too aristocratic, or at least snobbish, in its aestheticism, perhaps the times were not yet ripe for a major revolution in the so-called minor arts.

Expressionism

For the art historian the years around 1900 are of bewildering complexity, and no great artist can be picked out as really typifying them. But around 1905 the eruption came: with expressionism, with the Fauves in France, with *Die Brücke* ('The

Bridge') in Germany, soon too the group in Munich known from their journal *Der blaue Reiter* ('The Blue Rider'), and here and there small groups scattered over Europe, all going in the same direction or immediately accepting and passing on the word.

Expressionism—the word was only coined some years later—had no defined programme, no definite philosophy, no rules, no special publicity. The young men who formed the style, often working close together, had a certain inheritance in common in art nouveau—the flat, non-naturalistic, decorative patterns, the concern for the 'spiritual', the imaginative, and the move away from a naturalistic treatment of a simple subject. They were all heavily influenced by the work of Gauguin, Munch (who was in many ways akin to Gauguin), van Gogh and to a lesser extent Seurat. They had learned to use colour freely, and to express by pictorial means human values and feelings, the realities which are more than the eye can see. They had learned that a painting is a flat surface covered with colours and lines, a human creation that surpasses the slavish copying of reality as it is seen in a naturalistic way.

Perhaps expressionism was born that afternoon when Gauguin gave 'a lesson' to the young Sérusier (who later went off along other lines and did not play a decisive role in the movement again). In the summer of 1888, in Brittany, he had approached Gauguin asking for advice. Gauguin took him to a park. 'How do you see that tree?' Gauguin had asked at a corner of the Bois d'Amour. 'Is it green? Then paint it green, the most beautiful green green of your palette. And that shadow? A bit blue? Don't be afraid to paint it as blue as blue can be.' The painting, on the lid of a cigar box, caused a sensation among a group of young painters in Paris. They called it 'the talisman'.

The young painters inherited this attitude. They also inherited the almost passionate disdain for the Salon art of their times. Even art nouveau had not been able to overcome this broad stream of bourgeois mediocrity and shallowness, which made up the large 'official exhibitions' right up to the First World War, perhaps even later. What we now see as the great stream of art was in fact only a fringe. The revolutionaries were often revolutionary in the political sense, too, and increasingly opposed to the traditionalism and bourgeois taste of the Salon artists. Their

hate had been returned, and by 1900 the gulf between them was deep and wide. Yet in a way the Salon artists acted again and again as catalysts to the new movement.

Matisse must have understood that in the art of his day, both in Salon art and in impressionist naturalism, humanism was already dead. He tried to revive it by searching for new meaningful forms. His 'Luxury, Calm and Voluptuousness' of 1906 used the nude in the humanistic way; in many respects it can be compared with the art of such painters as Poussin. Of course, the old humanistic theme was not revived. But it is akin to the ideal

Matisse, *Jeannette, III* (Jeanne Vaderin, 3rd state)
Museum of Modern Art, New York, Lillie P. Bliss Bequest

world, the dream of a high humanity, conveyed by the metaphor of nudes. In other paintings of this time he used colour much more vehemently, less like Gauguin, more like van Gogh. The forms were new and show the urge to create paintings that show a subjective emotion in the face of reality rather than a naturalistic copy—creating an art that really is art, paint on canvas. It is easy to understand why a critic of those days called these works *fauve*, wild, as there is in these works a wild cry, a desperate attempt to get through to the human and to overcome the defects of the traditions of the nineteenth century.

Yet there is something remarkable in Matisse's development over the next years. The humanist element becomes increasingly smaller. His pictures remain colourful, but become more and more decorative. And in many works there is a stylization that almost chokes the human element; art becomes 'Art', and the means of art are beginning to become autonomous. There is a marked tendency to the abstract, even if Matisse never really reached the point of being a wholly non-figurative artist. Around 1910 he made a series of bronze heads which started from a 'normal' woman's head, and then went 'further' in each succeeding work, until the last is still recognizable as being human but has lost any sort of feminine or personal quality. It seems as if Matisse tried to recapture humanity in his art, revive humanism, but lost his track. Maybe he searched for a universal, 'mankind' and not 'this particular man' (a problem we will be returning to later when discussing cubism). But it seems to be the tragedy of much modern art that the artist sets out to grasp the fullness of reality and a fullness of humanity, and yet these slip through his fingers, leaving him finally empty-handed.

Developments in Germany

Expressionism is in a way more typical of German art. Matisse and his group may have had an influence on Germany, and probably at some points triggered the movement off, but as a whole the German style has its own character. It is as 'wild' as the French, if not wilder. There is the desperate search for a new, meaningful art, a humanity that seems to have been lost in the positivist streams of the nineteenth century, a direct expression of

subjectivity, a daring that makes clear how infuriated they were against the deadness of tradition. The art of Gauguin and van Gogh showed an equilibrium between the two opposing tendencies of their times, sticking to reality as it can be experienced by the senses and at the same time looking for the freedom of man. Now, with the expressionists, the pendulum swung completely to the side of the freedom of the artist, the freedom of man to create out of himself unhampered by the demands of naturalness or what the seventeenth century would have called 'decorum'.

The painters of *Die Brücke*, a group in Dresden including Kirchner, Pechstein, Schmidt-Rottluff and Heckel, sought a new art, against all tradition, against deadness. Their aims were for a direct expression of personal subjectivity, a new means of representation unhampered by 'truth' in the old sense (naturalness in colour and shape). They wanted a new 'truth', in which colours and shapes speak their own language, in which they have something to say about reality rather than describe it, using a new means which is not easy to define. 'Symbolical' might be misunderstood, as there were no symbols in the old sense. The colours and shapes in themselves were to 'express' the idea, the feeling, the truth about something, by directly artistic means. The work of art is something that stands by itself, and its relation to reality is not direct—'imitation'—but more in the way of a metaphor.

There was also a strong tendency towards naturalness in a new sense, almost primitive, bypassing the refined veneer of civilization—Rousseau's principles were still very much alive. They lived almost as if they were a primitive tribe, the highlights being the days they passed together in the nude beside a lake—reflected in quite a few paintings from that period, named, for instance, 'Girls on the Beach'. They were much interested in primitive art, to which they were drawn as to something of kindred spirit. The violence of it seemed to them genuine and real.

They searched for a new understanding of man in his relation to nature, and felt and therefore often expressed in their work a conflict between nature and culture. Yet there is a strong urban feeling in their work. Nolde, a true, natural man in the peasant sense, was not really one of them; he remained a solitary artist, with a much more lyrical sense for man and nature. They were striving for the more than passing, the deep truth, the essence

rather than the fleeting moment, the human truth rather than what the eye can see, the exterior alone.

It is not a random result of their new technique that objects, trees, men and women seem to merge into a whole, without any differentiation in colour or texture between, for instance, a human body or a tree, a lake or a mountain. The unity, the totality seems sometimes as it were to consume all differences. Philosophically speaking their work is universalistic, a longing for a universal unity which dispenses with individuality, with the particular—a kind of nature-mystique. In this way they looked for a solution to the problem posed by the art of the previous century, which in its search for the naturalness of the particular had exalted the senses and lost all deeper meaning.

The German equivalent to French impressionism had been a kind of brutal art, in which the ugly, the vulgar, the debased were sought (by Corinth and others); here too one often questions whether there really is a genuine reality behind what is received by the senses (specifically in landscape). In this way German art had made up for backwardness in adhering so long to classicism or romantic naturalism. The new generation, the expressionists, took over this heritage but now brought their art into line with what was going on in France. Yet there was no doubt about the fact that their art was German: it was less *charmant*, had less *esprit* and humour, it was more earnest, philosophical and in its own way romantic.

The group associated with *Der blaue Reiter*, 'The Blue Rider' magazine in Munich, was in many ways of kindred spirit to the one in Dresden, though they did not have much contact in this period before the First World War. There was a greater internationalism in Munich, more direct contact with what was going on in Paris and elsewhere. On the other hand there was less quest for the primitive, the 'natural'. Here the battle was more directly against the older school and its exponents, and with more consciously artistic aims.

Much of what has been said of the Dresden painters applies to those in Munich, and need not be repeated. But rather more must be said about Marc and Kandinsky, the two greatest exponents of the group. They had a strong antipathy to all naturalism, for, they said, it had not only killed art but also

killed the spiritual both in art and in man. 'We must destroy the soulless, materialistic life of the nineteenth century', said Kandinsky, and 'we must build the life of the soul and the spirit of the twentieth century.' He spoke of the nightmare of materialistic ideas that had degraded life into a monstrous, senseless play. He also commented angrily on the contemporary art in the exhibitions:

> 'Rooms hung with canvasses, on which elements of 'nature' are represented with paint: animals in light and shadow, standing near the water or lying in the meadow, beside a Crucifixion of Christ painted by an artist who does not believe in Christ; then flower pieces, or human figures, standing, sitting or walking, often nude; lots of nude women, sometimes foreshortened from behind; apples on a silver tray, a portrait of old Mr Such-and-Such, a sunset, flying geese, portrait of Baroness X, flying ducks, a lady in white, cows in the shade with fierce yellow patches of sunlight, a lady in green. . . .' [1]

Why all this? This was his question, and a very right and proper one. He shows it is the end of an era. Art had become senseless, useless.

The principles of the great art in the tradition of which this art claims to stand have become hollow and superseded. As it was formulated in an earlier chapter: Venus is both dead and buried. The great Christian-humanist culture of the time before the Enlightenment has broken down. In the exhibition Kandinsky describes we are moving amongst the ruins.

How is he going to achieve a new, spiritual, truly human art? First of all by making art into art. He said: 'I have heard a well-known painter saying: When you are painting, take one look at the canvas, half a look at your palette, and ten at the model. It sounded right, but I soon found that I had to proceed quite differently; ten looks at the canvas, one at the palette, half a look at nature.' The artist, he said, must express himself, the times in which he lives, and the 'eternal', what belongs to all times and to all cultures. This, the objective—what I have called the universal —has to be shown by means of the subjective.

In the book from which I have already quoted he characterized the art he was looking for as follows (and it must be acknow-

[1] *On the Spiritual in Art*, 1912.

Kandinsky, Woodcut from *Klänge*, 1913

ledged that his works between 1910 and 1914 really fit his aim in a
wonderful way):

> 'The strife of colours, the sense of the balance we have lost, tottering
> principles, unexpected assaults, great questions, apparently useless
> striving, storm and tempest, broken chains, oppositions and
> contradictions—these make up our harmony.'

It is really not difficult to understand that soon after Kandinsky
wrote these words he came to abstract painting, an art in which
there was no longer any subject-matter, what we nowadays call
non-figurative art. Of this he said: 'Abstract painting sheds the
skin of nature, but not its laws, the cosmic laws.' He was looking for
a restoration of art, hoping to regain something that was lost in the
nineteenth century, the universal, the deeper structure and law of

reality. Art was given a high place in this quest: it is almost the tool and revelation of a new mysticism—or at least it gives form to a new life, a life of the spirit. We know that Kandinsky was highly influenced by the anthroposophy of Rudolf Steiner, a kind of westernized, 'demythologized', eastern way of religious thinking.

I must refrain from going deeper into the art of Kandinsky, analysing his pictures and showing his development. Nor can I deal at length with the work of Marc, who started with a kind of impressionistic painting just after the beginning of the century, gradually came to a less naturalistic art in which the general or universal became uppermost over the particular (almost always choosing animals as subject-matter), and ending with an almost abstract art, different and yet akin to that of his friend Kandinsky. Marc was much more directly influenced by cubism, to which we shall have to turn very soon. He tells us:

> 'I found man to be ugly—animals are much more beautiful . . . but in them too I discovered so much that I felt to be appalling and ugly that my representations of them instinctively, out of inner necessity, became increasingly more schematic, more abstract. Each year trees, flowers, the earth, everything showed me aspects that were more hateful, more repulsive, until I came at last to a full realization of the ugliness, the uncleanness of nature.'

Elsewhere in his letters he says that abstract art meant for him the search to let the world itself speak rather than our soul being moved by the sight of the world. 'The longing for indivisible Being, for liberation from the sense-deception of our ephemeral life, is the main objective of all art.'

Abstraction

So this generation, at the beginning of our century, was looking for a solution to the problem of regaining truth and reality. They had been lost in a development in which the senses were the only source of knowledge, the basic principle of the Enlightenment and of nineteenth-century positivism. They were looking for absolutes, the principles that governed life and art and perception too, the deep reality of human life, the truth of things behind their appearance. Art, in line with art theory in its long develop-

ment from the Platonists through the Renaissance and romanticism, was given the task of revealing this 'eternal truth', that which is more than the eye can see. The work of art has to show deep human values, just as a mediaeval Madonna or, at a later date, a humanistic allegorical painting did. So we can understand Marc when he wrote in a famous article in *Der blaue Reiter* that the true artists were striving 'to create in their work symbols of their time that will belong on the altars of the coming spiritual religion, behind which the technical aspects will disappear'.

This deep-felt reaction against the positivism of the nineteenth century which dissolved all reality, as it were, leaving man with his perceptions alone, searching for true absolutes and distrusting (or even disgusted with) reality, led to a completely new type of art, abstract art, an art that was truly and solely art, and at the same time spiritual, conceptual and 'absolute'. As such it was parallel to the efforts of the new school of philosophy, that of Husserl's phenomenology (geographically not far from Kandinsky and Marc, even though they probably had no contact with each other). In Husserl's main work, which was published in these same years before World War I, he criticizes the science of his day for having degenerated into an unphilosophical study of mere facts . . . positivistic science . . . , a 'naturalism' incapable of coping with the problems of ultimate truth and validity, as it had no room for ideal entities such as meaning or laws as such.[2]

Husserl wrote in the introduction of his book:[3]

> 'To get rid of all traditional ways of thinking, to recognize all the spiritual fences that shut off the horizon of our thought and pull them down, to get hold of completely new philosophical problems in the complete freedom of thought that has resulted from the breaking down of all the fences and the opening up of our horizon— all this is hard to achieve. But nothing less is required . . . what is necessary is a completely altered approach, different from the natural way of experience and thought.'

But these philosophers and artists were trying to overcome the doubtful results of the positivist world-view of the Enlightenment without questioning its basic principles. For in starting from

[2] H. Spiegelberg, *The Phenomenological Movement* (The Hague, 1960), p. 79.
[3] *Ideen zu einer reinen Phänomenologie und phänomenologischen Philosophie*, 1913.

man, from *his* sense-perception, *his* thinking, it automatically closed the world; it shut off any possibility of a transcendental, truly living God. 'God is dead', Nietzsche had already proclaimed many years before, 'we have killed him, and the stench of his corpse is over Europe.' But the tremendous effort involved in attempting to regain true humanity was tragically bound to fail. The strivings and search for renewal in the arts were much more concerned with art for the sake of life than with art for the sake of art. What Holbrook Jackson wrote about the English poet Davidson can equally be applied to these artists:

> 'The strife of the poet for a new expression, a new poetic value, is too evident, and you lay these . . . works down baffled and unconvinced, but reverent before the courage and honesty of a mind valiantly beating itself to destruction against the locked and barred door of an unknown and perhaps non-existent reality.' [4]

What does it mean 'to get rid of all traditional ways of thinking', to strive for 'a new expression' and 'poetic value', a spirituality beyond the material? We can see what it means simply by looking at one of the great works of Kandinsky in the years immediately before World War I, perhaps his best period, and certainly the works of a genius. But for many people visual art does not communicate as clearly as words do. Certainly poetry can help the understanding of painting, as too painting can sometimes make clear the intentions of the poet, or, for that matter, the philosopher. So to give some idea of the mood of this striving I should like to quote one of Kandinsky's poems from this period, *Im Walde* (In the Wood)—though it is not so much a poem as soft-spoken prose. It is taken from his anthology published under the title 'Klänge' (Sounds).

> The wood was getting thicker all the time. The red trunks ever closer together. The green crowns ever denser. The air ever darker. The thickets ever more close-set. The mushrooms in ever greater number. Finally there were only mushrooms to tread on. It was more and more difficult for the man to move forward, to push

[4] *The Eighteen Nineties*, first published 1913 (reprinted by Pelican Books, Harmondsworth, 1950). This excellent book deals with very much the same problems as I do here.

through and not slip. Yet he went on and repeated the same lines over and over again, each time more quickly:
The healing scars.
Complementary colours.
To his left, and slightly behind him, walked a woman. Every time he completed the phrases, she said, convinced and with a strong rolling 'r': verrry prrractical.

Cubism

Around 1906–7 some of the younger painters in Paris, most of whom had followed in the tracks of the Fauves, the expressionists, turned in another direction: cubism. Cézanne's paintings influenced them, and with him they wanted to search for what is more than the eye can see, the principles, the structure of reality. A letter from Cézanne to a young painter, written in 1904, probably summed up his own aims badly, but it suited the young painters very well, for here the carefully-sought balance was broken and the place of nature and sense-perception reduced: 'Treat nature by the cylinder, the sphere, the cone, all brought into perspective.' In another letter of the same year he had written: 'You can never be too scrupulous nor too sincere nor too subjected to nature; but you are more or less master of the model, and above all of the means of expression. Penetrate into what you have in front of you, and persevere in expressing yourself as logically as possible.' It was this last piece of advice that meant most to these young painters.

Amongst this group of young painters was Picasso. What influenced him, as well as the others, were, first, Iberian sculpture, blending Greek classical art with a more primitive search for the impersonal and general, and soon, too, African masks and sculptures. The fact that in their reaction against the superficial naturalism of the nineteenth century they 'discovered' the truth and beauty of primitive art (which had previously been the concern only of ethnologists) betrays a deep spiritual similarity in aim and in the understanding of reality. Primitive man feels one with nature and its forces, and in his religion he uses his masks to lose himself and become one with the spirit (often an animal one) of the tribe. For modern man, even if in a less mythical way,

nature is the only true reality, and man is basically no more than biological/psychological. The aims of the cubists, their quest for a new expression, a new art, were in the final analysis the making of a new world-view, one that broke away from the age-old humanism of western society. The personal was lost, for there was no longer a personal God. Man, animals, plants, things, they are all basically the same. So there should be no basic difference in the way they are depicted.

The cubist movement was very complex in its aims. There was the same search for the absolute as we found with the Munich group of *Der blaue Reiter*, the same wish to portray the true reality behind the appearances. It was rather like Plato's search for the basic ideas behind all reality; and it was certainly not by chance that their art was characterized by mathematical, or rather geometrical, forms, just as Plato had said that the geometrical was the deepest idea behind reality. In keeping with the whole of the western tradition they were rationalistic and intellectual. Yet there was a strange violence, particularly in the works of the first years of Picasso's cubism, something irrational, overflowing emotions, as if he passionately wanted to break down the old image of man, too long revered in a humanist sense as supreme beauty.

Picasso summed up all the conflicting and yet connected ideas of early cubism in his 'Demoiselles d'Avignon', an unsurpassed masterpiece which can at the same time stand as a kind of symbol for all modern art. In this work, painted in 1907, the new era, the new world that even today has not yet been fully realized, was already defined, its world-view depicted, its idea of man represented in a way that still makes us hold our breath. A friend of Picasso recorded his reactions when shown the painting:[5]

'. . . It contains six huge female nudes: the drawing of them has a rugged accent. For the first time in Picasso's work, the expression of the faces is neither tragic nor passionate. They are masks almost entirely freed from humanity. Yet these people are not gods, nor are they Titans or heroes; not even allegorical or symbolical figures. They are naked problems, white numbers on the blackboard. Thus Picasso has laid down the principle of the picture-as-equation.

[5] Quoted from E. F. Fry, *Cubism* (Thames and Hudson, London, 1966), which gives many more quotations of contemporaries of cubism.

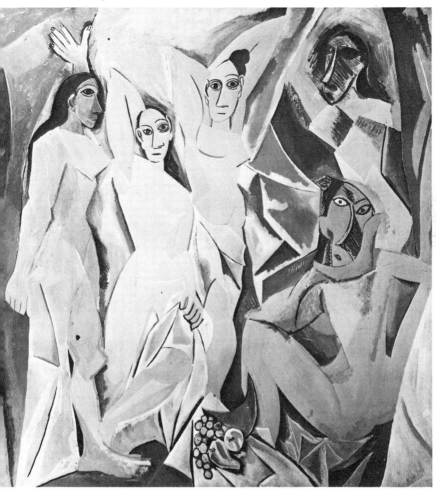

Picasso, *Les Demoiselles d'Avignon,* Museum of Modern Art, New York

One of Picasso's friends spontaneously christened the new canvas
"the philosophical brothel". . . . Painting, from now on, was
becoming a science, and not one of the least austere.'

Indeed, as is suggested in the lines just quoted, this picture is
completely a-moral; it is neither moral or immoral. Morality has
nothing to do with it. Even if its starting-point was a brothel
(hence the name, after Avignon Street in the red light district of

Barcelona), the painting is neither propaganda for this type of sexual activity nor does it show any indignation or say how awful prostitution is. It is simply a picture, as such still in the old humanist tradition, a picture of a number of nude figures, standing in this way for humanity and timeless reality and truth. It is not a question of moral or other standards, but of the quest for the universal. 'Philosophical brothel' is really not so bad a name after all.

What had already struck Picasso's friends at the time was the complete lack of expression in the figures themselves. The figures are taken as objects, their own feelings play no part. The painting treats general structural problems, and looks away from the specific to the general. In this respect we note the geometric, stylized way the figures are rendered. And yet in the raised arms of the central figures, in the exaggerated points that thrust into the surrounding plane, we feel the fierce violence—not of the figures, but of the artistic expression.

Another problem is the use of space. It is clear that 'Renaissance' space, with perspective, depth, foreground and background, has been discarded. This use of space has been called 'acoustic' (using a term from McLuhan), a space that has no depth, nothing in front or behind. Yet, even if there is not much indication of space in the traditional sense in Picasso's painting, it is not flat: not only are there remnants of traditional space rendering (one figure being in front of the other), but a kind of conceptual space is to be seen in the rounded forms of the figures, the curtains and so on. Here a principle of Cézanne was carried to its extreme, and certainly this picture is not so much a depiction of reality, a rendering of what the eye can see, as a building up of a work of art that as such is an independent equation of reality.

The figures represent as it were three aspects of early cubism, or, rather, of early modern art. Perhaps we can discern in this the different stages in the artist's work. But even if we cannot really say just why it was done in this way, it surely has a tale to tell. First we have the Cézanne-type nudes in the middle, though they are simplified and more geometrically rendered than anything Cézanne ever did, including his very late 'Baigneuses' (bathing women) that are not dissimilar. The mask-like faces show resemblances to Iberian art. The figures are female, but there is

nothing feminine about them. Here was expressed the quest for the general, the universal. The violence of it is witness to Picasso's hatred for the trite individualism and superficial naturalism of the previous period.

It was this that drove the painter on to abstraction or near abstraction, just as it did a few years later with Kandinsky and Marc. We can see this on the left-hand side of the picture. The woman's back and the drapery of her clothes (if that is what it is) merge with the curtain, becoming a pattern that has a meaning of its own, and losing its descriptive quality. To the right there is yet another aspect: here the figures have mask-like faces, horrible masks, demonic and violent. The friend of Picasso we have already quoted said of them:

> 'Picasso, somewhat deserted, found his true self in the company of the African soothsayers. He composed for himself a palette rich in the colours dear to the old academic painters: ochre, bitumen, sepia . . . and painted several formidable grimacing nudes, worthy objects of execration. But with what a singular nobility Picasso invests everything he touches! The monsters of his mind drive us to despair . . .'

The quest for absolutes

So this is an art which is definitely not naturalistic. It seeks the general, the universal. It tends towards abstraction, even towards the demonic. It loses a humanist humanity, and is at the same time both extremely intellectual and irrational. In short it sums up all aspects of modern art at the very moment that it was born.

The predominant concern following this painting was for the discovery of the universal, the governing principle 'behind' the given visual image. This is what has been called analytical cubism. The forms that were visually observed were analysed and the underlying geometrical shape, cube or cone or pyramid, was discovered and painted. These figures or objects (a still life with guitars, for instance, or with studio utensils) were placed in a cubistic space. Or Picasso, Braque, Derain or some of their friends would paint landscapes: not of a specific spot, of course, even if a particular place was mentioned in the title of the painting; a house would be a universalized one, not a particular

house recognizable from the position of its doors and windows; a tree, too, would be generalized, not a specific one—it was not even possible to tell what the season of the year or the time of day was:

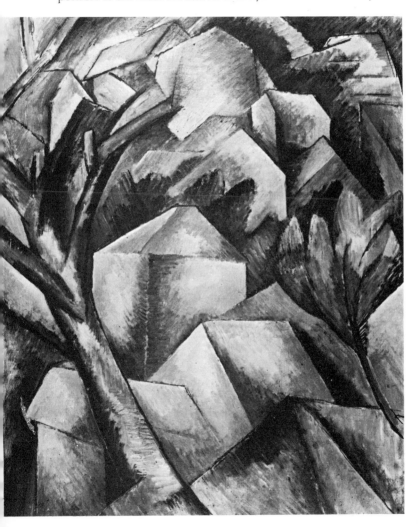

Braque, *Maisons à l'Estaque,* Museum of Fine Arts, Berne, Hermann and Margrit Rupf Foundation (Rights Reserved ADAGP, Paris)

it was not the fleeting but the lasting aspects of the subject that were portrayed on the canvas.

This stage of cubism is rather less fierce and violent than the early start made by Picasso. Its green-ochre colour-schemes are very beautiful, and to a certain extent their aims were achieved. Yet there is always the urge to go further, to let the forms live their own life, to break down the image yet further in a quest for more consistent analysis. When a final stage was reached in about 1909, there was a kind of standstill in the development. For a time the style remained the same. Figures were broken down into a kind of crystalline structure, merging with the background—it is hard to tell where the figure ends and the 'space' begins, for there are no contours. It was a kind of supreme, beautiful puzzle. Where *is* the face? O yes, that must be a hand, that could be a glass, this must be the guitar . . .

The decisive step

It is at this stage that Picasso must have realized that their quest had failed. They had searched for the universal, the general structure of things, that which is more than the strictly individual and specific—and in so doing had lost the personal, the human, the 'real'. It was as if it had been shown to be impossible ever to reach the universal directly, without seeing the absolute through the specific. He who would know love must experience personal, specific love, or there is but a dim abstraction which is no love. Their quest to show what Plato might have called the idea, or Aristotle the form, had ended in beautiful pictures that yet presented no more than strange puzzles, enigmatic images in which the real content was virtually lost.

When Picasso realized this, he had to take another step forward. Maybe he hesitated for some time—and this is why the development seemed to have come to a standstill. For the next step was to be a tremendous one. The consequences of it could not be foreseen. Slowly it must have entered into Picasso's mind that the step was unavoidable, whatever the results. Only a man of his stature, his talents, his daring, his insight could ever have done it.

And he took the step. He did so when he accepted the failure, and took the consequences. There are no universals. The general, the absolute, is non-existent. And if there are no universal principles, if there are no absolutes, then . . . we can understand his hesitation . . . then this world is absurd, nonsensical, without meaning.

The term absurd here is really an anachronism: it was used only later by Sartre, Camus and the theatre of the absurd. But the idea of the absurd had already been there for some years. At the turn of the century there was an absurd play by Jarry, his *Ubu Roi*. The strangeness and absurdity of this world was shown by an art that was not naturalistic, yet was trying to show the truth, a new truth, the truth that there is no truth, that anything may and can happen. This was already true of some nineteenth-century art, the writing of Rimbaud and Mallarmé, Edward Lear's nursery rhymes (and their accompanying illustrations), Grandville's drawings, Odilon Redon's lithographs, even in a work like *Alice in Wonderland*. But the absurdity, often presented in humourous terms (even if we would sometimes want to call it black humour), had been something apart from the main trends . . . now it was to be at the heart of the movement.

We must realize that the men and women who were involved in these new trends of around 1910 were only very few in number. At the most they could not have numbered more than a thousand. But what was happening was finding a response with an ever-increasing number of people. Picasso, after some years of preparation, had dared to break through the sound-barrier of reality . . . and the sonic boom was not only heard at the time but the last reverberations are still around us—if we but listen.

The poet Apollinaire, a friend of Picasso, wrote a poem which expressed their spirit and their aim:

> 'O mouths, mankind is in search of a new form of speech
> With which no grammarian of any language will be able to talk
> And these ancient languages are so close to death
> That it is really sheer habit and laziness
> That allows us to go on using them for poetry
> But they are like invalids who haven't the strength to say no
> Look people would soon get used to being dumb
> Mime is good enough for the cinema
> But we must determine to speak

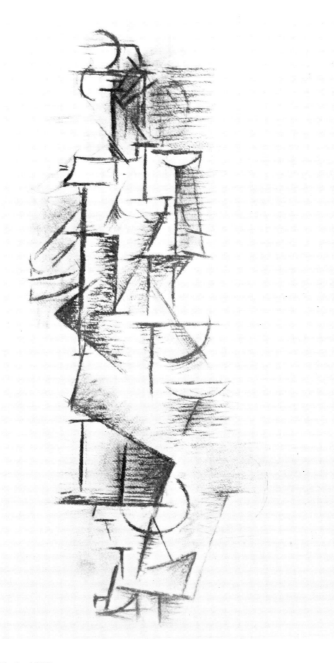

Picasso, *Nude,* 1909

To move our tongues
To splutter and stammer
We want new sounds new sounds new sounds.' [6]

This change in cubism, taking place in the years 1911–12, is called in the textbooks of the history of art the change from analytical to synthetic cubism. The artist felt free to play with the forms that had been invented. The crystalline aspect disappeared, and the colours again became stronger and played a larger part in the composition. A new element appeared: the 'collage', the use of real things in the painting, as a piece of a daily paper, cloth, etc. These things, taken from 'real life', were brought into the painting as an element in the artistic composition, sometimes quite apart from their original utilitarian meaning, sometimes taking their associations with them. They had already incorporated letters, too, into their paintings. In one sense the new art was closer to reality, more recognizable, more direct. But on the other hand the play with reality was more free, more whimsical. But it was precisely this play with natural elements that enhanced the absurdity of the artistic statement—Golding in his book on cubism uses the word 'satirical' here. And surely, whoever stresses the absurdity of reality laughs at it—or weeps. It was laughter which was predominant at that time: but the cry was there too, and was to be heard again, more loudly, in the years to come.

Four reactions

One group who certainly heard Picasso's 'sonic boom' was a group of young painters then working in Paris. One of them was a Dutchman: Mondrian had already a career behind him, first as an impressionist, then as an expressionist, but now had begun to search in the direction of cubism. He followed analytical cubism. But when the change came it is as if he said: 'No, Picasso, you are going in the wrong direction. You have been doing fine, searching for the true absolute. But now, why . . . why do you forsake us?' So Mondrian went off in his own way. During World War I he

[6] Translation by S. W. Taylor, from the introduction to the catalogue of the Apollinaire exhibition at the Institute of Contemporary Arts, London, November 1968.

was in Holland again and had more contacts with the theo-
sophists; but what was decisive were his discussions with Dr
Schoenmaeckers, a mathematician, philosopher and mystic. This
man wrote: 'We are now learning to translate reality, by means
of our imagination, into constructions which can be controlled by
reason, in order to re-form these same constructions again in a
"given" natural reality, thus penetrating nature by means of forms
that can be seen.'[7] This is exactly what Mondrian tried to do. For
Schoenmaeckers as well as Mondrian (and Kandinsky, too, and
most of the others involved in the artistic renewal) had a strongly
utopian trend in their thinking.

Through this influence and through his contact with young
artists like van Doesburg, Mondrian evolved around 1920 his
own particular style, the depiction of the absolute, true
'plasticism' as he called it, the creation of absolute form. Pictorial
elements were reduced to their simplest and most rigid terms:
black horizontal and vertical lines, white, red, yellow and blue
colour—and nothing else. But there is no doubt that his art has its
own particular kind of beauty, a harmony and inner balance. In a
way we can say that he defined twentieth-century style; his
influence on architecture, typography and so on has been very
great. Going through a modern city we see something of the
world that Mondrian dreamed of. Yet whether he achieved what
he really wanted, the 'plastic' realization of the absolute, is an
open question.

Apart from anything else, Mondrian's art is extremely intellec-
tual (and neo-platonic). One can readily believe the anecdote
told about Mondrian, that he was sitting in front of a white
canvas for a whole afternoon without being able to get started
with his painting. For even the first little black dot would break
the absoluteness of the whiteness, and would create something
specific and individual. But, we may ask, what would the
charlady coming in the next day think of the white canvas—or of
the white canvas with the little black dot?

There was another group of painters around Picasso and
Braque. They saw in cubism a new style, and some of them had
various theories about it: that painting should be in harmony
with the universe which is itself an organism, that it should reflect

[7] Quoted from Jaffé, *De Stijl* (Amsterdam, 1956).

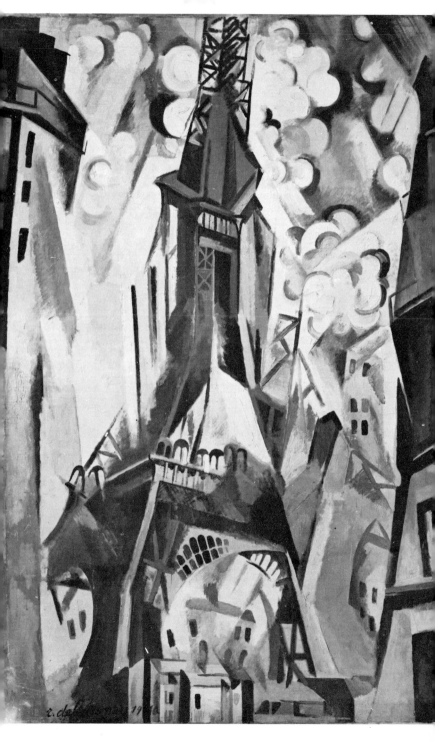

true reality, and so on. In a way their theories were half-truths as far as Picasso's and Braque's art are concerned; yet they are helpful for understanding the spirit of the time. Gleizes and Metzinger wrote in 1912:

> 'There is nothing real outside ourselves; there is nothing real except the coincidence of a sensation and an individual mental direction . . . we can only have certitude with regard to the images which they produce in the mind . . . the only difference between the impressionists and ourselves is a difference of intensity . . . There are as many images of an object as there are eyes which look at it; there are as many essential images of it as there are minds which comprehend it . . .' [8]

Perhaps the fact that they saw in cubism a kind of renewed and more intellectual impressionism is their basic misunderstanding, and the reason for their failure to be true cubists.

Delaunay had a better understanding of what cubism meant, though he used its stylistic means to make a somewhat modernized version of Cézanne: for him cubism was a new means to represent the modern world. His 'Eiffel Tower' shows his method. At this same time the Futurists, an Italian group of artists, had come into contact with those in Paris, and with much noise and enthusiasm inaugurated their own version of modern painting. They were interested in movement, in machines, in power. They had reacted strongly against the naturalistic and romanticized art of late-nineteenth-century Italy, and against the burden of Italy's past artistic splendours. We sense the strong influence of Delaunay; and their analysis of movement and of the modern world—crowded streets, racing-cars, sprinting cyclists—again made use of cubist elements to make up a new style.

These efforts to use cubism as a new means of representing reality, modern reality, were often very interesting. But it is curious to note that most of these painters—one exception is Feininger—sooner or later either went on to paint abstractly or fell back into a more traditional style. Either they searched for the absolute, or for pure beauty and pure art, or they recoiled from the consequences to which their quest might lead them, the absurdity of reality. Only a few dared to go on, but then followed the surrealism of de Chirico, of whom I shall have more to say later.

[8]Quoted in Fry, *op. cit.*

Delaunay, *The Eiffel Tower*
Kunstmuseum, Basle, Coll. Emanuel Hoffmann-Stiftung

Going back to a more traditional style was another answer to Picasso's step, the last and decisive step to modern art. Just as Renoir did not dare nor want to follow Monet, so here again there were artists of whom in one sense it was their weakness, in another their greatness, that they did not want to break with 'real' reality.

Derain, one of Picasso's friends from the early days of cubism, the man who had introduced Picasso to negro sculpture, is one of the most important of them. He began to paint in a style that became the landmark of the School of Paris between the two World Wars. It was a style that, compared to impressionism, looked for the more classical and stable elements in reality, human figures, landscapes. But it also sought stylization and decorative qualities. Again and again one senses that there is an inherent weakness in this school—perhaps deep down they felt that the true moderns were really right, but they could not face their revolutionary, terrifying representations. They were perhaps the first to ignore the deep and disquieting aspects of modern art. But they did not like to fight against it, and even tried to minimize the gulf that separated their own works from those of the 'avant-garde'. They were the aestheticists who would carry on maintaining that art is really no more than art, a sensibility, a feeling of artistic appeal, and little—or nothing—more. In this way disquieting questions about content could be silenced and their own work, with its lack of real depth, defended.

The last group that reacted to Picasso's step was completely positive in its acceptance of it. They accepted the truth of the absurdity of this world and this life. They saw that now all values, norms, forms, traditions, all that belonged to western culture including its art, had lost their meaning. They looked for a great upheaval, the breakdown of our culture, in the acceptance of nihilism and anarchism. The greatest of the group was Marcel Duchamp, one of the most influential men of our century, a man of great intellectual ability, a man who could and did dare to risk the consequences of his thinking.

But not even Duchamp could translate principles into practice just like that. It took time, though his development was really surprisingly quick. His first great work, in which he showed the influence of the cubists, of Delaunay, perhaps too of the futurists, was his famous 'Nude Descending a Staircase' . One could call it

Derain, *Les Deux Soeurs,* Royal Museum of Fine Arts, Copenhagen,
Rump Collection (Rights Reserved ADAGP, Paris)

Duchamp, *The King and Queen Surrounded by Swift Nudes*
Philadelphia Museum of Art, Coll. Louise and Walter Arensberg

a study of movement. One could also call it a parody of the
'Golden Stairs' of Burne-Jones; or one could just as well see in it a
kind of parody of the cubists of Delaunay's type. It was a shocking
picture—it became the great focal point of the Armory Show in
New York in 1913—not because of the strange immorality which
was suggested by a nude woman descending a staircase, but
because it was so hard to see the woman at all, and certainly not
the tantalizing, titillating elements that both moral and immoral
men were looking for.

One of his next works of 1912 (now, with most of his other
important works, in the Philadelphia Museum) was 'The King
and Queen Surrounded by their Swift Nudes'. It could also be
called a caricature of cubism, or a parody of futurism, but one
thing is certain: it shows two towering static built-up forms, in

shapes that we would call modern—if we think of cars, or ocean liners or futurist, science-fiction architecture—while between them is a sort of stream made up of moving shapes, resembling metal sheets (developed from the 'Nude Descending a Staircase'). One thing is more than certain: there is no king, no queen, no nudes even. They are anarchistically destroyed in a kind of black humour. And not only is the royalty of the king and queen destroyed; their humanity is dead and gone, too.

'Man is dead' is a theme that is common to much modern art. Man is dead. He is nothing but a machine, a very complex machine, an absurd machine. The theme of absurdity, already clear in the two works mentioned, was developed further in Duchamp's 'Bride', also in Philadelphia. In another version this painting is called 'The Change from a Virgin to a Bride'. Indeed, sexual overtones are always to be found in this type of work, as if this is the only thing that has been left of humanity. What we see (to quote the Philadelphia catalogue) is 'an engine—not with a soul, as one might suspect, but with the clumsy addition of a superimposed human digestive and nervous system'. It is the kind of mechanical contraption you would find in a laboratory, or a sort of absurd apparatus parodying the anatomical drawings in medical textbooks. And, of course, it is hard to find anything of what the title suggested—the title is only a kind of malicious addition, turning the onlooker into a kind of voyeur, soon discovering that it is not the painter but he himself who has the dirty mind.

Of course there were many more works. The most specific examples of what we are saying are Duchamp's 'ready-mades'. For instance he takes a bicycle-wheel and puts it on a base; or he takes a comb, a normal everyday comb—and puts his signature to it. Of course these things are absurd as works of art, but their absurdity is willed. Duchamp wanted to kill the idea of high art standing for high human values. His art is anti-art—and yet lives only by virtue of the fact that there is a tradition of high art in western culture, an art that stands for high values. These works stand at the cradle of the Dada movement that came to the fore in the years of the First World War. It was Dada that tried to laugh away all that is of value in our world, a nihilistic, destructive movement of anti-art, anti-philosophy, yet with mystic

overtones akin to Zen Buddhism. It could well be seen as a new gnosticism, proclaiming that this world is without meaning or sense, that the world is evil—but with no God to reach out to, as God is dead by now. In the Philadelphia Museum there is also a work by Morton Schamberg from about 1918 called 'God': it is described as 'Mitre-box and plumbing trap, $10\frac{1}{2}$ inches high' . . .

The Dada movement was founded in Zürich in 1917 by a group of young artists. It used all art forms and tried to break all taboos, all norms for art, all sacred or non-sacred traditions. Dada was a nihilistic creed of disintegration, showing the meaninglessness of all western thought, art, morals, traditions. It destroyed them by tackling them in an ironic way, with black humour, by showing them in their absurdity, by making them absurd. And this was not just a few men on their own: they were a strong group and were to have considerable influence, determining the form and approach of much that came later, right up to our own time. So the Dada movement was not the whims of a few lunatics at the fringe of our culture: it gave form to at least one side of the spirit of our age.

If we look at the collages of Kurt Schwitters, at the works of many of the Dada artists and those who were working in this line in the surrealist movement, we discover how much of it came from cubism, and how important the work of Marcel Duchamp has been. Picasso, in breaking through the barriers of reality, opened a kind of Pandora's box. The spirits took their abode in the minds of men like Duchamp, and brought a whirlwind of anarchy, nihilism and the gospel of absurdity. The wind is still blowing, and is becoming a storm: a storm called revolution.

Chapter six

INTO THE NEW ERA

Can't you understand what I'm trying to say
Can't you see the fear that I'm feeling today
If that button is pushed there is no running away
There'll be no-one to save with a world in a grave
Take a look around you boy, it's bound to scare you boy,
And you tell me over and over and over again you don't believe
We're on the eve of destruction.

P. F. Sloan, *The Eve of Destruction*

IF WE put on exhibition all the most important works of modern art up to 1920, we would already be able to see almost all the different aspects of twentieth-century art. Expressionism, abstract art, cubism, Dada, with their new methods of depicting reality, the collages, the particular styles, the use of colour, the search both for the absolute and for absurdity, their negation of all values, their pan-eroticism, we would see all the best and worst features of the art of our century. The years since 1920 have added virtually nothing that has been really new.

But the new spirit spread. While the modern movement was previously the work of a restricted group of artists and their public, it now influenced the minds and way of life of an ever-increasing number of people. In fact it is not too much to say that a new era in cultural history was inaugurated. At the start the painters were the real avant-garde, but there were also writers, poets, playwrights, composers, architects, philosophers, and 'ordinary' people taking it up and working towards a new world.

The third step to modern art was like the overture to a new play, a new drama in world history. It was in itself revolutionary, and it was also the starting-point of a revolution in which we still live today. For breadth and depth even the Russian revolution cannot stand comparison with it, and seems almost old-fashioned in its aims and achievements.

So art played a vital part in giving form to a whole new mentality, a new spirit. It was one of the main agents for spreading the new thinking, the new ideas. Modern art is not neutral (art never was!). Its message is a new age, a new culture, a new world.

But modern art did not come as something inevitable. Men,

responsible men, creative talents, human beings made it what it is, gave it form and content. Yet even if it owes its specific style to particular people, it was still inevitable in the sense that it was the necessary outcome of the long development that we have been tracing from the eighteenth century, or even from as far back as the Renaissance. It is true, and represents the truth, in the sense that it is the expression of a reality: one in which God is dead and so man too is dying, losing his humanity, what makes him man, his personality and individuality.

It is striking that in our age there have been many attempts to achieve an impersonal art, an art that does not show the particular individuality of the artist. For modern art is inevitable too in being a reaction against the meaninglessness to which nineteenth-century art had led, and at the same time against the cult of the artist-prophet-priests of culture, even though modern artists themselves continued to play this role, if without its aura of romantic heroism.

So in this sense modern art is true. But at the same time it is a lie. Its portrayal of reality, of man, is not a true one. Man is not absurd. Reality is beautiful and good not only on the 'spiritual' level, but ever since the very beginning when God said it was good. We may appreciate the efforts, and even admire the greatness, of men who have tried to find the universal, the general 'behind' appearances; yet at the same time their quest was doomed to fail, for all universals break down as soon as the Creator, He who made man in His image, is denied or left out of account. It was doomed to fail because men started solely from their senses and their own brains, not accepting any reality beyond them.

This duality, this truth and falseness, must be accepted if we want to understand modern art, and the modern age. We must recognize causality, that nothing comes of itself. But we are not slaves of causality, caught in a fatalistic way in the age in which we live. Human freedom implies that we can say no, that we do not have to accept the spirit of our age, that we can resist spiritual forces today in the same way as the early Christians were exhorted by Paul to stand firm 'against organisations and powers that are spiritual, . . . the unseen power that controls this dark world'.[1]

[1] Ephesians 6: 12, J. B. Phillips.

But if Christians today are to say no, we must say no with knowledge and insight, and meet the situation as it really is. We are not free to opt out of the period of history God has placed us in, nor opt out of the task He has given us to live as His children here and now. But it is not just Christians who have this responsibility and freedom to say no. Others who are concerned for the future of man and society, and who see these forces at work, are just as well able to deny the spirit of the age, even though they may lack the Christian's basis for doing so.

A new art for new needs

But our reaction to modern art has no need to be wholly negative. For modern art can also be seen as an answer to new needs and new challenges. The difficulty is that these are deeply interwoven with the deeper issues we have been discussing. It reflects and expresses the new age, with its machines, its technological possibilities, its speed, its new means of communication, its deep and wide international contacts, its economic and social patterns which require new forms, new ways of expression, a new sensibility and new thought-patterns. Modern art as a new spirituality, a new religion (even if a nihilistic one) has often gone to extremes, yet it has created new forms and opened up new possibilities. New ways of expression and new methods of portrayal have been evolved which, when the specific message for which they were made is discarded, and when the highly subjective, esoteric quality has been toned down, could be used to meet new twentieth-century needs.

So alongside modern art as such, the historical stream, the group of artists expressing basic beliefs more or less common to each other, there is an art, or rather a style, which we might call twentieth-century. An example is Cassandre, who around 1920 began to use some of the cubist stylistic methods for his highly imaginative and effective posters. In fact, in typography, pamphlets, posters, in many different forms of visual communication we find that new stylistic principles are being used, different from those of the last century, different from those still used by people who are now behind the times. They are found in traffic signs, the justly famous signs of the London Underground,

Andersen, poster for Shell, London, early 1920s

in statistics, in magazines, in . . . well, everywhere around us, for they form the visual language of our age, and as such can be understood by everybody without having to be learnt. Put Samuel Pepys or Dr Johnson down in the streets of one of our new cities today, and they would feel dazed and mystified : we would have to teach them to understand what was being communicated to them.

Much the same could be said of music or speech or many other aspects of the twentieth century. Yet twentieth-century people, though they may understand all these new ways of expression and communication, still feel estranged in the presence of modern art. However great the artist may be, however honest his motives, yet people sense a lie. It is not the method, the pictorial language, the means of communication, for they can appreciate the traffic signs or the toothpaste posters. No, they realize that there is more to modern art. There is the crisis, the absurdity of our age.

After all, there are plenty of good reasons for using new means of expression. It all depends on what you want to say with them.

There is a tremendous difference between the wry, anarchistic humour of Duchamp's 'King and Queen' and the lyric poetry of a Lyonel Feininger, yet both use a cubist style; or between the cool abstract beauty of a Mondrian picture and the gay interior with its primary colours that would never have existed without Mondrian. The Bauhaus, the famous German school of design which was active in the twenties, and which numbered among its teachers some of the greatest modern artists, was a major influence in modernizing the world, and in a double sense. It made modern stylistic forms applicable to twentieth-century life, and at the same time did much to spread the spirit of true modernism. We can be thankful for the first, even if we would want to criticize it in detail, for as true purists they were sometimes too dogmatic in working out their principles of modern design. But only in this way could they renew architecture, interior design, furniture, lamps, everything that we would nowadays call industrial design, as well as being active in the fields of ballet, drama and much more besides.

A new art with a new message

Modern art is a complex phenomenon. But in the final analysis one thing stands out just as much as with 'old art': each work of art has its own message, its own quality, its own form. And each has to be 'interviewed' for its own individual peculiarity. Some are more extravagant; others use what may seem strange forms while their message is still positive and good; others may even use rather more traditional forms and yet convey a message of revolution or absurdity; others may have a rather indifferent meaning but yet are beautiful in their colours or their forms, while others again are hideous even if they mean to speak kindly; and then of course some are really deep and important, others shallow and simply boring. To distinguish between them we must understand the forms and means they use.

Too many have bypassed modern art with a shrug of the shoulder, failing to see that it is one of the keys to an understanding of our times. For many of these works, particularly the more extravagant ones, are signs of the crisis of our culture. They embody new ways of thinking. They proclaim the meaninglessness

of all we may think sacred. Some of these works may be making a plastic bomb to put under the liberal, establishment chair of western culture in which you may be sitting. Beware. This art forces you to choose. It makes you take a stand—one way or the other.

This art is the work of your neighbours, your contemporaries, human beings who are crying out in despair for the loss of their humanity, their values, their lost absolutes, groping in the dark for answers. It is already late, if not too late, but if we want to help our generation we must hear their cry. We must listen to them as they cry out from their prison, the prison of a universe which is aimless, meaningless, absurd.

Marc sought an art that would form altar-pieces for the spiritual religion of tomorrow. Indeed many paintings are such altar-pieces. But they are conceived for a nihilistic temple that will never be built, for the echo of Isaiah's words is still heard: 'Man, don't be so foolish as to bow down before images you have carved yourself.' It is virtually impossible for man now to accept a religion he has invented. In this lie both modern man's real tragedy, his despair, and his understanding of himself.

Yet Marc did make one of these altar-pieces, the large painting now in the art gallery at Basle. It is called 'Tierschicksale', the fate of the animals, and was painted in 1913. We see a rigid structure in cubist style. If we look closer we discover deer, more deer, till we see that almost the whole picture is made up of deer, running, standing, lying. The fate of the animals: they are bound to cosmic laws which are rigid and leave no room for freedom of any kind. They are bound to die. Man, Marc said once, is different from the animals insofar as he knows that he has to die. On the back of the picture are written these words: 'Und Alles Sein ist flammend Leid'—and all being is flaming agony. The fact that we are, that we exist, is no cause for joy. It is no more than a question mark, or rather pain and sorrow. We are bound to being. Bound to die. Here motifs that were to return in existentialism, in Heidegger, for instance, were already alive.

There is a deep pessimism behind Marc's work. Yet we must realize that this is really much deeper and truer to reality than a superficial optimism. It does not bypass the truth of which the Bible speaks when it says that all creation is groaning in travail,

Marc, *Tierschicksale,* Kunstmuseum, Basle

longing to be set free from its bondage to decay.[2] Alas, Marc did
not know that there can be a salvation from this death, that
creation will be set free.

Beneath the search for the absolute in much modern art, the
desire to express what is 'behind' the oppressive appearance of
a reality which is almost too naturalistic and too rational, there is
an anxiety, a feeling of being lost, of death pervading all. Hence
the desperate quest for the real, the positive which lies in the
depths, behind, beyond this world. It is a quest for a mystical
truth. But it is a truth without God, without any sort of god at all.

[2] Romans 8: 18 ff.

The irrationality of the rational

I must repeat once again that I have no intention of giving in this book a complete history of modern art. My aim is simply to point out its main features—and some of its problems. Yet my tale would not be complete if I left it at 1920, even though almost all the modern developments had been achieved already by that time. Some of the great artists of the modern movement took their experiments with the new art further. I want now to discuss two of them in particular.

The first is Paul Klee. He had had contacts with the Blue Rider group in Munich before the war, and created a highly original style and approach of his own. Perhaps the twenties, while he was teaching at the Bauhaus, were his greatest years. His art was a 'cold romanticism', as he called it himself, a kind of mysticism which sought to depict what is behind, above, beneath the surface of things: the forces of creation, change and destruction, good and evil. It was a sort of cosmological mysticism, or rather cosmogenetical: concerned with the developing, evolving forces behind reality. But they were not sought in any kind of transcendent God—in this sense Klee's mysticism is nihilistic. In many ways he is akin to the surrealists that I shall be considering in the next section. But there is also another side to his art, his experimentation with pictorial possibilities and the laws of visual communication. In this he is comparable in a way to the logical positivists of that time, who were also very much taken up with the study of the meaning of words.

His influence has been great, especially on some of the surrealists such as Miro. His enigmatic depth, the frailty yet power of his works (small drawings, watercolours and a few paintings), his wit and his tragic sense, all these made a great impact. His feeling for colour is exceptionally refined. Yet there is a kind of ghostliness in his art, an almost magic force that makes his art modern in a very deep sense, the art of a man who knows about absurdity, chance, alienation and agony—a man who does the same things as Picasso, but in a refined, sophisticated, almost soft way that makes Picasso look brutal and barbaric. The titles of his works are fascinating and enigmatically irrational: they were often given after completion, or rather as the finishing touch to a picture.

Klee, *Zwitscher-Maschine* (Twittering Machine)
Museum of Modern Art, New York

His work almost always makes its impact through this interplay of title and image.

A friend of Klee, and fellow-teacher at the Bauhaus, was the man we have already discussed for his part in the development of art before 1920. Kandinsky had been in Russia, his native country, during World War I, and had even become one of the leaders in artistic matters after the Revolution. Soon however the Communist leaders became hostile to the modern art that was prevalent in the years round 1920, so that Kandinsky and some of the other modern Russian artists had to flee to the West. In Russia he must have been influenced by the suprematist movement of Malewitch and others, a movement parallel to that of Mondrian, but freer in its handling of straight lines. Back in Germany his art achieved a very specific geometrical quality, quite different from his earlier, more expressionistic type of abstract art. Yet in depth the meaning was the same. Look at the work reproduced here. There are geometric forms, but it does not seem to be rational. Rationalism had valued geometry very highly, almost as the basis of knowledge, because it seemed so completely rational and at the same time so completely certain and free from subjectivity and the possibility of human error. But time had shown that that certainty was not too certain, and that basically geometry and mathematics, despite their rationality, induced a problem: the how and why of their 'truths', their origin, the fact that they were so completely 'outside' man. As Gauguin had put it (in *Avant et Après*), 'of course, as everybody has always said, does say and always will say, two and two is four —but that bores me, and deranges much of my reasoning'. It became apparent that rationality itself was irrational. And this is exactly what Kandinsky painted: the irrationality of the rational.

Looking at the picture we see that, where once, centuries before, the Madonna had been in the centre of the picture, or possibly Christ, or a saint, standing for high principles in reality, or, later, man pictured allegorically as some ancient god or goddess—now stands geometry. Geometry is the basic principle of reality, but an irrational, strange and enigmatic geometry, like an esoteric, mysterious rite. And as we look again it seems as if the whole picture is exploding. There is a sort of volcanic, destructive force in this strange geometry. Science threatens man, and so is

Kandinsky, *Im Blau*, Coll. J. B. Urvater, Antwerp

destructive too. So, in a new way, such a picture is an allegory, a
kind of super-ornament that is yet much more than an ornament,
a play with forms that yet is loaded with menacing meaning.

The surrealist protest

The trend in the time between the World Wars was in general,
however, towards a more acceptable, a less fierce and thorough-
going modernism, a more human approach. Two styles were
predominant: one was a new kind of stylized, generalized,
classicist art, with some of the stylistic qualities of cubism taken
over without its deeper intentions. We could mention here the
work of Maillol, who was very popular in this period, or the

De Chirico, *Les Muses Inquiétantes,* Coll. G. Mattioli, Milan

painter Gromaire, or, in England, Eric Gill and John Buckland-Wright. Some of the more important architectural monuments of this time are the Town Hall in Hilversum by Dudok, the Museum of Modern Art and the new Trocadero in Paris, and London University's Senate House, to name just a few.

The other trend was more expressionistic, and even if the artists involved (such as those who contributed to the Dutch art magazine *Wendingen*) used symbolism in their art, as a whole it can be termed realistic. The sculptor Epstein is a good example of this trend, or we could pick out Stanley Spencer, Permeke, Chabot, and the many artists who belonged to the so-called Paris school which I mentioned in the last chapter. In architecture the works of the Amsterdam school, with de Klerk as its main representative, may be mentioned, or Mendelsohn's Einstein tower in Germany.

As a whole this period liked smooth forms, stylized shapes, predominant horizontals and verticals and the play with cubic volumes, all either in a more classical or in a more expressionistic vein, the whole pervaded with a warm romanticism.

Many adherents of the modern movement felt that its very modernity was thus betrayed and deprived of its real meaning. The modern forms were used out of their own context and became the patterns for fashionable decoration or for pretty pictures, or for the often pompous official or ornamental sculpture attached to new buildings (such as those at the Rockefeller Centre, New York, for instance).

But alongside these movements (and those of 'de Stijl' and the Bauhaus which were still strong), there was another major force: surrealism. This had its roots in the Dada movement and in some lonely forerunners such as de Chirico. Ideas, feelings, sentiments came out into the open that had been at work previously, but in a more concealed way. The work of these painters could perhaps be explained by saying that Mondrian and the others were building a beautiful fortress for spiritual humanity, very rational, very formal: but they did so on the very edge of a deep, deep abyss, one into which they did not dare to look. But the surrealists did look. For them fear, agony, despair and absurdity were the real realities. It was these they wanted to take up and express in their art.

Surrealism was born in the early twenties in France, and involved writers, visual artists and later also film directors, though perhaps it is the painters who have had the most lasting results. Yet surrealism is much more than a new style. Surrealism is no easy formula, not even a well-defined theory, and in the final analysis not even an artistic movement; it is a way of life and a direction of one's activity, an attitude of intellectual agony. Surrealism is revolutionary and destructive: the whole of western culture and its society are thrown away in a battle against all that exists, in a revolt against everything to which a bourgeois world had previously held firm. They were against nation, God and reason—particularly the latter. They were against personality, conscience, beauty as an aim, talent, artistry, even the very will to live. Marx, Nietzsche, Freud, Jung were their spiritual leaders, along with men like the Marquis de Sade, Lautréaumont, Rimbaud, Apollinaire. They had an interest in long-forgotten mysticisms, gnosticism, the primitive—the primordial as they called it. One of them wrote about the early years:

> 'I . . . will not soon forget the welcome mood of tonic absurdity, ironic subterfuge, gay as Satie's music, which pervaded them. Their featherweight bombs exploded into golliwogs and tinsel flowers. Surrealism, Dada's firstborn, was tougher, more doctrinaire. The view that the soul (if any) is divided into two compartments, like a Parisian autobus, was gaining acceptance, and the surrealists, needless to say, staked their all on the dark horse.'[3] ·

Their aim was a liberation of life, in every respect, to free man from this strange world that holds him in a thousand ways; on the basis of Freudianism they wanted to liberate man from convention, culture and society. The third issue of *La Révolution Surréaliste* said: 'Ideas, logic, order, Truth (with a capital T), Reason, all this is given to the nothingness of Death. You do not know how far the hatred we have against logic can lead us.'

This was a truly anarchistic movement. It sought complete freedom. Those involved were never able to work together with the Communists, even if some efforts were made to bring the two revolutionary streams together. They were looking for freedom, complete freedom. Yet their works, full of overt or concealed erotic symbolism, were also full of irrationality, absurdity,

[3] Stuart Gilbery in *Transition*, 22, 1933.

alienation, sadism, evil and hell, the horrific, black humour. The basic motifs of their work were man's *échec*, his failure to gain true freedom and true humanity, the fact that he is a stranger in this absurd reality that he experiences as a prison, as frustration, as an obstacle in his way through to himself. French existentialism found in it one of its roots, and gave it a rational, philosophical base: Sartre was in the group in the thirties, and Camus also had contacts with it.

Surrealism was a movement. As such it was confined and restricted. Its specific forms belonged to this period and to this group. Yet its influence has been great, and it has pervaded much of the expression of our age. Almost all artistic activity since that time has had some sort of surrealistic tinge.

In the wake of surrealism came, too, the attempt to make a new language as a tool for the expression of new feelings and experiences. The Dada group, as well as the surrealists themselves, had already worked with strange new irrational ways of verbal expression. The most extreme were the poems by Dadaist Kurt Schwitters, such as the following:

> Bumm bimbimm bamm bimbimm
> Bumm bimbimm bamm bimbimm
> Bumm bimbimm bamm bimbimm
> Bumm bimbimm bamm bimbimm
>
> Bemm bemm
> Bemm bemm
> Bemm bemm
> Bemm bemm
>
> Tilla loola luula loola
> Tilla loola luula loola
> Tilla loola luula loola
> Tilla loola luula loola
>
> Grimm glimm gnimm bimbimm
> Grimm etc. etc. [4]

Quite different, and more well-known, are such writers as James Joyce in his *Ulysses*, Kafka in his story of the man who became a spider or in *The Trial*, Henry Miller in his *Tropic of*

[4] From *Ursonate* (Merzverlag, Hanover).

Cancer. Many French writers belonged to this movement even if they were never members of the group as such. Amongst the painters were such men as Max Ernst, Miro, Tanguy, Magritte, Dali, Masson, and many others.

What drove them on in this way? Perhaps the best way of expressing it would be to quote at some length from the high point of Miller's *Tropic of Cancer*, where he comes to a mystic ecstasy:

> 'There are always too many rotten pillars left standing, too much festering humanity for man to bloom. The superstructure is a lie and the foundation is a huge quaking fear . . . Who that has a desperate, hungry eye can have the slightest regard for these existing govern-ments, laws, codes, principles, ideals, ideas, totems and taboos? Out of nothingness arises the sign of infinity; beneath the ever-rising spirals slowly sinks the gaping hole . . . I see that behind the nobility of (man's) gestures there lurks the spectre of the ridiculous-ness of it all . . . he is not only sublime, but absurd. Once I thought that to be human was the highest aim man could have, but I see now that it was meant to destroy me. Today I am proud to say that I am inhuman, that I belong not to men and governments, that I have nothing to do with creeds and principles. I have nothing to do with the cracking machinery of humanity—I belong to the earth! . . . A man who belongs to this race must stand up on the high place with gibberish in his mouth and rip out his entrails. It is right and just, because he must! And anything that falls short of this frightening spectacle, anything less shuddering, less terrifying, less made, less intoxicated, less contaminated, is not art. The rest is counterfeit. The rest is human. The rest belongs to life and lifelessness . . . If I'm unhuman it is because my world has slopped over its human bounds, because to be human seems like a poor, sorry, miserable affair, limited by the senses, restricted by moralities and codes, defined by platitudes and isms . . . It may be that we are doomed, that there is no hope for us, any of us, but if that is so then let us set up a last agonizing, blood-curdling howl, a screech of defiance, a war-whoop! Away with lamentation! Away with elegies and dirges! Away with biographies and histories, and libraries and museums! Let the dead eat the dead. Let us living ones dance about the rim of the crater, a last expiring dance. But a dance! . . . The great incestuous wish is to flow on, one with time, to merge the great image of the beyond with the here and now. A fatuous, suicidal wish that is constipated by words and paralysed by thought.'

What has become of man? Miro once painted a picture of a picture. He took a reproduction of a secondary seventeenth-century Dutch picture (it could just as well have been a Vermeer

or a Rembrandt) and gave his own reinterpretation. Nothing is more telling. Man is dead, it says. The absurd, the strange, the void, the irrationally horrible is there. The old picture is treated with humour, scorn and irony—black humour and devastating irony—until nothing is left. As the image is destroyed, so too is man.

In surrealist painting there are two distinct styles: one abstract, the other 'concrete'. In the latter we are confronted with meticulously precise painted images, 'normal' as far as technique goes: but what is realized is a world that is strange, abnormal, irrational, not so much a nightmare as a horrible day-dream. It is as if they put a mirror in front of us and ask us whether we think this strange—whether the world we think to be normal is not really just as strange, as irrational, as absurd, as this. This way of painting was started by de Chirico just after 1911: he painted deserted and haunted places, alienated men, as inhuman as puppets, sitting in the middle of boxes with biscuits and the tools of the mathematician, or talking together in a silent dialogue amidst an endless and incongruent space. Man become inhuman—or subhuman, if you like—is a displaced object in an estranged world.

Salvador Dali's works, with their more Freudian overtones, were done with a morbid imagination, and with superb draughtsmanship. Magritte and Delvaux have a comparable message. Or there is Max Ernst, whose most typical works are his strange collages: figures made from cuttings out of nineteenth-century illustrated magazines, disorganized, disproportioned, irrational in an irrational world.

All this art showed a world out of order. It brought things together in a haphazard way that gave them as it were a new life, a new absurd and irrational meaning. It is as if we see these things with new eyes. Here we see them 'as they are', 'in themselves', out of any rational or structural context. They get a new life . . . haunt us and dislocate us . . . With the *objet trouvé* or the collage, as well, we find things brought together in a new nonsensical and yet poetical order, and we are confronted with reality in surreality. In the final analysis what we are being confronted with is the material world, the very stuff we are made of—and it appears a phantom, an irrational, meaningless and

nevertheless obsessive reality. That they often did achieve this effect shows their artistry, their great imagination, and sometimes surrealist works can look almost natural. But the title of a landscape I came across recently is very telling:[5] 'Abstract Vision in Form of a Spanish Landscape'. This is alienation—what looks real is unreal. Man is a stranger in God's creation.

The other line was the abstract surrealism of men such as Masson, Matta and sometimes Miro, Ernst or Yves Tanguy. Here the drawing was often done in a dream-like way, as if the artist was a medium who just drew as it seemed to want to go—like surrealist writers who sometimes wrote their poetry in this way. Strange, unknown and yet evocative symbols appear, a sort of poetic reality. But this is no ideal spirit-world, no paradise. On the contrary. It is the image of hell, a confrontation with the haunted, the evil, a feeling of 'floating in an empty space', as if being itself collapses and falls to its utter destruction.

Surreality and Christian reality

Buñuel, the surrealist film-maker, shows that man's attitude to man is like that of a scorpion to a scorpion: eternal, cruel war. His pictures are like de Sade's *Justine*; even the best intentions always lead to disaster, to sin, pain and putrefaction. Why? He said: 'Because man is not free.' Because there is no justice. Because this world is wrong and rotten . . . There is no way out— except perhaps by an anarchist revolution. But one senses that Buñuel does not even believe his own dream at this point . . .

Surrealism demands that we pause here, for we cannot simply describe it and leave it at that. Perhaps the Christian especially is troubled as he hears in it an echo of the Bible's realism about the world, and yet, and yet . . . Is surrealism, is all that is expressed in modern art, really the whole truth?

The picture the Bible gives is in one way certainly even less pleasant. It is not rose-tinted, blindly optimistic. It does not tell us that everything is fine: it says that the universe groans in pain as it looks forward to a future deliverance, that the whole of

[5] By Mati Klarwein, 1963, reproduced in R. E. L. Masters and J. Houston, *Psychedelic Art* (Weidenfeld and Nicolson, London, 1968), plate 58.

creation is now in the bondage of corruption[6] It points not just to the condition of the world, but also to the reason for it. As Isaiah put it,[7]

> 'The earth mourns and withers,
>> the world languishes and withers;
>> the heavens languish together with the earth.
> The earth lies polluted
>> under its inhabitants;
> for they have transgressed the laws,
>> violated the statutes,
>> broken the everlasting covenant.
> Therefore a curse devours the earth . . .'

So the Bible is very realistic about sorrow, pain, evil, hatred, jealousy, cruelty, unrighteousness and human misery. But the Bible makes it clear that the cause is human sin. It was not only the Old Testament prophets who were scathing in their denunciation of it, it was Christ Himself, too, and the early Christians, such as Paul in his devastating analysis of human corruption in the first chapter of his letter to the Romans. There were always those that scoffed at God, as Malachi pointed out in Old Testament times and Peter in the New Testament, for they could not see Him at work. But they will know that the wrath of God is kindled against all unrighteousness and that the hills will tremble and the carcasses will be torn in the midst of the streets . . [8] If God seems to withdraw and let men go their own way—for the time being—in a way this is even more terrible: for the God who hides Himself is also the God who will judge. God has given man such tremendous possibilities in the creation He has made. Yet men have misused them, wrecked them, turned their backs on the God who has made them. Yet God loves them and because He loves them, because His holiness and His love are absolute, He cannot look on evil . . .

There would seem no solution. An anarchist revolution will change nothing, for it will not change sinful man. There is no solution—but for redemption, for man to be saved from the consequences of his sin by the death of Jesus Christ. For it was to bear the curse on man's behalf that Jesus Christ went down into death.

So the surrealists' view of reality is in a way more akin to the

[6] Romans 8: 19–22. [7] Isaiah 24: 4–6, RSV. [8] Isaiah 5: 25.

Bible than that of optimistic humanism. But the Bible in which
God has revealed Himself speaks of a way out. Of those who
refuse the way out, those who cry out in anger against the evil of
this world, but yet see evil as ultimate reality, the psalmist says:
'The fool says in his heart: "There is no God." They are corrupt,
they do abominable deeds, there is none that does good.'[9]

Certainly the surrealists share the realism of the Bible. Buñuel
and the others echo the words of the old 'preacher' of Ecclesiastes,
who looked at the futility and desperation of life around him,
and at the final end of man: 'the hearts of men are full of evil,
and madness is in their hearts while they live, and after that they
go to the dead.' They also share the Bible's standpoint by not
accepting death and evil; for Jesus Christ did not accept it,
either: He was 'deeply moved in spirit and was troubled' when
He came to Lazarus's grave, He was angry with the merchants in
the temple because of their sin and greed in fleecing the poor in
the name of religion, and He warns us that there will be strife and
labour, for He never preached a sentimental peace. Though the
surrealists may hunger and thirst after righteousness, their fear
and agony comes precisely from the fact that they cannot see
how it can be achieved. For they know nothing of love and beauty
and real mercy.

The Bible is not less but more inclined to speak of the evil of
this world. Suffering is a reality. If we read the book of Revelation
we see something of the world of today in which we live—and we
hear the repeated message of 'Woe' unto the inhabitants of the
earth. Yet the Bible is no black book. It is not just pessimistic. Nor
does it preach the agony and the absurdity of the surrealists.
Black humour, the sick joke, irony, pulling things down for the
sake of it, the erotic as an ultimate value, these are not found in the
Bible. For the Bible does not see man as imprisoned in a world in
which there can be no love and in which nature is the enemy of
man.

It shows us that at the beginning of all history God said that
His creation was good. Nature itself is to the praise of God, and so
clearly does it reveal Him that Paul can say in Romans 1 that man
has no excuse for not accepting Him and for turning instead to
what he knows to be evil. No, God hates unrighteousness far more

[9] Psalm 14: 1.

than ever man did. And Christ came for the very purpose of breaking through the reign of evil and sin and suffering, He came to make the world normal. And God must come in judgment because without it this world would be absurd, and love would have no place.

Buñuel and the other surrealists come to us and say, Protest against evil by doing evil, hate God and your fellow-men, the world can only be redeemed by revolution, terror and the tearing down of everything that is still standing. Christ comes to us and says, Seek your peace in Me, know a new, eternal life which will work itself out in this life, in loving your neighbour, showing mercy and humility, hungering and thirsting after righteousness. It is a revolution, not of terror, but of love.

To the surrealists, in their rejection of the God of the Bible, His creation has become a strange prison, irrational, full of agony and fear, a place where they feel they do not belong. They long for a better world in which the absurdity does not exist, not under-standing that it is sin and hatred and cruelty that is the real absurdity, alien to the creation as God made it. They long for freedom, but seek it in man himself, by opening their inner self, their subconsciousness—and so have lost it. Because they have rejected the transcendent God, they are bound to the immanent —and they know it. Again and again God warns man through His prophets not to forget Him; now we can see why. There would be truth in the surrealist affirmation that this world is hell —if there is no God. But it is a lie, for there is a God; it is a lie because there is beauty and truth for whoever wants to see it; it is a lie because man knows that love and righteousness are possible, and, thank God, belong to the true, real reality.

The real and the horrible

The challenge of surrealism forces us to react. But its themes are expressed all around us today: it is but one expression of man's alienation from reality, his sense of absurdity. Here we must return to Picasso, for his varying styles illustrate the tension of the age.

Picasso's great break through the boundaries of reality took place around 1911. Afterwards he painted absurd man, absurd

reality; man made up of some planks; man as non-man. This was what I would call Picasso's first 'horrible' period. But, even so, he was a great man and no mere dogmatist. When he painted the woman he loved, he was free to paint her rather differently. Loved ones cannot be absurd. So in 1915 he painted Olga in a 'normal' way, resembling an Ingres portrait. Even here love breaks through barriers of absurdity and lostness. Again and again in his life we see Picasso returning to a more 'loving' and free expression when he loves a woman. Unfortunately it did not often last very long.

Since 1915 he has had two styles, one more classical, the other more absurd, more cubist. But even here his expression tones down, and the paintings are more decorative than statements of absurdity. Yet even his classicist paintings have some disquieting elements for those who look closer. But generally Picasso followed to some extent the trend of his time to a more realistic and less agonizing art.

But in the mid-twenties, influenced by the Dada and surrealist movements, he again produced pictures in which beauty was lost in the quest for the 'disagreeable form'. Haftmann in his book *Painting in the Twentieth Century* states that the 'Tree Dancers' (in the Tate Gallery) was the first in this line, near to surrealism. To describe it he uses words and phrases such as convulsive, hysterical, new associations that always seek to hurt, masks, crying forms, absurdity. This is the beginning of what I would call Picasso's second 'horrible' period. Its masterpieces are several pictures of bathing girls on the beach. Look at the girl in the picture reproduced here. She is painted in an almost normal way, as any classicist would have done. But how has she been painted? She is made up of bones (for man is dead). But she still has sex. She is like a machine, a horrific machine (isn't man really a machine?). Yet she looks down at us in a superior sort of way—it is an indication of Picasso's greatness that he can achieve this—as if she were saying to the person looking at the picture, 'I'm much greater and more human than you, aren't I?' These pictures depict extremely forcefully the way twentieth-century man looks at himself and understands himself.

In the thirties Picasso became more 'friendly' again—and more erotic and sensuous. Once, enraged by the Spanish civil war, he

Picasso, *Bather* (Rights Reserved SPADEM, Paris)

painted his most human work for many years, his 'Guernica'. It is a depiction of war: and here agony, distress, evil and sorrow are real, caused by real reality. But there are questions which remain unanswered: were Picasso's spiritual friends, the communists and the anarchists, really more friendly themselves, and less inclined to use terror as a weapon? And if he is protesting, against whom is he protesting? The fascists? Or against the world as such? Is it not a cry for revenge rather than for repentance? It is Picasso's most human work; but it is enigmatic, and its symbolism far from easy to understand.

Around 1940 another 'horrible' period begins. Now a whole gallery of female heads is created, each more absurd than the last, with strange double faces, horrible grimaces. Why? It was Picasso's answer to the critics of his time, who began to accept him by toning down the content, saying that he was just using a new style, a new way of representing, suggesting that the content of his pictures was the same as traditional painting. They explained his forms by saying that he used the cubist technique in order to show things from different sides at the same time. This of course was seldom if ever true of Picasso (though might have been the theory behind some of the lesser cubists). Picasso, hearing his true expression thus deformed and made soft and almost positive, now began, in his disgust and anger, to show what their words really meant. The horrible series of heads are made to fulfil exactly the theories of the critics. This is a face shown from two sides at the same time—Picasso seems to cry out, look, it isn't nice and sweet, it isn't normal reality, look, you fools . . .

At about the same time Picasso wrote a play called *How to Catch Wishes by the Tail*. It is one of the most absurd pieces of theatre ever written, more absurd than anything the theatre of the absurd has conceived. It was read publicly in 1944; the cast consisted of Simone de Beauvoir, Jean-Paul Sartre, Leiris and others of the group led by Albert Camus: existentialist philosophy and Picassian surrealism belong together. At this time too Picasso began his series of reinterpretations of old paintings. He took Courbet's 'Girls by the Seine' and remade the picture in his own style, not to prove that the critics were right but to show what the picture really meant—or to show what was left of humanity. He took Velasquez's 'Las Meninas', a picture of the Spanish royal family (in the Prado, Madrid), and painted both the whole and the details in his own way—in a kind of artistic anarchistic murder of the whole royal family and their way of life.

Then there are his series: the bull, Balzac, a girl's head, and others. The series would begin with a 'normal' drawing, and then he would begin to change it, each picture going further than the last. It gets more cubistic, loses more and more of its normal appearance, is reduced to almost nothing. In a film that was once made of Picasso he went on after one such feat, and starting from

Picasso, *L'Indicatif Présent*
etching from *Poèmes de Luc Decaunes,* Paris, 1938

the last, almost abstract drawing turned it into something else. It was clever, obviously the work of a man of great talent and imagination. But it is more. It shows that he does not stand behind any of his styles. An artist's style expresses his personality, his views, his character, his understanding. So normally a man's work will show basically the same style, or at least a consistency before and after a break in the development of a style. But Picasso, being a true nihilist, does not believe in any such view: each different approach is taken up and discarded, changed and then discarded again. He can believe anything, look at things in as many ways as he likes, for everything is possible, even if they are mutually exclusive or contradictory, for there is no one true way. [10]

A different twentieth-century response

Is Picasso really *the* man of our time? History textbooks tend to show us history as pursuing an inevitable course, with artists expressing the spirit of their age. What is often not made clear is that the schematic simplicity of a period as it appears in the textbook shows only the main lines. History is more complex, and any number of different streams can be found side by side. It is important to realize this: it means that man has the freedom to choose, and that he therefore can be accounted responsible for his actions.

Is Picasso the man of our time? To a certain extent, yes. He brought about the end of a period, the time of the Enlightenment, by breaking through the reality-barrier. He was and is the exponent of a trend that has grown increasingly since the beginning of this century, and is becoming (or has become) the main stream. But though Picasso is certainly the man of our time, responding to some of the great questions of our period, and formulating a new way of approach with his answers, that does not mean that there are no other possible answers, or that no other direction of thought and action can be taken.

Georges Rouault is a proof of this. He is of the same generation as Picasso. In his younger years he was influenced by a movement

[10] Cf. H. P. Raleigh, 'Value and artistic alternative: Speculations on choice in modern art', *Journal of Aesthetics and Art Criticism*, 27, 1969, pp. 293 ff.

within the Roman Catholic Church that looked to more sincerity, more real faith, less traditional forms, to what we have come to call in our century authenticity. This movement, as is natural for such a Christian endeavour, was very critical of its period. So Rouault began to paint judges, prostitutes, upper-class people and so on in a rather aggressive way. He is a contemporary of the fauves and the cubists, but he is different. His prostitutes are not amoral beings, symbolizing the end of morality as such; they are symbols for prostitution, for cheap love for sale, for the depravity of his time. His judges are akin to those of Daumier: they stand for the corrupt courts of his time. He prophesies against the times in which he lives.

Yet his figures are still symbols in a negative sense. Only in the twenties does he come to a more humane—not humanistic— point of view; compassion, charity, love come into his work. His greatest achievement was the series of etchings—done with a very intricate special technique—called 'Miserere'. Its plates depict war, love, man's pride and weakness, suffering and sacrifice, with Christ as Redeemer—in fact, it shows humanity in a variety of aspects that is fantastically rich in comparison to Picasso's Bathers, painted at about the same time: these show only mankind destroyed, and all the fine nuances and complexities of life are missed.

Rouault shows that another kind of art is possible. It is an art which is a positive answer to absurdity and surrealism and existentialism. Yet it does not show the rosy sentimentality, more humanistic than human, that much so-called Christian art has produced.

Rouault has shown what it means to believe in God and to love man in this age. And we must be thankful. Why did many Christians miss it? And where is the Protestant counterpart of Rouault? Most Protestant artists still worked along traditional lines, either Victorian or impressionistic or following a sweetly symbolistic line.

Why did Christians miss it? Why were they fooled by Salvador Dali when he made his strange, mystic works? Dali's 'Last Supper' portrays a very mystical celebration of the sacrament, with a ghost-like Christ (one can look through Him). His 'Crucifixion of St John of the Cross' was named after a heretical

il serait si doux d'aimer.

mystic of the sixteenth century who had this strange conception of a cross hanging over the world but not touching it. Did Christ not die for *this* world, for the people of *this* earth, including their material concerns, their daily needs, for normal human life, or was His work spiritual in a solely mystical sense, out of this world? It is doubtful whether Dali was ever truly Christian rather than no more than surrealist. He only introduced mystical elements taken from a heretical (but not biblical) tradition. For mysticism in one way or another was always part of the surrealist approach, which was as much 'gnostic' as nihilistic. Were Christians misled by Dali's seemingly traditional way of painting which was, superficially speaking, naturalistic? Or were they themselves caught up in an unbiblical mysticism?

So, following the Second World War the modern movement made great headway. Not every young painter went this way, though a great number did. And those who did not were simply considered old-fashioned and out of the game. And in the years since, more and more painters, both those of the older generation and also those of the younger generation who first went in other directions, were won over and became abstract painters of one kind or another. Modern art has won the battle.

Rouault, plate from *Miserere* series

Chapter seven

MODERN ART AND THE TWENTIETH-CENTURY REVOLT

I do not paint, I hit.
Painting is destruction.

Karel Appel, *Poème Barbare*

AFTER HALF a century of hard and devoted activity, the modern school has won the battle. They have not won cheaply. They have won partly because their opponents have not fought them on proper grounds. Many did not take them seriously or laughed at them, or thought it a passing whim or fashion. Others tried to avoid the real battle, tried to be 'in' and 'with it' (or whatever the current phrase was) without taking issue, just by saying that modern art was a new style, a new way of depicting reality. These tried to turn modern art into a new 'normal' art, in the old humanist tradition. But very few really went into the heart of the matter and tried to see what lay behind it.

At the beginning of modern art the public had reacted violently. Kandinsky relates how in 1912 at an exhibition of his work in Berlin people spat at his pictures. Now, he said in 1936, people do not do that any more, they say: 'Isn't that nice?' And, he added, the change does not mean that times have become easier for the artist.

The question is, what had happened? Perhaps the more human, less extravagant trends of modern art in the twenties had softened people up and made them more susceptible to it. Perhaps they began to realize that at least the modern artists were struggling with problems that were really relevant to the period in which they lived, and appropriate to their own cultural situation. More probably they began to understand that the current streams of non-modern art were none too strong and often had no adequate theoretical or 'spiritual' basis. The real creative forces were not there. Humanism had lost its deep grip on people, for its main principles had turned into problems.

Modern art in its more consistent forms puts a question-mark against all values and principles. Its anarchist aims of achieving complete human freedom turn all laws and norms into frustrating and deadening prison walls; the only way to deal with them is to destroy them. Now this principle has a curious side-effect. If we see a work that in its way destroys meaning, and says to us that there is no real sense, it not only makes it hard for us to see the value of the reality depicted in this way, but this very message turns against the painting itself. After looking at a Baj painting of a general, it would be hard to have real respect for a general if you met one afterwards, for his office has been downgraded. But the meaning of the picture itself also becomes downgraded and loses its power. So you see people walking through an exhibition of modern art, and you would expect them to be enraged, for sometimes things which are quite holy to them are being taken to pieces—but they walk on amused, or even hardly interested. For the message itself has no longer any meaning. Anything will do.

Not very long ago the absurd play by Picasso that I have already referred to was played at St Tropez in the South of France, complete with all its obscenities and worse. For instance, a woman urinates in the middle of the stage, with the sound amplified. But to the dismay of the producers nobody stirred, nobody walked away enraged, nobody seemed shocked. There might have been some snobbishness in this—today everyone has to accept things like that, especially when a big name like Picasso is behind it—but it may well be too that the defiance of all sense of propriety in a completely absurd 'plot' made these actions in themselves senseless and so defeated its own end.

This does not mean that modern art has no influence. Even the well-meaning ignoramus walks through the gallery of modern art with a question mark: is this art, what does it mean, why do they do it this way? Even he is reached, perhaps against his will or without even realizing it, by one message: look, these things are works of art, and a thing like this really means just as much as 'your' Rembrandt. Or, rather: these may not be works of art, but yet they are brought here and considered important: are all the old values really gone and meaningless today? 'Your' Rembrandt speaks of another world that is dead and gone . . .

And so even he comes out with something destroyed, or at least wounded.

There are still people who think they can bypass these things, can ignore them. Sometimes people are still enraged—but in being thus hurt they feel at the same time they are old-fashioned, and out of touch with what is going on.

Modern art has won the battle. The galleries of modern art see it as their task to inform people, to educate them, to bring them up to date, and, rather idealistically, to promote modern art. Unhappily they side with the modern movement, either out of a deep commitment to its meaning and aims, or from an optimistic humanist attitude that this is the new culture, and humanity must find its way through this crisis; or sometimes they may even do so without realizing what they are really doing. But, whatever their motive, they are all promoting one main stream. Sometimes one even has the feeling that this modern movement has become the official art of today—and that some of its products are nothing more than a new Salon art, as superficial and as shallow as that of the last century.

Modern art has won the battle: that means that other streams are sometimes ignored, and that artists who do not follow the trend are bypassed. They have a hard time, even if they are first class. Or, even if they are sometimes shown, their work has lost its force because of the 'side-effect' of the more far-out art I have described.

The fact that modern art has won the battle also means that it is known and available everywhere. For many before the last World War modern art did not mean very much. Now, and certainly for the younger generation, things are different. The great names of the modern movement are well known, exhibitions all over the world have made their art familiar, books, articles and lectures about the different schools or representatives are in every bookshop. James Joyce's *Ulysses* can be bought as a paperback on every bookstall; even de Sade's works, together with many other 'classics' of pornography, are available without difficulty and for low prices. Films are even made of such works of literature. The great breakthrough has probably only taken place since 1960, and certainly as the result of the renewed and vigorous activity of the modern movement's supporters. If in the

wake of this avalanche of modern work of all kinds there is a strong anarchistic trend among the younger generation we must not be surprised. These men speak about real things that belong to our age, and give insight and meaning—even if in a negative sense. The revolution which the great men of the modern movement have been dreaming about in the past three-quarters of a century is beginning to be realized.

The modern movement has won the battle. It has done so too because many were not alert. Christians have clung to tradition and fought little battles with their fellow-Christians. They have only too frequently not understood that art and literature, philosophy and even popular music were the agents of the new spirit of the age, and have left these alone or optimistically assumed they were too remote to be of influence. Humanists, in a bourgeois mentality, optimistically felt that this gloomy existentialist stream was only a passing whim : the tide will turn, for man is basically good . . . Or they too ignored the movement or underestimated its influence.

The only Christians who did not ignore modern art were an intellectual group of liberals, who took side with the new movement, often even claiming modern art as a new religious art.[1] Otherwise Christians of all types and kinds and shades of orthodoxy bypassed the modern movement in art and thought, and, what is more serious, did little to solve the problems of our particular times: the problems of mass-man, of modern communication, of technology squeezing away human freedom, of the lack of a true foundation to culture. The basic principles of the Enlightenment have proved to be false gods, but there were no new ones with which to replace them. Why, even the true and living God was dead—or so some of the theologians said. Certainly Christians were active in helping people—and in preaching salvation. And, happily, people were sometimes saved, thank God. But the main problems of our culture were not tackled. Yet they were true problems.

[1] See, for instance, F. Eversole (Ed.), *Christian Faith and the Contemporary Arts* (Abingdon Press, Nashville, 1962).

Abstract expressionism

The modern movement won the battle. Now we must see what they had to offer. After the war, there was initially a silence, but soon things began to happen, and first in Europe. There was a group of young artists from Holland, Denmark and Belgium who called themselves Cobra. It was a new form of expressionism, wanting to renew art and life by giving free way to creativity. 'Everybody can do it!' 'Create!' And they did create, with child-like non-rational works, direct and uninhibited, free and un-ashamed. They wanted to be like children, innocent, free from the tarnish of a culture which had become too old. Their works were less aesthetic than those of the expressionists of the beginning of this century, and there was a surrealistic tinge here and there. Some Dutch artists, among them Karel Appel, who gained international fame, were of most importance. For the first time such a new movement had a chance to come immediately as it were into the limelight and be officially recognized, in a large exhibition in the Stedelijk Museum, the gallery of modern art in Amsterdam.

In America, after long years of preparation, there was the explosion of a strong modern movement. In it were such different artists as de Kooning, who painted women, sex-bombs without beauty or femininity, utterly horrifying demolitions of the woman image, Guston, Rothko, with his large abstract compositions made up of 'soft' rectangles, Arshile Gorki whose art was not without surrealist overtones, and of course the most influential —Jackson Pollock. In the mid-forties he had come to his 'drip-pings'—large canvasses that were painted 'abstractly' by dripping paint on to them from a can as they lay on the ground, the end of a development in search of a contentless art. De Kooning said of it:

> 'Every so often, a painter has to destroy painting. Cézanne did it. Picasso did it with cubism. Then Pollock did it. He busted our idea of a picture all to hell. Then there could be new paintings again.'

Rudy Blesh in his *Modern Art USA* (New York, 1956) relates how it began:

> 'Everyone had been talking about "a way to get the explosive moment of creation on the canvas". (He) had just done it: simply

Karel Appel, litho in *Reflex*, organ of the Experimentele Groep in Holland

turned the paint loose in the air without a parachute. A violent Duchamps, not gravely accepting the "laws of chance", but flinging the door open to chaos . . . (But) order marshalled itself in all that wilderness. Those violent forces—the whirls, the plunges, the thrusts—began to float in an equilibrium of violence against violence . . .'

Kline, Clifford Still and many others made up this new American school of painting, full of variety, yet one in its modernity. They called it abstract expressionism. This title described rather well what most of the artists did. Of course some were different, such as Mark Tobey on the West Coast, who quietly reflected in his art the spirit of Zen Buddhism in his abstract repetitions of little forms—always the same and yet always different, a continuous mystical pattern.

The skeleton of Achilles

In studying these artists and movements one is struck by a paradox. There is a great upsurge against rationality, against the calculated and the finished form. It is a search for the free, direct expression of personality in order to find something more than personal, the mystical all, the ideas behind the discarded 'outward' reality which was deemed unworthy. It is a search for something more, something different from what the rational can encompass—in one word, the irrational. Yet no art has been more philosophical than this art. It was an art by thinkers for thinkers. It involved much discussion by the artists, and even more by the public, or at least the informed and interested public.

In Europe artists from many countries took part in the new movement, many of them working in Paris. Matthieu was elaborating — and somewhat commercializing — the idea of throwing paint onto the canvas in his large abstract signatures; Poliakoff was working more calmly at his abstract coloured canvasses; and we could name many more. Especially important was Dubuffet, whose 'Art Brut' brought together some elements from the Cobra movement with a magic mysticism that looks for the primordial, the not-yet-formed, the just-being-formed, and wandered into the depiction of material itself, confronting us with it in its bare existing self in a way comparable to the abstract surrealists. Later he made his *hourloupes*, strange, coloured, outlined, interlocking fields that mean nothing and yet irrationally evoke forms of men, men become one with the surrounding fields, a great mystical union in colour and shape, but just the opposite of a quiet *nirvana*, more of a hectic hell, apparently gay, but . . .

Sculpture up to the middle of the century had kept to a more or less classical style, with the exception of some modernists such as Zadkine and Lipchitz, some surrealist abstractionists such as Arp, and some constructivists who made strictly geometrical shapes that yet seemed free and fantastic. But now, in these years following the middle of the century, a great flood of destruction entered sculpture. Wotroba's lying figures decayed and fell into ruin—or this is how it seems when trying to follow his development. Germaine Richier made her strange 'primordial' figures,

natura naturans, man being a chance product of material just beginning to take shape.

In the later fifties there was a movement toward 'junk-sculpture', figures welded together from *objets trouvés*, things found at a rubbish dump. Paolozzi made figures like ancient gods, but yet at the same time like discarded pieces of junk, as primordial machines, absurd and yet with a certain kind of primitive sacredness, but very modern and twentieth-century.

In this same period a kind of 'junk-painting' was of importance. Paul Buri, Tapies and others made paintings of sack-cloth with holes in it, with pieces of metal or wood stuck on, like a new kind of collage, in a neo-Dada style. Perhaps one of the most important artists in this group was Rauschenberg, an American who made large paintings combining real *objets trouvés* with old posters or papers or illustrations with brush strokes superimposed in a way comparable to that of the abstract expressionists. He said: 'A pair of socks is no less suitable to make a painting with than wood, nails, turpentine, oil and fabric.' About his 'Allegory' Andrew Forge wrote (in the catalogue of an exhibition in the Amsterdam Stedelijk Museum, 1968):

> 'It is one of Rauschenberg's most extreme achievements. What is extraordinary is the way in which such powerful, aggressive forms as the metal, as the umbrella are brought to terms with the picture surface. And yet they remain self-contained, intact. None of the affinities or correspondences I have listed lead to the dominion of one form over another. Things, passages, live side by side as equals, free to expand, to breathe, to display, unassailed by the "personality" of their neighbours or by some overriding and generalising intention. The calm sun-like frontality of the umbrella is undisturbed by the metal's brittle vigour—although it is not indifferent to it. Nor is the energy of the metal curtailed by the umbrella's stillness. Allegory could indeed be an allegory of freedom, of self-determination, of a good city.'

Or, I should like to say, of a shabby world in which all things are of equal value, but no great values persist . . .

Yet there is some mysticism in this neo-Dada world. Rauschenberg says (in the same catalogue):

> 'The logical or illogical relationship between one thing and another is no longer a gratifying subject to the artist as the awareness grows that even in his most devastating or heroic moment he is part of

the density of an uncensored continuum that neither begins with nor ends with any decision or action of his.'

Neo-Dada was near to a kind of neo-surrealism. It exalted the chance-product: the artist's jottings or the random throwing of paint onto the canvas, a creative process in the line of the surrealist writers of the twenties. In the fifties it was called 'Informal art' or 'tachism'. A very intelligent German painter, Hans Platschek, has written about it, analysing its sources and meaning. Besides Picasso and the Dada and surrealist movements he mentions Jackson Pollock, Dubuffet and Wols. He says about the latter's work:

> 'The "sick" paintings are yet also signs of a reality that is felt to be rotten and inappropriate, one whose unity is denied. With the destruction of elements of form appears at the same time a destruction of structures and signs of a reality—at least in the painting. The destruction of real objects is not possible, and so their images are questioned . . .'[2]

In all this type of art the onlooker is asked to be active. He has to 'go into the picture', and in a kind of irrational, completely free action get his own meaning out of it. In a way the painting is the catalyst that gets our mind at work, gets us in touch with the irrational forces of reality. And in this way it affects our way of seeing and experiencing reality. And it really does so. Rauschenberg is right when he says, 'If you do not change your mind about something when you confront a picture you have not seen before, you are either a stubborn fool or the painting is not very good.'

In fact, confronting these works of art, we cannot escape the fact that our own view of reality is challenged. Inevitably we are drawn into an argument with modern man about his ideas, about values, norms and ultimate truth, about humanity and our responsibility to help build the future world. These are deep and difficult problems, undoubtedly. But the positive good in this art is that it makes all cheap answers, all worn-out traditions, all ideas that are not firmly based in real truth, pale and useless and senseless.

[2] *Neue Figurationen*, 1959, p. 79.

Arman, *The Skeleton of Achilles,*
Art Museum of Ateneum, Helsinki, Coll Sara Hildén

One thing binds all these groups and arts together: the assertion that reality is at stake, that it has become a question-mark, that it seems to be something man cannot be happy with, something that is strange to him. Crisis, alienation, absurdity, it is words like these which describe the artistic situation. There is an underlying 'philosophy', one that can be called a renewed kind of gnosticism, saying that this world is wrong and man ill-fated. This is nihilism and at the same time a new kind of mysticism, reaching out for the depth behind appearances, the truth through the squalor and the destruction. Or, to put it another way: we see in this desperate search how true Paul was in his letter to the Romans (see 1:21ff.).

One has to begin to see that there is truth in it—no man can work without having at least some grounds to start from, some assertion that holds when confronting reality. The old humanist images are faded, and old values generally are often no longer of much use as they do not answer present-day problems. And in the midst of this men are searching for new forms and new answers. Perhaps a new culture is growing that can come into being only when the old civilization is completely destroyed. But if things continue the way they do the new culture will be neither humanist nor Christian.

The situation can be summed up with Arman's box of shoetrees. Of course, there is no denying that these *objets trouvés* are arranged in an artistically accepted pattern. There is certainly nothing against the use of unorthodox materials, and I should like to think that the whole is an abstract work of art. But then we should miss the real content of the 'picture'. Shoetrees are junk, and the garbage man would throw this thing away without any feeling of remorse. Yet this work still belongs to the old western tradition that art is bound up with the deepest things in life, that it reflects and expresses a particular view on life and its deep ultimate values. Here we see what is left of the old allegories of Venus and Achilles and the classical figures that have stood for humanist values for so many centuries. Venus and Achilles died in the eighteenth century; they were buried in the middle of the last century. Where are they now? Arman has the answer. He calls his work, very aptly, very consciously, 'The Skeleton of Achilles'.

Another, perhaps even more final view on the situation is found in the work of Lucio Fontana, one of the first ever actually to make holes in the canvas. For centuries men have made their paintings on a solid base of wood or canvas. The canvas has in fact represented the base and the starting-point of the artist's endeavour. It has meant the freedom to create, even if within a set framework, an artistic world, whether it is no more than decorative or is more serious or loaded with meaning. But now man has lost his base. The foundations of the building of our civilization are worn and crumbling. Now it is a fitting allegory of our culture to gash the canvas, to break through the traditional barriers. It is a working out of Gauguin's call to every artist never to set any limit to his freedom; to destroy the final ground of all art as it reflects the ground of being itself. Fontana slit the canvas with a razor-blade, jabbed at it in a fierce moment of rage against all limitations, in a moment of despair of ever finding the reason for such a ground at all. He called his work (made in 1964) 'The End of God'. First we are left with nothing but the bones of Achilles. Now God Himself has been destroyed.

Two British artists

Although there has been a thriving artistic life since the last World War, the number of really great names has been small. The scene was made up of groups and movements rather than by great commanding figures. Henry Moore and Francis Bacon have been exceptions—making up for the fact, perhaps, that Britain has played only a secondary role in the upsurge of the modern movement.

Indeed, it seems good to pause a moment to reflect on this phenomenon. Britain has been in many cases the place where the new ideas were born or their consequences thought through most deeply: at the beginning of the Age of Reason, for instance, or in romanticism, or evolutionism, or mysticism. Yet the revolutions which have occurred elsewhere have bypassed Britain, where the principles have been worked out with much more restraint. Only one from outside Britain can appreciate fully how much the 'old times' still persist there—certainly out-

side London. The break-up of society, the alienation of man in an all-pervading technocracy, extreme socialism that takes away the individual's freedom, these things are so much less conspicuous than elsewhere. Maybe this is why existentialism came in later, as something foreign and imported, though the flourishing school of the theatre of the absurd in England shows that the soil was fertile. Modern art too came only from elsewhere, and that rather late, even though England had helped to lay its foundations. One reason might be that though the orthodox, evangelical Christian groups did not as such play much part in the intellectual climate, yet their view on life had enough influence, as a salt that had not lost its savour, to hold up the revolution against the bourgeois spirit. Also, the old consensus may be in ruins in Britain as elsewhere: but the ruins have often been well cared for instead of torn down.

But to return to the artists we have mentioned: Henry Moore of course was no newcomer. He was already doing his sculptures before the last World War. His main theme has been the reclining figure, which he initially began to develop under the influence of Ancient Mexican art. He wanted to make his sculptures look like natural things, like pebbles in the stream or rocks in the sea, worn down through the ages. This gives his sculptures a double impact: on the one hand they are human figures, on the other rocks with holes in natural forms.

In the thirties Moore was in close contact with the surrealist movement, and even much later, in the fifties, beside the sculptures just mentioned he made strange, absurd figures, mainly small bronzes, related to his other work and yet quite different from it. Just as with Picasso, Moore has different styles. In the course of time, I feel, the surrealist tinge prevailed, and modernity won over the more humanist elements in his earlier work, until finally he was making large bronze abstract works, fantastically refined and strong in shape, and yet like existentialist *chiffres*, symbols for something unnamable, irrational, something deep and mystical almost like primordial products of natural forces.

In this respect he followed the same trend as many other great artists, such as Marino Marini, for instance, another great sculptor whose major theme of 'man on horseback' also got more abstract in the course of the years. It was as if the truth of the

Bacon, *Head VI*
Hayward Gallery, London (Courtesy Arts Council of Great Britain)

initially humanist theme of defeat, man riding on nature without being able to tame it, was so deeply felt that gradually it took over even its means of expression, which began to show increasingly the decay and collapse of all forms and values even in the very piece of sculpture itself.

Francis Bacon is the other great English artist, a man whose images are horrible to look at and haunt the imagination. Images of misery, of despair, of alienation, of decay, of a world in which paralytic, neurotic, leprous schizoids move in cages, human beings become animal and yet remain human, a world in which people, having lost their heads, cry out for help, for reality, and yet are real even if lost in the void. His most famous works were a series of 'portraits', reinterpreting Velasquez's unsurpassed portrait of the pope in the Galleria Doria in Rome which is very human, very 'normal', very beautiful and very much the great man (though not in a proud way). Bacon's pictures are like caricatures, not so much of that particular pope as of mankind,

not humorous images but great cries of despair for lost values and lost greatness, for a humanity deprived of its freedom, love, rationality, everything that the great humanist painters had celebrated for centuries as they drew on their Christian and classical tradition.

Bacon himself said about his art:

> 'Also, man now realizes that he is an accident, that he is a completely futile being, that he has to play out the game without reason. I think that even when Velasquez was painting, even when Rembrandt was painting, they were still, whatever their attitude to life, slightly conditioned by certain types of religious possibilities, which man now, you could say, has had cancelled out for him. Man now can only attempt to beguile himself for a time, by prolonging his life—by buying a kind of immortality through the doctors. You see, painting has become—all art has become—a game by which man distracts himself. And you may say that it always has been like that, but now it's entirely a game. What is fascinating is that it's going to become much more difficult for the artist, because he must really deepen the game to be any good at all, so that he can make life a bit more exciting.' [3]

Pop and op

Already in the fifties, beginning in England, there was a reaction against the abstract expressionism that prevailed. This art, even if it celebrated man's creativity, even if it demolished the image, even if it exalted the unreasoned, direct stroke, was esoteric, a kind of art for art's sake, works of art made by artists for the artistic few, a snobbish ivory tower. At least, that is what the artists who inaugurated the pop-movement thought.

They reacted by looking for their inspiration to the non-art imagery of our times, the cheap poster, the cartoon, the flag, numbers, illustrations from magazines, preferably the cheap ones. Or they started to copy the commonplace, the obvious, such as a can with brushes on the table in the studio. They exalted the image, accepted it positively, celebrated it, and made an art more real, more truly of this century. They found beauty in the things around us, in the style of the images around us. It

[3] Quoted from J. Russell, *Francis Bacon* (Methuen, London, 1965), p. 1.

Wesselmann, *The Great American Nude 2*
Museum of Modern Art, New York

was positive and fine. They used all the twentieth-century techniques, the collage, bringing the real thing into the picture, or pasting together popular images like the cinema-ad's sex-bomb, the body-building man, the vacuum cleaner and what not. Girls under showers, highways, the cliché from the cartoon, shelves with rows of Coca-Cola bottles, great American nudes, cars and roses, the American flag and so on were shown life-size, more than life-size, in a cataract of images upon images.

Warhol, *Campbell Tomato Soup Can,* Galerie Ileana Sonnabend, Paris

In a way it was positive and happy. Unfortunately our century has taught people to see the absurd in all these things, the commerciality, the cheapness of all the shining chrome, the emptiness and the superficiality. So together with the positive crept in the negative, the critical tone, the downgrading of many things which were not necessarily sacred yet prized or valued emotionally. Pop art has become in this way a kind of recast of Dada and neo-Dada, a mixture of humour and rage, of smiles and tears, of condescending acceptance and irate rejection, of love and hate, or life and death. It is a strange, sometimes fascinating, sometimes boring, mixture of positive and negative elements and attitudes.

Pop art has brought the figure back into art, the 'normal' image, the human element that was so obviously lacking in the other modern streams. Maybe precisely because of its 'normality'

Vasarely, composition, Galerie Denise René, Paris

we feel even more the element of crisis, of the death that has tinged so much of our present-day world. This was the work of Liechtenstein, Wesselman, Rosenquist, Dine, Warhol, Hamilton, Peter Blake, and so many more.

Alongside this has grown op art. It derives from the Mondrian type of 'pure' art, the experimentation with the possibilities of the visual in 'tachist' art, and probably too from the new development in typography, together with some of the elements of the neo-Dada trend. Its abstract images, more often than not made of geometric forms, straight lines and circles, use all kinds of visual devices to get a static form into movement. It is an art of experimentation with visual means; it makes form configurations that have no other meaning apart from being a form configuration but yet make an impact on the mind and are at least interesting as configurations. As a kind of experiment with the possibilities of optic effects in art it yet makes designs that 'work' and have a frequently irritating effect on the onlooker.

To me it seems to be an art parallel to linguistic analysis. With

this philosophy, born out of logical positivism, the idea was to keep away from all problems that are beyond human capabilities and to begin with language itself in order to find a way to come closer to truth. Yet this turning away from all deeper problems is not simply neutral. It is only possible when one does not want to accept not only god or God but anything transcendental. In the same way this almost clinically clean psychological experimentation with optical possibilities has the same deep roots as the other forms of art that engendered it.

Vasarely and Soto are perhaps the best artists in the op-movement. Another is Paolozzi, who has made his name as an important representative of junk-sculpture, and later created strange, absurd, neo-Dada, hard-edge works such as the thing now in the Tate Gallery called 'The City of the Circle and the Square' (1963). But since the fifties this British artist has also worked in other media, literature, film (a film called *The History of Nothing*), and graphic work. I quote from a catalogue of his prints exhibited in 1968 at the Amsterdam Stedelijk Museum:

> 'The series of serigraphs published in 1965 called "As is when" is based on the life and work of Ludwig Wittgenstein. From a collection of weaving-patterns, photographs, architectural drawings and so on were made collages. With the help of these the serigraphs were then made. The result was twelve prints that portray moments out of Wittgenstein's life or of ideas from his works (Paolozzi is equally inspired by Wittgenstein's going to watch a film as by his thoughts on reality and experience). Wittgenstein's ideas about playing with language are consciously expressed in Paolozzi's work. In connection with this playing with language he plays with optical elements, or makes new plays with fragments of existing languages or creates fragments of new languages. It is remarkable that he does not consider it important to give his playing with language any other meaning than the playing itself. The denial of this so-called meaning gives the playing, paradoxically, meaning, and translates it into magic objects.'

Titles of his works in this line, graphic designs in strong primary colours, are 'Universal Electronic Vacuum', 'Moonstrips Empire News' and so on.

One inference one could draw from Paolozzi's preoccupation with Wittgenstein is that, if we want to understand the deeper sense and meaning of Wittgenstein's work, surely one way of

Paolozzi, drawing, Del Deposito Genua, Italy

doing so is to use the art of a man like Paolozzi to get into it, to sense the real meaning, its irrational absurdity, its chance element, its magic and loss of meaning.

Happenings and hippies

As we have seen, the movement that was expressed in art was much wider than art. Its expression, too, was wider than the traditional forms of painting or sculpture or theatre. One of its manifestations was in the 'happenings' introduced around 1960. These were created by playwrights and artists, first in New York, then soon all over the world. They find their later development in total theatre. These wholly random happenings took place all over the world, and were often very much more than simply art: they were at the same time a new form of political demonstration —as with the Provos in Amsterdam in 1966—and often a new kind of religious rite, or an orgiastic, mystical, atheistic, or rather nihilistic, cult.

Here too we find many kinds of movements and trends coming together: the most important, however, were the neo-Dada movement and the surrealist tradition. In the Dutch magazine *Randstad*, in an issue[4] completely devoted to the happening, we find mentioned among the 'precursors' many surrealist or dadaist manifestos or publications. Including as it does the political happening, we can safely say that the happening generally is a product of twentieth-century anarchism as this has been fostered and promoted by artistic movements. The anti-art movement was always basically a way of life, an attitude and a cult rather than a new art, even if in some ways it has been creative in forming new artistic means or even a style.

It is remarkable that in this movement we also find again and again the idea of destruction; in Vostell's decollages, for example, in which a TV image is destroyed, or Metzger's ideas, wanting to make a large piece of sculpture that decomposes slowly in the course of a few years. The idea of destruction even brought together an international group for a conference held in London

[4] No. 11–12, 1966. Some of the examples quoted below are also from this issue.

in 1966, the 'Destruction in Art Symposium', showing the relationship between anarchistic activity and this type of art, together with the promotion of the obscene and much else. And in 1967 another congress, on the dialectics of revolution, took place in London, and was attended by people such as Ginsberg, Goodman, Laing, Stokeley Carmichael, Marcuse, Eliade and so on.[5] Art and the revolutionary spirit seem increasingly to be one.

What is a happening? It is a kind of instantaneous free play in which all people present participate. It induces a kind of traumatic state of mind, just as in the more static environments, which bring us into an absurd, strange and frustrating situation where our own psychological reaction is a part of the effect. They were prepared for by the surrealist exhibitions in the thirties in which Marcel Duchamp played an important role, and his is the presiding influence in the new form of activity. Its impact has been great, not least in its influence on the sort of environmental manipulation of visitors at World Fairs and other exhibitions.

An example from the issue of *Randstad* already quoted will give an idea of what a happening is. It is of one held in 1962 on the island ·of Ibiza, where many artists came together. It was organized by an American who had participated in New York happenings in 1959.

> 'Fifty-seven people came together in a small room. We had arranged to play an Ornette Coleman record on a too quick speed, but later in the programme. Somebody, one of the public, put on the record much too soon . . . I felt myself swept away, losing all feeling of identity . . . Bob, clothed in animal skins, who was doing a bird-dance, was just as surprised as I. We looked each other in the eyes. Then my I stopped being. I was dissolved, washed away in the total energy of the room . . . A blue light switched on . . . It was just done at random by a girl . . . all individual feeling and thinking had disappeared . . .'

One reason for the happenings to emerge was the revolt of artists against the snobbery of the art dealers and their clients. They felt that their works of art which cried out 'absurdity', 'destroy', 'this world is meaningless', 'we are all dead', were hung on the wall, provided with a tag and a lamp, and were then

[5] The lectures were published in a book under the title, *The Dialectics of Liberation* (Penguin Books, Harmondsworth, 1968).

objects of high artistic discussion for people more interested in status, in investment, in novelty and escape from boredom than in anything they said. A happening cannot be tampered with, as it does not happen to remain longer than the thing lasts.

But it turned loose many forces, and had a deep impact. It was one more proof that the times were ripe, that the modern movement has won the battle—even though there may still be many who do not belong to it. Many, however, do not dare or do not care to challenge or oppose it. When they do they must carry the burden not only of being called old-fashioned, but also of being called authoritarian, or of not understanding the new quest for freedom.

Freedom, that was at bottom the catchword of the movement. Anarchistic freedom. It was the same spirit which inspired another movement which caught the world's attention: the hippies. It started in San Francisco, then caught on in New York, England, and in many other centres of the world. In a way it was a kind of Bohemian life, something that formerly was found only in some circles of artists—loose morals, drugs, a kind of a-social behaviour. It was now offered in a new form and with new slogans: drop-out, tune-in, turn-on. It was an anarchist movement, looking for freedom, for authenticity, for a life that really was life and not the struggle for money and a career. It was a revolutionary movement, even if it was not aggressive. In it, many of the elements brought forward by the modern art movement and the new philosophy were synthesized. Just as it was not by chance that the Provo movement with its happenings started in Amsterdam, the city of the famous Stedelijk Museum of modern art, so San Francisco did not just happen to be the first hippie centre, simply because there were many students there. San Francisco was the centre of the new American literature, where many of the so-called beat generation contemporary with the English Angry Young Men, a kind of existentialist literary movement from the early fifties, had flocked together. The most important of them were Alan Watts, who had occupied himself with Zen Buddhism and similar concerns, Snyder and Allen Ginsberg. Their creed and protest are epitomized in Ginsberg's famous poem *Howl*:

'I saw the best minds of my generation destroyed
 by madness, starving hysterical naked, . . .
What sphinx of cement and aluminium
 bashed open their skulls and ate up
 their brains and imagination?
Moloch! Solitude! Filth! Ugliness! . . .
Moloch the incomprehensible prison! . . .'

It is a long, emotion-loaded poem which sums up all the tears, the disillusionments of a generation that is witnessing the end of our western civilization, great in its technology, great in its organization, but without an answer to the basic human questions, with God murdered, a generation left to live in a world hopeless, forlorn, desperate, frustrated, full of agony, a world over which Moloch reigns. God is dead and Moloch reigns—this at least implies that the void is still felt, that men are still seeking for answers, that the spiritual is a void. Yet men are crying out for the spiritual, for the true Truth, for the Way, for Life. The hippie question is there in all its despair. Do we have the answer? Or is the answer just another old formula? It is the same question again: 'Is there a life before death?'

It was in this environment of protest and desperate search for meaning and sense, for freedom and real values, that the young hippies moved. Many came from well-to-do homes, from Christian backgrounds, from the classrooms of the better colleges and universities; they came to live an anarchistic and antinomian life. In a way it was like the extreme wing of the old Anabaptist movement again, if not in a Christian form: it was passive, but liable to break out at any time into a war-like activism to conquer the world for a utopian kingdom of God. Free love, nudism, the use of drugs, a new religion looking for a God who is not personal and not interested in the things of this world—why should He be, said these grandchildren of the gnostics of old, abhorring the idea of creed and definitive definitions . . .

And a new art came with them. An art that was able to express their anti-rationalist yet intellectual mysticism, their trances and unity-with-all, their joys and wavering truth, their human-itarianism and yet revolutionary being-different, their un-inhibited sex and love as sublimation.

They found their inspiration in art nouveau, another art of protest against rationalism and technology, another art that sought for the mystical and mysterious, for freedom in subjectivity and indulgence in sex. The forms created by William Blake were used again a century and a half later as an expression of the very same basic ideas.

And so the psychedelic forms emerged: posters, patterns on clothes, or body-paint, illustrations in their many underground press magazines. They were influential. The hippie movement may be a sub-culture, as *Time* called it, but it has influenced the western world more deeply and widely than many people realize. And with its forms some of its basic philosophy spread, even if tamed or made bourgeois.

This is not the place to go into details, for their art is now a familiar one: endless moving forms, figures and ornamentation fused into a swirling whole, letters like flames or clusters of forms, asymmetry, colours in all shades and kinds but never really loud, and in a way sweet and subdued, the whole making a bizarre effect without being shocking. If it is sometimes shocking, it is in its very free representation of nudity and sex, not in its style. In a way there is a search for beauty, for beautifying the surroundings, rather than the shabbiness of pop and neo-Dada.

But hippie art is more than just visual forms. It is music, dance, light-play, a kind of total art that takes the whole man into a kind of magic, mystic whole (even though sometimes aided by drugs), a kind of neo-pagan ritual not excluding its orgiastic aspects. In this there is continuity with the movement of the happenings. But here there is apparent again the quest for a kind of beauty, though an informal, improvised one, rather than the exaltation of the ugly and desperate that made happenings often disgusting.

The music that belongs to this is beat, or rock, or pop.

Jazz, blues and beat

Any analysis of our times that ignored its music would be incomplete, and so I must briefly examine the rise of the musical form that expresses very much the same message as the arts I have been discussing.

LET US JOIN TOGETHER JOYFULLY TO CELEBRATE OUR AWARENESS THAT WE CAN MAKE OUR LIFE TODAY THE SHAPE OF TOMORROWS FUTURE.

Back cover, *Seed* magazine, Chicago, January 1968

At other times, for instance in the seventeenth and eighteenth centuries, before the deep, dissolving effects of the Enlightenment became apparent, there was a unity in the whole culture. As far as music was concerned there were different streams, and certainly different kinds, church music, for instance, or opera, chamber music, dance music, and many more. But there was no break in society. Ordinary churchgoers in Leipzig would listen to Bach's cantatas in church. Even if they did not understand the supreme quality and depth of the music, they could enjoy it. The music was not written for an élite. Nor were the simpler and folksier kinds of music strange to the ears of the cultivated. There was a sense of normality and genuineness about all this music that made it everybody's music. The nineteenth century made music into a kind of refined, cultural, almost pseudo-religious revelation of humanism, composed by the great heroes and prophets of mankind. Everyday music became vulgar and coarse, low and without truly human qualities—with the exception of the waltzes of Strauss and other kinds of simple classical music for the uneducated.

The twentieth century made the split complete, particularly with the advent of modern music, with its weird sounds and lack of consonance. So now we have three kinds of music, roughly speaking: widely-revered classical music, true modern music appreciated only by intellectual modernists, and popular entertainment music, apparently of no quality and no cultural import. Perhaps we should add a fourth kind of music, the hymns sung in church and popular choral music, both also remnants of a great musical past and not yet devoid of all its qualities though often artistically poor.

In the first few decades of our century entertainment music (dance music and popular songs) was shallow and devoid of musical interest and power. Into this world burst jazz and blues. They came from quite a different background and from an unpredictable quarter, from the Negro section in the USA, from the freed slaves. Western psalmody and hymnody, the surviving older types of Anglo-Saxon folk-music and brass-band marches were interpreted by a poor and uneducated race that had a special gift for music, for rhythm and melody, with only dim recollections of the musical traditions of the Africa of their

forefathers. Out of all this grew new kinds of music: the Negro spiritual, a development of the hymns of the Wesleyan type, the folksongs and particularly the completely original blues, and then jazz, born in New Orleans but soon dispersed all over the USA to wherever there was a Negro ghetto.

Louis Armstrong in 1927 sang, 'I'm not rough, and I don't bite, but the woman that gets me, got to squeeze me tight, 'cause I'm crazy 'bout my loving, and I must have it all the time', in a voice that to a western ear could only be called rough indeed. This one stanza forms the middle of a record with the strong, seemingly unsophisticated, fierce trumpet of Louis himself, the soaring clarinet of Johnny Dodds and the pulsating rhythm of a music that to western man could only be felt to be new, exhilarating, uninhibited and filled to the brim with life—all that was missing in the sweet and dull and unimaginative entertainment music of the day.

So young people took up the music, and loved it, in a revolt against all that was namby-pamby in their own culture, against the shallowness and commerciality that seemed to symbolize their own world. Taking this music, scorned by what we would now call the Establishment, was in itself an act of protest, even if only a mild one. The result, in the thirties, was the jazz-clubs: the new music was studied, records collected and exchanged. They listened not only to jazz, but also soon to the blues that could be heard on many rare collector's items, records from race-series originally released in the Negro ghetto and now cherished by the happy few who could lay hands on them. What this music meant to the Negro himself is another question. More often than not the real Negro was far out of sight of these youngsters, who nevertheless loved the music and discussed whether any white man would ever be able to make music as good as this. Hot music. Hot jazz. The blues of Bessie Smith and Ma Rainey, or of legendary names like Blind Lemon Jefferson, Kokomo Arnold or Barbecue Bob.

Jazz in the thirties had a great influence on entertainment music, and Negro musicians such as Fletcher Henderson and others began to shape a new music to be played by white men— the bands with big names and popularity such as Benny Goodman and Artie Shaw. They turned this music into a rage, and the new streamlined swing was all over the world. The jazz clubs did

not like it at all: their jazz had been stolen from them and turned into another bourgeois music, commercial jazz. Many of the musicians did not like it either, especially the Negroes, who felt that their music had been betrayed and misused and turned into a white gimmick.

Around 1940 there was a reaction. A new music emerged, 'bop' or modern jazz, created by intelligent, well-trained young Negro musicians. It was much influenced by modern music, with the existentialist undertones of protest, rage, agony and despair. It was melancholy, and an exaltation of the individual's ability to achieve something difficult. As far as the jazz clubs were concerned this was not the jazz they looked for—it was too far off, too difficult, they were not yet ready to accept the modern sounds and disjointed melodies. But they discovered that the old New Orleans jazz still lived; and they got hold of it and a New Orleans renaissance took place, almost exclusively for white people. Or they got hold of the real folk blues; hearing a man who has been a murderer and a convict sing of his sexual experiences is not exactly soft and sweet—it is the real stuff, strong as life itself, even if it was only a voice of a man on the platform.

Another protest came, this time neither intellectual nor modern. Modern jazz in a way was a sign of acculturation, the Negro coming to grips with the modern movement. The other protest was as Negro as could be, non-intellectual, very forceful, a music in which all seemingly Negroid elements were exalted, a music that was really too hard for white ears. For years 'rhythm and blues' was a music only the coloured people knew and listened to. They enjoyed a music that they knew was not the white man's choice, and could not be stolen. Or could it?

Out of the New Orleans revival came the Dixieland movement. Dixieland was white man trying hard to play the old New Orleans jazz. Some idealists really played it pure, authentic and 'original', and abhorred all compromise. But others turned it into a new kind of entertainment, catering to the dancing crowd. But in this way the lilting, joyful music, strong and intricate, became dulled and tame, and cliché was heaped upon cliché. So jazz again was losing its force and ability to be a symbol and expression of protest.

Therefore a new music emerged, again completely non-intellectual, with a thumping rhythm and shouting voices, each

line and each beat full of the angry insult to all western values, if these could be called values, of music or of culture or of behaviour. 'Rock and roll' rolled in—rhythm and blues was, about ten years after it began, borrowed by the white men.

In the years after the war some of the US Negro churches were booming—whether it was really a revival or what it meant precisely is hard to say, though there was certainly much real if utterly non-intellectual Christianity involved. There was created a new music, 'gospel', mostly sung by quartets of men or women, or by soloists like Mahalia Jackson. In the groups the responsive pattern was characteristic: one voice takes the lead, the other voices form a driving, rhythmic, answering refrain.

This device was often taken over by the rhythm and blues groups, and so came into rock and roll. Other elements were added. From the folk blues came the harmonica. The rhythm changed. It became a new style, and at least some groups of young people knew it. It was still outlawed by the Establishment, and the protest was felt in the roughness and the lack of sophistication.

But it was in the sixties that it really clicked. It began in England, and was called 'beat'. Everyone knew the Beatles, the Rolling Stones, and all the rest. At first most of the songs were simply stolen from blues, rhythm and blues, rock and roll and all kinds of Negro folk songs, heard on the sometimes rare records. But soon new compositions were made. But however it happened, beat conquered the world. The new movement of protest and non-western-cultural-standards, as such non-humanist, was winning, if not the whole of society, then certainly the younger generation. It was everywhere.

Of course, the bearers of the modern tradition tried to ignore it at first. They had put their stakes on modern music, *musique concrète*, electronic music, the chance music of John Cage, the new sound of Stockhausen. In the same way they bypassed neo-art nouveau, which did not get a showing in modern art galleries and remained a kind of underground art, reaching the new multitudes of the young, the new generation. It would seem almost a tragedy that the very moment the ideas of the modern movement reached a wide audience and gained influence, the older modernists ignored it as they had their own cherished standard of shock and renewal and protest. Yet in beat (with the

better groups), as well as with neo-art nouveau hippie art, the old wounds of culture were beginning to heal, the break covered, the gap closed. A new culture begins to emerge that leaves the old standards far behind, a neo-paganistic primitivism, a new way of life of which this art forms an integral part. Western culture, as built since the Renaissance and the Reformation, slowly undermined since the Enlightenment, is still there, but as a tottering ruin, while the new culture is coming in. The new emerging art forms are still full of the battle-cry, and make up the revolution in which we are living. The new culture is only slowly evolving. But its shape is already seen.

Beat groups, protest singers, folk singers, these are the people forming the new art still in the making. Their protest is in their music itself as well as in the words, for anyone who thinks that this is all cheap and no more than entertainment has never used his ears. Of course, there are many imitations, many who take advantage of the situation to make money, and there is much beat that is simply popular music which is borrowing the tricks and forms of the real beat. How could it be otherwise in our western society? And there are of course plenty of bad groups as well as the good ones—there has always been variety of quality in any style. But in dismissing some of the exponents of the form we cannot afford to dismiss the message, which is heard by millions, often on a subliminal level and therefore unconsciously brainwashing, from pop radio stations all over the world. We cannot simply stop it, nor is it wise to close our ears. We have to cope with it, and, at least, to understand its message.

Chapter eight

PROTEST, REVOLUTION AND THE CHRISTIAN RESPONSE

Everywhere I hear the sound of marching, charging feet, boy
'Cause summer's here and the time is right for fighting in the street, boy

Rolling Stones, *Street Fighting Man*

THE TIMES in which we live are not a unity, of course, any more than any other period of history has been. Different streams and movements are working side by side. But a period is characterized by the most powerful main movements of the day, powerful either because they have a large number of adherents, or because they have, apparently at least, a fitting answer to the problems of the moment.

When we speak of 'our period' we are thinking of western culture. But we must realize that western culture has grown, at least geographically, because of its influence on other countries. Modern artists may well be from Argentine or Brazil. Films are made in Japan as well as in the US or Europe. The cultural situation does not coincide with the economic, though is closely bound to it. This is not the place to deal with the problem of whether modern technology can be 'exported' without also exporting the basic implications of western culture. But it would certainly seem that we are exporting with our sciences the crisis of our own culture, undermining the religious and social systems of the non-western world.[1]

The arts today (thinking particularly now of the visual arts) are diversified. Many artists are still working in the ways of the nineteenth century, their work being impressionistic, or at least naturalistic, using the technical principles of the classical period of the sixteenth to the eighteenth century. Yet one feels that they are increasingly losing ground. They are repeating old formulae and, in keeping the older traditions alive, are standing aside from

[1] See further A. T. van Leeuwen, *Christianity in World History* (Edinburgh House Press, London, 1964).

the main streams of today—certainly from those of the last decade that with revolutionary force are breaking down everything that has no deep roots to stand against them.

Pop art, new forms of caricaturing art, strange new forms of surrealism, these are the things which are constantly reclaiming our attention. Most of it, to some degree at least, is critical of the world we live in. *Time* magazine, for instance, said this at the end of a review[2] of Westermann's strange 'sculptures':

> 'His innocence is only a mask for a stilled malice directed against a society he thinks has gone mad . . . His visual jokes are intuitional and may indeed have no rational point. But they end up as a kind of emotional fishhook, snagged in the memory. They are images not wholly explicable, but impossible to dislodge.'

The modern movement has now emerged from the smaller art-dealer's shows or the larger exhibitions in the galleries of modern art. It has come out into the open. Its products can be bought in the large department stores. In Holland, for instance, signed copies of Niki de St Phalle's 'Nana' were sold at relatively low prices at the end of 1968. Of these 'Nanas', pop-like sculptures of sexy females in glowing colours, it was said:[3]

> 'They are feasting. One can only feast at the cost of others. Gentlemen, it is at the cost of us that this happens. They kick our bellies, our armies, our morals; they jump our philosophies, they make the grand finale on our nation. Traitoresses.'

Niki is the wife of Tinguely, the man who makes the absurd machines, another anarchist. Together they made the huge image of 'Hon', a sculpture of a nude woman of enormous size which one could enter, through the pudenda of course. It was an exhibit in the Stockholm museum of modern art. Thousands came to see it. Has the modern movement won?

One can also of course make works of art in series, by mechanical reproduction. In this way you can buy a work of modern art at a low price. Op art and 'minimal art' are very suited to this type of work.

Minimal art could be an illustration of something Klee said in

[2] Issue of 20 December 1968.

[3] In the catalogue of an exhibition held in 1967 at the Stedelijk Museum, Amsterdam.

Niki de St Phalle, *Nana*

his diary in 1915, 'The more horrible this world is, the more abstract art will be, while a happier world brings forth a more realistic *(diesseitige)* art.' Minimal art uses the least possible number of elements. Often it plays with a rhythmic arrangement of the same very simple forms, sometimes it presents a cube as sculpture. In recent years there has grown from this an art that has been called 'hard edge', that presents forms in simple configurations or 'paintings' with very basic forms in bright colours, all done in a meticulous, technically perfect way, often using new materials. Yet this art has often strong emotional overtones that echo what was said in the quotation from *Time* magazine about Westermann above.

The art scene today is made up of strong extremes. It may seem strange that while the visual arts are predominantly abstract and certainly not realistic, the film as an art form is not going in the

same direction. It has developed many new techniques, but its main concern is still with reality—the nude that has been considered outmoded on the canvas is here in all its photogenic reality. Yet this does not mean that the film is not touched by the modern movement. Of Bergman *Time*[4] said that the body of his twenty-nine films 'now amounts to a great literature of heroic despair'. In some films the distinction between 'reality' and imagination is blurred. One no longer knows whether a thing is what is supposed to be going on in the person's mind, whether it is an aesthetic idea, or whether it represents the 'real' story. Yet reality is there. It is sometimes no more than straight, hard reality with no comment. But we must question whether this is really still reality at all, or whether it is, in a very different way, just as 'abstract' as the non-figurative visual arts.

Art in a way is dying—as a high human endeavour. It has lost its romantic high quality, it is coming back to reality. We should not weep because another humanist myth has lost its hold on

[4]Issue of 10 January 1969.

Derrick Woodham, *Blue*
Courtesy Richard Feigen Gallery, New York and Chicago

men. But what has come into its place but anti-art, just as there is anti-philosophy, anti-theatre and so on? It testifies to the fact that art is in a deep crisis at the same time that it is attracting so much attention. Borderline cases can be found, as in minimal art, or the art of Fontana (a canvas with a razor slit . . . is that really art?) or the music of John Cage which is either noise produced by chance or even complete silence (Cage called his book on music *Silence*). Yet in another way one often feels that art has really become superfluous. After seeing the Documenta exhibition in Kassel in the autumn of 1968, having gone through the op art section I felt that Piccadilly Circus or Broadway with their neon advertising are much more fascinating, more fun and more meaningful—even perhaps more artistic.

Maybe the real art of our times, comprising both the aesthetic and the imagination and command of technique, is to be found in advertising, or in magazine layout, or in the graphic design of leaflets or even in scientific drawings. Or there is the often very fine visual means of depicting statistics, and so on. The forms are often strongly influenced by modern 'high' art, but they have got a meaning, a sense, have become 'normal' and to the point. They have become human and so they live.

Even when abstract forms are used in a brochure or on a book cover they are appropriate to their function, because they have no pretentions to meaning something of great depth, but simply evoke a certain feeling or idea. This is the exact opposite of what happens in much minimal art, in which, for instance, forms are used which have been inspired by iron tubes in factories or girders in buildings. What often had a fascinating beauty in its own setting, fulfilling a specific task, is strange and almost hallucinatory when emptied of sense and context.

Perhaps too most real art today is in television. There are not only the often very imaginative openings, using drawings, letters, animated figures, photography and so on, but also the representation of many aspects of reality, quite apart from news film and the direct documentary. But maybe it is indeed 'cool communication', suggesting its message through the medium, but never 'reasoning' about it, never defining its value or relating it to an absolute. The message often is hard-core reality, 'facts' themselves, and that is all. TV belongs to the modern world

quite as much as the avant-garde cinema. On the screen we can watch with our own eyes the emergence of a new world.

The search for humanity

'When the mode of the music changes, the walls of the city shake', wrote Tuli Kupferberg in the *International Times* of 27 February 1967. The mode has changed. Are the walls really shaking?

There is a deep dichotomy in our culture, a duality as deep as if there are two different sets of reality. A few years ago there was a cartoon in the *New Yorker* showing a modern box-like building with an abstract wall-painting on it. The caption said: 'The more rational the building, the more irrational the painting.' This sums up the problem and the inherent disharmony of our time.

As we have seen, it all began when man wanted to be autonomous, when he lit the torch of his own reason and resolved to start only from his senses—with the 'enlightenment' of the Age of Reason. And so the sciences have acquired a new meaning of almost religious significance, and reality equated with what can be seen, weighed, measured, heard. The rest is only secondary reality, not only based on the material and the biological, but in a way resulting from it, for 'struggle for life', 'evolution', 'libido' and 'sublimation' have become the key-words to understanding human reality, and man is now nothing but a 'naked ape'. This is what I described in an earlier chapter as 'man in the box'. Man, being human, however, tries again and again to evade the logic of his own position, and searches for his true self, his humanity, his freedom, even if he can only do so by means of sheer irrationality or completely unfounded mysticism.

Man today is in revolt against the world in which he lives, against its dehumanizing tendencies, against slavery under the bosses of the new Galbraith élite, under a computerized bureaucracy, against alienation and the loneliness of the mass man. He searches frantically for a new world. He is willing to risk the hardship of revolution. The tragedy is that man has no new principles to offer. All his endeavours result only in a world which is even more consistent with the principles of the Enlightenment, of autonomous man—autonomous yet reduced to atoms or rabbits.

In a way this revolt is something to be welcomed. It proves that man is still human, and that deep inside he still knows that he cannot be in the box, that he is more than an atom of a rabbit.

'Something is happening here, and you don't know what it is, do you, Mr Jones?' sings Bob Dylan. He points to the fact that many feel and sense that there is something changing, yet they do not see the reasons for the change or the principles behind it, and so they fear it. Some say optimistically it is just a symptom of the third industrial revolution, and all the turmoil today is only a sign that man has not yet adjusted to the new situation—in which technology, in a new, even more all-embracing form, is to shape the new world. But then, if this were true, we are even more bedevilled by technology. Is there no way out?

Those who put their faith in a perfected technology have of course some grounds for their optimism, even if they also have their problems. We are living in an advanced world, better equipped than any before to tackle the great problems of mankind: housing, transport, safety, health, home comforts, efficiency. We have better communications, safer systems, more convenient utensils, better organization. Much of our western society is wealthy, affluent. Economics, by applying the methods of the sciences, has been able to break through old barriers; together with sociology it has been the means of providing for everyone goods and services previously undreamt of. No longer is the world one with a happy few, a small class, at the top, with the masses of the nameless poor at the bottom. Democracy, leisure and convenience for everyone have been achieved—well, perhaps not quite, for we are still uncomfortably aware of the areas where they have not yet arrived.

Certainly the world is a fast-changing one: air transport is faster, and within the reach of an ever-increasing number of people. Television, in the course of one or two decades, has changed the habits, knowledge and whole outlook on the world of a large majority of the people. Cars are now a commodity instead of a luxury. More people get better schooling and higher education at university and college level. Books are cheap and within the reach of all. People live longer as a result of the rapidly advancing medical care and research.

All this is true, and many of these things have no doubt led to

much greater happiness and satisfaction in life for many. No-one wants to undo them, or go back to being without them, or deny their importance. Nor can it be denied that they all have a deep influence on our lives. Certainly one aspect of the crisis of our age is to be found in the fact that we have not yet completely adjusted to them; we have not yet found the right attitude to them, for we are often still like children completely taken up with a new toy. But the overwhelming ecological problems of today show that we must stop playing at random: our utensils may destroy us, our machines cause the decay of the very earth on which they stand. Perhaps we have bought our affluence at too high a price.

Our world is changing, and we with it. It has become much larger, as our horizons have widened; but also much smaller, for we get instant information on problems and events in places far away. We get involved in things we have never even thought of before. So our world has become much more complex, and in our answers to the problems of life we have to cope with far more factors than ever before.

All this means that Christians must go through a period of study, thought and re-evaluation that will take much of our energy. Conflicts will arise within Christian circles as older people especially are not consciously aware of this need for re-orientation, and therefore think that the old answers are still valid and sufficient. It is not that the foundation has to change, or that the basic doctrines have lost their meaning. But the expression and formulation of them sometimes needs rethinking as we listen afresh to God's Word, and seek to present it to the new world in which we are living.

The whole cultural situation however is much more complex than can be dealt with simply by asserting that we have to adjust and rethink. There are many negative elements in the techno-cracy of today. We must find out what they really are, think through the means of removing them or at least formulating our attitude to them.

We must also learn to react positively to the positive elements of the revolt and protest around us. For it, too, is against the evils of technocracy. We must rejoice in the fact that man is shown to be still human by his protest against the forces that would dehumanize him. We must be alert to see that the lawless and

César, *La Grande Duchesse*, Allan Stone Gallery, New York

negative revolutionary elements do not obscure the real issues, so that they do not become themselves an obstruction to finding the solution they seek.

Plastic people

Technology is to be welcomed insofar as it offers man new tools and possibilities. But it becomes a real menace to the humanness of man, his freedom and personality, when it becomes an idol, a technocracy. For then a tool is made into an idea, a means into an end, a method into a truth. People become no more than consumers squeezed into the mould of standardized, dehumanized pseudo-man by the pressures of the advertising industry. As our consumer-goods become standardized, so our homes become standardized, *we* become standardized, rolling off the conveyor belt of modern technocracy. Surely we can understand the protest of one of the younger Dutch poets who said:

> 'What is creativity? A man in Boston, Massachusetts has covered the wall of his drawing room, his study, his bedroom, his closet and his kitchen with sealskins painted white, orange, blue, yellow. . . .'

Television is a focus of our standardized homes. Here too, inbuilt in the programmes, is one view, one approach to reality. Sometimes the programmers are consciously trying to convince us of a certain view, but more often they just go on making their programmes without being conscious that they are in fact brainwashing their public. It is their job to be new and up-to-the-minute, which means that they are compelled to follow the latest trends and insights and ideas, often without any attempt to come to grips with their underlying principles. So modern views are constantly 'preached' in a most effective way: effective because it is not intended or overt, so we are not on our guard against it. The message is there, from pop music up to the most sophisticated 'cultural' programme and the most intellectual lecture.

Indeed, if we want to stand for freedom, human freedom, we have to have our eyes open for this danger of manipulation. We must point it out wherever it becomes apparent. But we must realize that protests alone do not help. Those who are responsible

for it often do not, and cannot, see its consequences. So it is our task to instruct the public, and particularly our own younger generation, that they may see and be aware of this inbuilt scientism, this faith in autonomous humanity, that is constantly flung at them. Understanding is the first step against all manipulation, for manipulation can only be effective insofar as it works as a hidden persuader.

There are two results from the view that technocracy is all, that man is solely determined by economic, sociological, psychological and biological laws, that ideas, religion and everything else which is human are no more than secondary reflexes, sublimation, rationalizations, the result of conditioning. The first is the idea that if things do not go well the system has to be changed. But a change of system is not going to improve the situation if the spirit underlying the system is not altered. The second result is that man is just plastic.

'Man is plastic' is the very clever formulation given by the theatre of the absurd for man's situation. Man is plastic—as dead, as machine-like, as ugly, as open to manipulation, as cheap and as banal as plastic. Plastic, the supreme product of technocracy, the fruit of research, organization, big capital, large factories, the clever selling techniques. Plastic people is a phrase that has become almost a slogan.

Our affluent society, our modern science and security and health, our gadgets and luxuries that were beyond even the great, wealthy kings of the past, all these things, none of them evil in themselves, have made man, not human and free, but manipulated, plastic; for the spirit of the age is in it all. What could have been blessings have so often become a curse. Instead of making man free they enslave him. Instead of bringing life they bring death. It is at this very time, in the face of all these great achievements of humanity, that man is in revolt, against the dehumanizing, the alienation, the frustration, the one-dimensionality, the atom-ness and rabbit-ness of man. Man is crying out for his humanity, his man-ness. But where is it to be found? For we are really no more than conditioned robots, religion is just another idea of our own, something to give us the tranquillizing thought that we are more than highly complex bundles of atoms evolved in a long history, looking at ourselves . . .

Beyond the material

Man wants to be human. Caught in technocracy, in computerized bureaucracy, he tries to wrestle free. But to get this freedom he must 'jump out of the box', find a freedom outside technocracy, outside the world of naturalistic law and determinism. For modern man understands reality only in terms of scientism, So he has, it would seem, to get out of reality. He becomes a mystic.

There is no age as mystical as ours. Yet it is mysticism with a difference: it is a nihilistic mysticism, for God is dead. Very old ideas are being revived: gnosticism, neo-platonic ideas of reality emanating from and returning to God, and Eastern religion, a religion with a god that is not a god but impersonal and universalist, a god which (not who!) is everything and therefore nothing, with a salvation that is in the end self-annihilation. In the quest for humanity man is even willing to lose his identity, his personality. It is like the creed that the Beatles sing (on their Sergeant Pepper Lonely Hearts Club Band record): 'When you've seen beyond yourself . . . the time will come when you see we're all one and life flows on within you and without you.'

We must understand the issue at stake: man searches for his humanity, and for real reality, reality that is more than the brain can encompass and the eye can see. Man searches for water—water that is the beauty of the waterfall, the drink offered to the thirsty, also the dirt in the ditch, the rain that beats in our faces, the cold snow as well as the hot bath at home . . . and he hopes to find it in a mystic unity, in which water is me and me is water and all is one and all is God! Water that has been reduced to H_2O has been deprived of its reality as water. For every aspect of reality is God—and man today wants to experience God. It is not faith or knowledge which is the key word, but experience.

For the same reason he is willing to follow the ways of Zen, in which reality is accepted and yet overcome by being bypassed, and man has become free by being able to transcend the dilemmas of life and thought. Zen has had a great attraction in our time, and many artists have been influenced by it—Mark Tobey, for instance, and the poet Alan Watts, one of the hippie leaders in 1967. Zen seemed to give an answer to the deep questions, and

offered the wisdom of a long tradition where western man was just beginning his stumbling search for a new way.

So man in quest of his humanity, in his search for a way of escape from the world of scientism, technocracy and the affluent society, from everything that is rational, becomes irrational: something un-understandable, something alien that we cannot talk about in sensible and 'normal' speech, that we cannot discuss and certainly not explain. So man has come to live in a twofold world—the rationalist 'box' and the irrational domain of freedom and Being.

In our time this dichotomy has become very deep and radical, but it is not new. Ever since the Enlightenment man has dealt with reality in a double way: reason and romanticism, positivism and idealism, naturalistic reality and the realm of human freedom in the arts, religion and morals. Kant in his great philosophical synthesis of the many attempts made to evolve a new system based on the principles of the Enlightenment—Descartes, Hobbes, Locke, Hume, Diderot and Rousseau—formulated this duality, this doubleness in his *Critique of Pure Reason* and his *Critique of Practical Reason*. Kant still dreamt of providing a unity in his answer to the deep problem of the nature of reality. But later Hegel realized that we must accept at the same time the yes and the no, the thesis and the antithesis, for we cannot get hold of the unity. And Kierkegaard understood that therefore faith had to be a jump away from reason. In our own time the existentialists have taken up the theme and highlighted the dilemma man is in.

Existentialism is the end of the philosophical tradition that begins with Descartes and was firmly established in the Age of Reason. It is the end, and also the logical conclusion of its premises. William Barrett in his *Irrational Man* writes about this as follows:[5]

'As a canny and sagacious Frenchman, he (Descartes) proposed to abide by the customs of his time and place (which included the practice of religion). Hence, when he launched himself into the Doubt, he made certain of securing his lines of communication behind him; he took no chances when he made the descent into the painful night of the void. The next step after the certitude of the *Cogito*, the 'I think', this turns out to be a proof of the existence of God; and with God as guarantee the whole world of nature, the

[5] Doubleday, New York, 1962, p. 244.

multitude of things with their fixed nature or essences that the mind may now know, is re-established around Descartes. Sartre, however, is the Cartesian doubter at a different place and time: God is dead, and no longer guarantees to this passionate and principled atheist that vast structure of essences, the world, to which his freedom must give assent. As a modern man, Sartre remains in that anguish of nothingness in which Descartes floated before the miraculous light of God shone to lead him out of it. For Sartre there is no unalterable structure of essences or values given prior to man's own existence. That existence has meaning, finally, only as the liberty to say No, and by saying No to create a world. If we remove God from the picture, the liberty which reveals itself in the Cartesian doubt is total and absolute; but thereby also the more anguished, and this anguish is the irreducible destiny and dignity of man. Here Cartesianism has become more heroic—and more demoniacal.'

Heidegger, Jaspers, Sartre, Camus, each in his own right and in his own way, speak of the absurdity of man, the meaninglessness of his being, of the quest for ultimate experience and for the way man can postulate his essential being by starting from his own existence. Keywords are agony, fear, *Angst,* boredom, becoming, nothingness, the nauseating, ultimate failure. And of course freedom, existentialist freedom, 'out of the box', beyond the material.

So man, existential man, tries desperately to find some meaning, and seeks it in some sort of ultimate experience, a kind of irrational, nihilistic experience that will prove his humanity and his freedom—a freedom 'out of the box'. It is a freedom that has nothing of the openness and peace that Christian freedom brings. The experience of ultimate reality means that a moment in one's life has to give meaning to the whole of it; it brings no joy, it is no salvation. Man's being is after all 'being unto death', *Sein zum Tode,* and death is the ultimate absurdity of man. For many this is all too remote: they are the ones who sit at the wayside, waiting for Godot (as Beckett put it), waiting for Godot (God? another source of meaning?) . . . Godot, however, never comes!

The artist is the prophet of this search for meaning beyond reality. 'Music is a prayer, a message from God, it is freedom, beyond the material', said Albert Ayler, a leader of the new wave in jazz of 1965. It is nothing new for art to be given this role. Ever since the beginning of the Enlightenment art has been

separated off from the sciences and assigned the realm of freedom and humanity. Romanticism further elevated art, particularly literature and music, to the highest domains of humanity, and gave it the function of revealing the deep realms of truth. Galleries were built as temples of art, for art was to be the great high priest and prophet of humanistic humanity. And so in our own day too, art is given a lofty role. The artist's task is to reveal the deep, irrational secrets of reality, the reality beyond the material, behind the appearances. At the same time he has the task of interpreting his times, to have a prophetic insight into the important trends and meaning of all that goes on. Today this almost invariably means that the artist has to be critical of current values and norms. This last idea is a rather newer one, and is the result of the fusion of age-old ideas about the seer-artist with the new notion of an ever-changing historical situation.[6]

What I have been saying was well expressed by Finley Eversole in his preface to a collection of essays published under the title *Christian Faith and the Contemporary Arts*[7]. He writes:

> ' "The human race," says Graham Greene, "is implicated in some terrible aboriginal calamity." It is this fact, reported and interpreted in the art of our time, which gives the forms of contemporary art the appearance of "chaos". It is this fact also which forces upon the artists of the present age their prophetic role. Indeed, it is not the preacher or the sociologist who speak to us most clearly of the "crisis in civilization" in which we are involved, but the artist. Our art, then, is an art of anguish and guilt, of isolation and emptiness, of doubt and damnation. Contemporary art has rediscovered the irrational—in the depth of the demonic! Yet our art has discovered, as the art of no other generation has, the meaning of freedom, of courage, of inwardness and honesty . . . Modern art, with its loss of God and the human image, is the drama of our age. Here we see what *really* is happening to man, to society, and to man's faith in God.'

Drugs—and religion

But there is another way of reaching out to the beyond, and of

[6] I have written about this at greater length in 'The Artist as a Prophet', one of the two essays published in my *Art and the Public Today* (L'Abri Fellowship, Huémoz, Switzerland, 1967).

[7] Abingdon Press, Nashville, 1962.

experiencing a reality that is outside the realm of common-sense, the technological, and the Establishment with its capitalism and security: drugs. With drugs, it is said, we can reach a vision of the world transcending anything we experience normally. We can have expanded minds, we can see what 'they' cannot see.

Why the drug? We quote from the *San Francisco Oracle*[8]:

> 'One of the great mysteries emerging under psychedelic substances is the recognition that the physical self is but a vehicle for the manifestation of soul forces which can be transmitted, transferred and stimulated like rays of Divine Light . . . Evocations of your dedication to the nature of the ethic: expose oneself to new forms of energy and find faith in molecular energy released by psychedelic molecules. Not blind faith. But faith in the harmony and wisdom of nature . . . Cellular consciousness touches timeless wisdom. Transcendental consciousness—pure energy—the light within—the Void.'

Awareness and consciousness are the key words. And yet all this ignores two objections. First, there is an in-built negative in the drug and its effects. This is quite apart from the effect of 'bad trips', people becoming insane or their brains being affected, for these could well be overcome in time with better drugs and do not affect the basic principle. The drugs are made in a factory, or even when they are natural plants or growths, they belong to the material world. The drug experience does not really transcend physical reality. We have expanded minds, and have new experiences, see new things, or rather see well-known things in a new light—and yet we are still within the framework of the Enlightenment, for we start from our senses, from our human experience. Faith here is not faith but confidence in a technique to see more than usual, while in principle we are still bound to our human experience.

A different slant on the same fact can be seen in the argument for drugs put forward from the side of 'scientism'. Arthur Koestler in *The Ghost in the Machine* discusses evolution. Incidentally, it is extraordinary how Koestler introduces in a strange and subtle way a kind of immanent thinking element which guides evolution in some way. To Koestler the human being is in a way a mistake of evolution, or a transitional phase to something else. But to

[8] Vol. I, no. 7, 1967.

Cover of *Back to Godhead,* magazine of the International Society for Krishna Consciousness, 1966

counteract the wrong element, and perhaps to take man's evolution a stage further, we must take drugs. 'Please, chemists, make better drugs in order to save mankind and promote evolution!'

The idea is not a new one. It was already in Huxley's *Brave New World*, in which he describes the technocratic world of the future, the rosy world emerging from a totally successful technological evolution and revolution; yet he introduces a drug, soma, that is taken by the super-men to counteract their fears and feelings of meaninglessness. The idea is not new: Huxley not only wrote about it, he used it. Huxley's technological age has already begun.

Thus drugs are both a product of a technological world and a need of a technological world, and so belong wholly to the framework of the world of scientism and technocracy. But this is just what the new generation of hippies and others want to escape. So in the end it is no good. Drugs are worse than useless. Indeed many of them see this and stop using them, though others continue to advocate them for different reasons. It is not easy to get rid of the demons once they are released.

But there is a second fatal objection to drugs, the fact that they are used to promote a false 'religion'. The aims of drug-taking as quoted above are very similar to those of Eastern mystical religions. And indeed, as we have already seen, many turn to these religions. They answer the craving of our times for a religion that is non-Christian in which one is never asked to believe in any creed and which is in a way no more than a method, a technique of preparing one's own salvation. It is a way of losing one's identity, one's individuality, and escaping responsibility for others. It is pseudo-religion.

Modern man longs for just such a new myth. He tries everything, all kinds of mysticism, the cults, even devil-worship. Man indeed is more than mechanistic science can account for. He still searches for truth, knowing that the world is greater than atoms and rabbits. His freedom proves it. But it is a freedom which may be used to choose the wrong, the sinful, death and perdition. Paul writes of 'men who by their wickedness suppress the truth'. This is their freedom.

Men and women, human beings, long for true and real reality, true, real life, the fullness of humanity—and the freedom that should go with it. But they have lost it, and continue not to find it so long as they stick to the basic principles of the Enlightenment, of which the first and the last is that man wants to be autonomous, and does not want to acknowledge God, the God of the Bible, the God and Father of the Lord Jesus Christ.

But who is to blame? Are those of us who are Christians innocent? Can we really say we warned them? Can we really say that we showed them the greatness of the fact that we are indeed new men, new human beings, in the resurrection of Jesus Christ? Have we shown that the world is indeed open, and have we testified not only with words but in our deeds and in our thinking and our wisdom that we know there is a living God? We must be honest—none of us is free of guilt.

Christians must acknowledge their guilt, too, for allowing their theology to be moulded by the thinking of their age. Too many have swallowed the theology of Bultmann, Tillich and others (especially as popularized by John Robinson), who all accept the picture of reality given by 'scientism': therefore, as Bultmann states, it would mean a *sacrificium intellectum,* a sacrifice of reason,

if he were to accept the miracles and the idea of God acting in time-space history as the Bible relates it. Religion belongs to the deeper and higher, to the same realm of the irrational—that which cannot be ascertained by science—as the one in which the existentialists look for humanity and modern art for meaning. Indeed, there is a great similarity and deep connection between modern mysticism, modern art and modern theology.

What is normal?

What then are men today looking for? What is the force that drives them on, always searching, never satisfied, always up and away again without a moment's peace?

The answer is the fact that the answers are no answers! We can have a drug experience . . . but we come out of it again, and nothing has changed (except for the fact that we may have a hangover). We can have a mystical experience, experience oneness, life that flows within us and without us . . . but one day we see that we were alone after all, and nothing has changed. The world that we wanted to help, to renew, to change . . . remains the same. (Did we really want to change it, in fact, or were we just escaping it?) We can look to the answers of modern art . . . but they tell us that everything is rotten, nothingness, putrid, empty, senseless. But where is beauty, where is truth? We searched for the answer, and they told us: love, love, love. And it was tried, and exhausted we found . . . that love, love, love meant sex, sex, sex, and that nothing had changed.

As we seek life, humanity, the fullness of reality, we must ask, what is this normal human life? There are thousands and thousands of people who do not understand the determinism of scientism, they do not see the fact that they are only rabbits and atoms—copulating atoms, looking at themselves and having problems and worry and frustration. They do not see the real danger of all power being in the hands of big business and industry, manipulating us for profit and making life a lie. They live and work, and think the world goes on as usual, as 'normal'. Modern art is a fake, a hoax and a mistake . . . life goes on, leaving

at the roadside the few who cry strange cries. You can try to lift them up and say to them, 'Why don't you join us? We are making a beautiful world in which everyone will be happy. We can offer money, safety, health and entertainment . . . Of course, there are still some problems left to be solved, poverty, under-developed countries, crime and so on, but we'll get these things sorted out in the end. Of course the world will never be perfect, and people will make mistakes or go off the right track, and you've a right to have a fling when you're young . . .'

These thousands, millions live a normal human life. They play it safe. They evade any real problems. They are nice people living a nice life. They have their little melancholies, unfulfilled dreams of youth—but life is like that. They avoid the major sins, for these do not fit into their pattern of life, the pattern of status and the approval of friends and neighbours. So they live their lives fairly happily,-even if not exactly adventurously, and look for fulfilment in their career, a nice home, a bit of affluence and some kind words at retirement.

This is of course what is called a middle-class mentality. But the mentality has not so much to do with class or social status. It may be strongest in the middle class. But middle-class people are not necessarily middle-class in this sense. It is really the same as what I earlier called bourgeois.

The bourgeois is what the Beatles sing about in their song 'She is leaving home'. She is leaving home, and her parents exclaim when they find that their daughter is 'dropping out': 'We sacrificed most of our lives, we gave her everything money can buy'—but the verdict is: 'She is leaving home after living alone for so many years.' Alone. For so many years. Yet we gave her everything money can buy . . .

Is that really real life? Is that what man was created for? Is that the life Christ died for? Is that Christianity? Heaven forbid!

Why is bourgeois life like this? Because it has no foundation. Morality and wisdom and respectability and love, these need a base, a meaning. Or else they atrophy, and become like withered leaves, or like old faded photographs on the wall. As we have seen, there are good reasons for believing that this type of bourgeois mentality grew in the period of Enlightenment, and is related to it. The higher middle-class people of the eighteenth

century read about the new view on reality, in their *Spectators*, their *Mercures*, the *Encyclopedia*, and they had no particular answer. They did not have a deep faith, and were not really committed in any way. They accepted the view of the new era—but avoided the consequences. They wanted to play it safe, and be nice, respectable people. They were not inclined to face up to the realities of their new view of reality.

So the young generation protests. The protest has already been heard for the whole of this century. And the preaching of the new ideas of revolution, renewal and change has not remained unheeded and without fruit.

The meaninglessness, the closedness of the world of the bourgeois is made stronger by the new means of communication. The media have to cater to the tastes and ideas of the many. They have to be neutral and avoid taking sides or giving strong verdicts. So they help to build up the image of the complete one-dimensional world. God is no more than an idea of a particular group. Neutrality, the average, means leaving out the basic questions, the basic truths. And so the bourgeois mentality is strengthened.

Many of the films people see, for instance (not the real avant-garde, 'important' films) are good entertainment, and often have a little moral point. Yet they are bad. For they depict as true a world which is limited and superficial, one without God, without the deeper questions in man's heart, without real matters of life and death, for life and death are reduced to sentiment, or adventures, or crime and violence or cruelty, without any sort of judgment expressed. Most films of this type are good in the bourgeois sense, and they are certainly not meant to be anti-Christian. But they help to close the sky. They leave God out of the picture. Maybe He was an issue in the past, and so He has a part to play in historical pieces, but not in the world of today.

The protest of the new generation is against this lack of commitment, this lack of real values, this lack of 'daring to live'. The shallowness and emptiness are appalling . . .

The new generation begins to look for real humanity, to long for the fullness and openness and freedom of truth and real life. But after a while it finds only the same old thing, the thing it wanted to avoid, to escape, to change, to decry in the first place.

Alan Starr expresses the tragedy of degeneration from idealism
to a bourgeois mentality as follows :[9]

> 'Now we have long serious discussions in cafés along the Bayswater
> Road,
> We see that there is a law of diminishing returns
> Where demos are concerned.
> It's not that I don't admire Jan Palach, of course,
> But I can't help feeling that he's externalising an internal
> inadequacy—
> The rebel finds the cause; you know what they say about men
> making God.
> My fiancé thinks so. And death's so final, isn't it?
> David left Cambridge last summer—we marry in June.
> We're moving to a house outside Dorking.
> (David says he'll be doing a fair amount of protesting—to Southern
> Region.)
> But we'll keep in touch:
> I still have my Bob Dylan records,
> And we'll go to the Round House and so on:
> Hear John Peel, maybe.
> David says we'll make friends easily if we join the Conservative
> Club.
> There are riding stables near our house.
> I've taken out a year's subscription to the Reader's Digest.
> I think we're going to settle down quite well,
> Really.'

The tragic protest

And so, inevitably, we have come to protest and the rumblings of
revolution. What is wanted is 'relevance and involvement'.[10] The
enemies are 'the destructiveness of industrial age values'.[11] What is
meant by this can be best summed up by bringing together what
I have called technocracy with the bourgeois mentality. Bour-
geois people do not want to be dehumanized and made into little
particles of the great industrial-technical-economic machine;

[9] Quoted from *International Times*, 14 February 1969.

[10] 'Why Those Students are Protesting', *Time*, 3 May 1968. See also
B. Bettelheim, 'Obsolete Youth: Towards a psychograph of adolescent
rebellion', *Encounter*, September 1969.

[11] From an article in *Seed* (Chicago underground press paper), 5
January 1968.

yet they have no real spiritual misgivings about it, for they have accepted, even if grudgingly, the basic presuppositions of scientism and the naturalistic view of the world. Perhaps deep down they do not accept the devaluation of all norms and values inherent in this view, but they have no deep, committed answer. They have certainly accepted it insofar as technocracy offers leisure, money, pleasure, a certain kind of security, sometimes (if you are at the top) power.

Protest sees through all types of bourgeois values which have no foundation and which try to buy comfort at the expense of a loss of humanity. It begins with the sexual revolution: 'The right of two or more human beings to love one another and to express this love in physical terms.'[12] 'Complete sexual freedom is a number one demand for any student movement. All forms of sexual repression and of puritan "discipline" should be abolished.'[13] A next step was to 'drop out', to leave the Establishment and live a kind of bohemian life—indeed, the protest had already begun in the last century with the bohemianism of the artistic circles in France. But now they have seen that they must move on: to quote from the article in *Seed* mentioned above:

> 'We can escape from these dehumanizing systems. The way ahead will be found by those who are unwilling to be constrained by the apparent all-determining forces and structures of the industrial age. Our freedom and power are determined by our willingness to accept responsibility for the future . . . The call is to live the future: let us join together joyfully to celebrate our awareness that we can make our life today the shape of tomorrow's future.'

They live in anticipation of a new world, an anarchist world, a world of absolute individual freedom. The French Revolution (at the end of the first period of the new era of the Enlightenment) stood for 'liberty, equality, fraternity': in the revolution of today it is called 'freedom, the end of privilege and licence, and love, love, love'.

But just as the French Revolution ended with a dictator, the end of freedom, wars and the end of all the things the revolution stood for, so this could so easily be the case today. Indeed the

[12] *International Times*, London, 14–27 February 1969.

[13] F. Halliday in the symposium *Student Power*, ed. A. Cockburn and R. Blackburn (Penguin Books, Harmondsworth, 1969).

revolutionary forces in our society are breaking down real democratic freedom, and the liberal freedom that each may think for himself. Revolutionary students are asking whether a professor who has particular views on certain issues should be allowed to remain a professor: intellectual freedom is in danger, too.

But what if the counter-revolutionary forces take over, defending the Establishment, and standing for their own bourgeois values? This has happened in Greece and in other countries (and almost happened in the USA). This may sound a better solution, but we must realize that again freedom is lost: totalitarian forces ask for support or else . . . This is the way that leads to the concentration camp. The revolution that starts with anarchism and ends with dictatorship is without any doubt anti-Christian; but so too could be the counter-revolution which may well not accept the Christian either, if he stands for freedom and justice and hungers and thirsts for righteousness. The freedom he stands for is different from that of the anarchists, but in asking for humanity and a refusal to bow down to the gods of the totalitarian state he will become a marked man nonetheless.

There is a tragedy inherent in revolutionary thought and action today, in the spirit of our age. They are in revolt against forces that are unjustifiable, against a world which is dehumanizing, a system that on many points is wrong, but . . . they have no alternative. Their own world view is basically the same as the one that is responsible for the world they are revolting against. So what will be the result of their revolutionary action? Only a world changed even more in the direction of the world view that has been the driving force ever since the Enlightenment, a completely secularized world, without God, in a closed system, with a duality of rationality and irrationality, naturalistic and mystic at the same time. The last remnants of the older world-view still flavoured with the salt of Christian values—open, knowing of a God, of justice and absolutes—will be done away with. Though many revolutionaries return after a while to bourgeois values of one kind or another in order to be able to live 'a decent life', yet their work will be done, and we must not minimize its importance for the world at large.

So far the revolution has been largely the concern of students

THE INTERNATIONAL TIMES

No 9 Feb 27-Mar 12 1967/1s

*j.p. sartre • p.j. proby •
tuli fugs kupferberg •
physiodelic backlash.*

WHEN THE MODE OF THE MUSIC CHANGES,THE WALLS OF THE CITY SHAKE !

or those of student age. But the danger is that the result will be a loss of freedom for all. As *Time* magazine put it,[14]

> 'Revolution is a serious business, with a terrible but often heroic tradition, and it must be reserved for situations of extreme despair when no other recourse is possible. Playing at it when it is neither possible nor necessary only makes reform harder to achieve and gives revolution a bad name.'

But the revolutionary groups will work on, nevertheless, for they see their work as a historical necessity. They may not be overthrowing governments, and there is no guillotine. But

[14] In the issue of 28 March 1969.

because it is happening in a more unobtrusive way the revolution is achieving more, much more, than most people realize.

The permissive society

Indeed it would seem that the fast-moving cultural scene and the great changes of the last ten years are the result of a revolution. And the end is not yet in sight. Occasional riots, fighting in the streets and on campuses, demonstrations and the like are only the open eruptions, small by comparison with the great volcano on which we are living.

The real revolution is caused by the claim that all values and norms are basically social, and that man is free to live as he wishes (provided that there is equality and no-one hinders another). So there should be not only no wars, no poverty and no discrimination, but also no barriers, no restraints, no authorities.

Norms had lost their foundation with the Enlightenment: Hobbes, followed later by Rousseau, had looked for a solution in the social contract. Today authority has lost all meaning. One cannot lay down the law for another, it is said; we are each a law only to ourselves, for authority has lost the values on which it depends. The remnants of the dignity of authority in the state, in the family, in the church even, are in danger of being swept away. And yet this only produces agony, frustration and neurosis, not to speak of the lowering of standards or achievement in schools, industry and in many other fields.

For though the new ideas are idealistic, and aim for a better world, yet they do not work in practice. Or perhaps we should say that they do work, but in the direction of the breakdown of our society. Statistics are there to prove that moral standards are lower or have collapsed, that there is more crime, more juvenile delinquency, more adultery, more divorces, more homosexuality each year. Some react to this by saying that those things no longer really matter, that traditional moral standards no longer count. There is a cry for free love, for easy ways to divorce, for permissiveness in every way. But when things get so bad that it is clear to all that they are bad, then the structures of society are called in question, and protest and revolution are looked for as a

means of making a better world. But these then serve only to quicken the whole process of breakdown.

We see the faults in the underlying principles of this, the inner contradictions as well as the contradictory results. To make freedom possible freedom is quenched. To end violence and war violence is used. The world must be changed . . . but very few have any real, supposedly workable suggestion about which road to take and what the new world should be like. We must see the tragedy of it as well as the frustrations that result from it.

Playboy magazine, in an article on the hippies in 1967, wrote:

'The rules of habit, tradition and authority are eroded. The threats that kept those rules in force—the punishment of God, pregnancy or disinheritance—have been eliminated by the dimming out of religion, the pill and the erosion of family structures. One of the dangers of the new youth style is formation of what critic Harold Rosenberg has called "the herd of independent minds". The opportunity, however, is to make a new tradition of the tradition of the new.'

Indeed, we must realize that the change of manners and morals, showing the speed of the de-Christianizing of the western world, the result of paying no more than lip-service to biblical truth or even to God Himself, this is itself the revolution. The permissive society is the result, not the cause. Pornography sold openly, nudity in film, stage and advertising, free love, experimental marriages and the like are now no longer new. The work of a group of people devoted to change the world, artists, editors such as *Playboy's* Hefner, writers, philosophers and idealists, have been successful. For the sake of promoting sales and making money, advertising plays on the fringes of what is and is not acceptable, and so the whole process of breaking down barriers has been speeded up beyond any normal development. The same may be said of films and every kind of mass entertainment. Today things can be shown in films that would have been· impossible even five years ago, and in advertising even the most intimate things are blatantly paraded. Here, if ever, the protesters are right when they say that capitalist society is prostituting women for the sake of profit.

An article in *Newsweek* sums up what I have been saying:[15]

[15] In an article entitled 'The Permissive Society', 13 November 1967. Europe may be one step behind, but is little different.

'The shattering of taboos on language, fashion and manners generally is part of a larger disintegration of moral consensus in America. Vast numbers of Americans distrust their government. Catholics in increasing numbers simply ignore the church ban on birth control. The family has changed from a breeding ground of common values into a battleground of generations. These dislocations have moved many writers to reach for the strongest language in their arsenal to capture the chaos of their time . . .'

Is this just moralizing? Or exaggeration? Yet there are many others who are seeing the same thing. The artists themselves, the makers and the children of the revolution of today, they see it— in despair, in frustration, or in fits of destructive anger. 'The destruction is more important than the content', said a beat musician on BBC TV not so long ago.

Martin Esslin (who should know, for he was very much involved) ends his book *The Theatre of the Absurd* as follows:

'Ultimately, a phenomenon like the theatre of the absurd does not reflect despair or a return to dark irrational forces but expresses modern man's endeavour to come to terms with the world in which he lives. It attempts to make him face up to the human condition as it really is. . . There are enormous pressures in our world that seek to induce mankind to bear the loss of faith and moral certainties by being drugged into oblivion—by mass entertainment, shallow material satisfaction, pseudo-explanations of reality and cheap ideologies. At the end of that road lies Huxley's Brave New World of senseless euphoric automata. Today . . . the need to confront man with the reality of his situation is greater than ever. For the dignity of man lies in his ability to face reality in all its senselessness; to accept it freely, without fear, without illusion—and to laugh at it. This is the cause to which . . . the dramatists of the Absurd are dedicated.'

The question is, what are they really laughing at? We must dig a little deeper.

Apocalypse

When we sense the feeling of our time it may strike us that so much of it seems to echo what is written in the Bible. We see man as it were crying out in his agony, hiding in the caves and among the rocks of the mountains, calling on the mountains and rocks to fall on him and hide him . . . yet, as the book of Revelation has it, 'the

rest of mankind, who were not killed by the plagues, did not repent . . . of their murders or their sorceries or their immorality or their thefts'.[16] When we read Paul's second letter to Timothy about 'the last days', we are struck by the fact how true all this is of our day, even more so than a generation ago: 'Men will be lovers of self, lovers of money, proud, arrogant, abusive, disobedient to their parents, ungrateful, unholy, inhuman, implacable, slanderers, profligates, fierce, haters of good, treacherous, reckless, swollen with conceit, lovers of pleasure rather than lovers of God, holding the form of religion but denying the power of it.'

We realize too when reading this how much we ourselves are also touched by the spirit of permissiveness: we would scarcely use such strongly critical words today. Paul goes on to speak of men 'who will listen to anybody and can never arrive at a knowledge of the truth'. We too must be aware how near our age is in spirit to that of the 'lawless one' described by Paul in another letter as coming 'with all power and with pretended signs and wonders, and with all wicked deception for those who are to perish, because they refused to love the truth' . . . and we are wondering whether God is not really sending upon them 'a strong delusion, to make them believe what is false'.[17] We can go on to read 2 Peter 2, or the great preaching of Jesus Himself about the last days recorded in Matthew 24.

As we walk through a modern art gallery, do we see the sky vanished like a scroll that is rolled up, the sun becoming black as sackcloth, the moon becoming like blood, the stars falling down . . .? Even theologians today dare to speak of a God who is dead. 'I hid my face and was angry', God says through Isaiah. 'They shall go to seek the Lord, but they will not find him; he has withdrawn from them', says Hosea.[18]

God is not dead, nor the world a closed system: He, the Creator, He who loves mankind even to the sending of His Son to die, He not only came in Old Testament times with His righteous anger and judgment upon men who forgot Him and walked in their own sinful ways, He will do so in our times, too, as Revelation makes

[16]Revelation 6:16; 9:20.
[17] 2 Thessalonians 2:9–11.
[18] Revelation 6: 12–14; Isaiah 57: 17; Hosea 5: 6.

clear. The world is open for God: it is the very core of the gospel that He has come in Christ to save the lost. But the other side of the same coin is that there is no love without judgment. There is a God to be feared.

This language is often too hard even for those of us who believe in Him. But if we do not listen to it, we shall miss the good news of the gospel as well as the many words of consolation in such books as Revelation itself. And we shall miss the key to our times that are hard and strange while our culture is breaking down. If any confirmation is needed, go to the films, read the books of today, walk round a modern art gallery, listen to the music of our times— and hear, see, open your eyes and ears to the cries of despair, the cursing, the collapse of this world . . . and see your Lord coming with judgment.

But see too His grace in all this, in wars and rumours of wars, in unsolvable 'world problems', in violence and revolt in the midst of opulence. For it means that He is still concerned for us. History is still in the hands of God. There is nothing happening of which He did not know before. Did He not send His prophets to foretell these things so that we should not be weak and falter and fall?

But we Christians too must beware. For we must understand that judgment begins with the household of God.

Towards a renewal of the church

> 'The good Samaritan is dressing, getting ready for the show;
> there will be carnival tonight on Desolation Row.
> Ophelia is near the window, for her I feel so afraid,
> on her twenty-second birthday, she's already an old maid.
> To her death is quite romantic, she wears an iron vest,
> her profession is her religion, and her sin her lifelessness.
> And though her eyes are fixed upon Noah's great rainbow,
> she spends her time peeking in to Desolation Row.'

Bob Dylan's song does not give an exactly flattering picture of the church: Desolation Row! And everyone knows the complaint of the Beatles about Eleanor Rigby and all the lonely people (where

do they come from?). The preacher is darning his socks . . . and
nobody is saved. For it is easy to say that 'they' are wrong and
haters of God. We must realize that in the Bible the people of God
as well are often depicted in quite dark tones. The prophets
thundered at the 'church' of their days, the Jewish people with
their temple . . . Jeremiah was even forbidden to pray for them.
We read in Isaiah 1 of the church people whose religion is only
lip-service, and who do not really trust in the Lord. No, the
situation of a weak, a fallen, a faithless church is not new. Again
and again the people of God have deserted Him, looked to other
gods, other ways of being saved, other securities and, with the
Bible in their hands, have asked of the prophets to speak nothing
but peace, peace—yet, says Jeremiah, there is no peace. Perhaps
faith is just a word, a formula, a tradition, and God no more than
an idea . . . And God cries out through the prophets in His Word,
today as ever, 'Where is the love of my people?'

Who were Christ's enemies here on earth? Not the godless and
lawless, not the criminals or the 'far-out' people. No, His enemies
were the churchmen of His days, the Pharisees with their ortho-
doxy and knowledge of the Bible, and yet . . . they were seeking
for their security in being Jewish, as children of Abraham,
and in their cleverness in dealing with the Romans. They did
not dare to follow God Himself, the Son of God amongst men,
with the adventure of trusting Him, loving in freedom—and of
taking up the cross.

In modern terminology this can be described by saying that
the churches have become bourgeois. They are moral, even
moralistic; they are either deadly orthodox, keeping legalistically
to the old creeds, or want to be radical, liberal, modern, and
demythologize the Bible, which really means taking out of it a
God who is too concrete and too real. A bourgeois Christianity is
one in which the salt has lost its savour, one which is lukewarm,
and neither hot nor cold—as the Beatles sing on the Sergeant
Pepper record, 'The love that has gone so cold . . .'[19]

Certainly, as in Elijah's day, there are still the 'seven thousand'
who have not bowed the knee to the gods of today. There are still
people who are ready to follow the Lord wherever He leads

[19] *Cf.* Matthew 24: 12.

them. But they are scarce. Would He find faith on earth when He returned? Christ asked. Unless we pray and work (in that order) for true reformation and revival, unless we return to the Lord, there is no future for any church. God Himself will throw it away as saltless salt.

We may study the present situation, point to the fact that our culture is collapsing, notwithstanding its technical achievement and great knowledge in many fields . . . yet we must never think that it is just 'they', the haters of God. We must realize that we Christians are also responsible. Much of the protest of today's generation is justifiable. But why did not Christians protest long ago? Why were we not hungering and thirsting for righteousness, helping the oppressed and the poor? To look at modern art is to look at the fruit of the spirit of the avant-garde: it is they who are ahead in building a view of the world with no God, no norms. Yet is this so because Christians long since left the field to the world, and, in a kind of mystical retreat from the world, condemned the arts as worldly, almost sinful? Indeed, nowhere is culture more 'unsalted' than precisely in the field of the arts—and that in a time when the arts (in the widest sense) are gaining a stronger influence than ever through the mass communications.

Christianity has the answer—if it only cares, or dares, to listen—the answer to the problems of our age. But why does it keep silent? Or why does it just say to people who are increasingly estranged from biblical language and thought patterns, 'have faith, have faith', without really answering the chilling questions being cried out in agony. Jesus saves: indeed, but that means not only saving your soul out of the shipwreck of this world! His saving grace redeems us here and now, and gives answers to the problems of today. He is able to redeem us, really and truly, not just 'spiritually' in a narrow sense.

Yet this does not mean that the answer is cheap. It means a call to repent, to trust in the Lord, to be willing to sacrifice. Our culture can be renewed, but if God gave reformation tomorrow, pouring out His Holy Spirit, we would still have to work perhaps a generation or more before the fruit would be ripe, the building mended.

My Word is for ever, said Jesus Christ. He does not ask us to jump in the dark, in blind faith. He never asked even His

disciples, or others who listened to Him in His own time, to accept Him only because He said so. There were the 'signs' to back up what He said, and the fulfilment of words spoken in the Old Testament. If Christ was really the one He claimed to be, if God really lives and is Lord of heaven and earth, then it is not so very difficult to believe the things He did. In the same way in the Old Testament God pointed to things that had happened in history, such as the great deliverance from Egypt, and the way He had spoken to His people from Mount Sinai. He points to the words of the prophets which were fulfilled, and sometimes gave miracles. Miracles were not the daily experience of people in Old Testament times—nor just childish fancy as some would have us believe—nor were there angels at every street corner. But, when necessary, God did move, and showed His power or presence. So too in the New Testament Christ showed His power over creation by walking on the water, the very symbol of chaos. He showed the power of His new creation, too, by raising people from the dead, healing, giving new life.

But even signs and miracles will not automatically produce faith. Even at the times when the Jews were shown great signs, when they were brought through the Red Sea and sustained in the desert, there were still people who did not trust in the Lord, but grumbled and cursed and rebelled. Today too people can be blind to the work of God, and deny with open eyes the things they see. Faith means love and trust. The question is not whether we believe that God exists (even the devils know this) but whether we trust Him, love Him, and are willing to follow Him.

But we will never follow a phantom, something beyond our understanding, something vague and above human experience. We cannot understand God fully, nor know His work completely. But we are not asked to accept in blind faith. On the contrary: we are asked to look around us, and know that the things He tells us through His Son and His prophets and apostles are true, real, and of this world, the cosmos He has made.

Therefore our faith can never be just 'out of the box', irrational. Faith is not a sacrifice of the intellect if we believe in the biblical account of history. For if we accept the view on reality revealed in Scripture, we know that 'the box is open', that the world is open, that there is a God who can and does act, who answers prayer,

who is not hidden away or remote from the factuality of this world. Yes, we can see things happen if we want to. Jesus Christ's promise was not an empty one when He told us that our prayers would be answered if we loved Him (saying this at the Last Supper, as told in the Gospel of John). The Christian can never be a rationalist, only accepting things he can prove with his brain, nor a naturalist in the sense that only those things are real that can be experienced with our sense-perceptions. The Christian is asked to use the brain God gave him, to understand His Word, to accept Him as the basis of the things He has done in history and in the lives of others, and in showing His dominion over the forces of this world.

Unless we understand that a demythologized Bible is a closed Bible, for all the proofs of God's work and acts are taken out of it; unless we understand that a blind faith is no faith, and that faith is never irrational, even if it destroys all scientism, the rationalism of the closed naturalistic 'box', knowing that reality is much bigger than the 'box'; unless we understand that we live in an open world, and that God has as much to do with the atoms as He has to do with the minds and hearts of people: unless we understand this we have no weapon against the spirit of our age. This is the battle of Ephesians 6!

Unless we see that faith means trusting in the Lord, listening to His Word, and that therefore a duality of nature and grace is a disgrace to God, robbing Him of His authority where He is indeed the Lord; unless we see that there is no higher and lower in the sense of grace and nature, but that the real division is between holy and sinful, true and false, love and hate: unless we see this we shall have no answer to the deep agony of the world. Our religion in that case would be just another mystic leap into irrationality, no better and no worse than eastern religion, modern mysticism, or even drugs. Our Christianity then would be no more than pseudo-religion.

But we do understand and see aright, if we are really willing to trust and follow Christ in all we do and are; then we must work it out in our lives, in our thinking, in our creativity. In the next chapter we must go on to consider how.

Chapter nine
FAITH AND ART

I'm going to live the life I sing about in my song.

Mahalia Jackson, *Newport 1958*

How CAN Christians live out their faith in the culture around them? Or, to put it more widely, how should man go about his life and work in this cosmos, God's creation?

First, he has to act in relation to the given structures of reality. These were given with creation, as possibilities, as open ways, as norms, as a framework in which to work. These of course are nothing like a 'natural law'. There is nothing 'natural' in this sense in the world, for the whole world was created by God, through Christ. 'In the beginning was the Word' . . . 'through whom also he created the world'.[1]

These norms or structures are 'possibilities'. We could not speak, for instance, unless we had been made with the 'possibility' of speaking. How should we teach, then? By following the given possibilities of teaching and learning, within a given structure. There is no marriage, no economics, no prayer, no art but for the fact that they were made possible by God in His creation: He created the possibility. So these structures are the horizon of man's activity. We cannot do anything but within the created order—to be outside this order is to be outside of reality. To this reality belong imagination, fantasy, the discovery of things unheard of and undreamt of—for God gave man these things, and imagination is not outside creation's structures.

Man can live and act within the structures, and he can do so in love and freedom, with his personality, his subjective humanity, given to him by the Creator of life. This is humanity: to make something of our life; to realize the possibilities God has given us; to realize a good marriage, if that is for us; to do a good job, to

[1] John 1:1; Hebrews 1:2.

enjoy the life one has, the possibilities laid within our personality.

Of course, sin has entered the world. Sin is a would-be freedom from God, but it is no freedom. It makes me captive to the law of sin which dwells in my members; 'for whatever overcomes a man, to that he is enslaved'.[2] And though the Christian has been freed from the bondage of his sin by Christ, yet so long as he is in a sinful world he has to do battle against sin, hungering and thirsting after righteousness, seeking peace, helping the oppressed —and fighting against his own sin, too, in order to have the freedom and openness that belong to the fruit of the Spirit: 'love, joy, peace, patience, kindness, goodness, faithfulness, gentleness, self-control'.[3] This is freedom!

Realizing one's possibilities, acting in love and freedom within given structures, fighting against sin and its results, all this is also what creativity means. Artistic creativity is only one of the many creative possibilities.

And if we are creative in this full sense, being new men and women, sharing the new resurrection life of Christ[4], then the fruits of His work will be seen in our lives, which will in turn have results in this world. This will never be perfect, of course. The Christian is no easy idealist, but very much a realist, for the Bible is under no illusions about the realities of human nature. But if we are 'salting salt' at all, then this will do its work in society, making sane and healthy what was crippled and broken. Simply doing the truth and acting according to the will of God will bring life and freedom and love and righteousness. This then is how we can define Christianity's influence in culture: as a fruit of a fruit of the Spirit; as salt in the world.

We are called to be creative in this sense. And we are called to bear the cross that often goes with it, for mankind often prefers darkness to light, enslavement to real freedom.

But are not Christians supposed to be pilgrims and strangers in this dark world? In one sense, no. This creation is God's, and we belong to Him, so we are at home in it. We are never frustrated because of the given structures of reality. The gospel is not one of bondage, but of freedom. As Paul stressed again and again, Christ came to make us free (see his letter to the Galatians, for example). We have been set free to be what man was originally intended to

[2] Romans 7; 2 Peter 2: 19. [3] Galatians 5: 23. [4] *Cf.* Romans 6.

be. Beauty, joy, love, all these things are God's gifts to mankind to be entered into and enjoyed.

Yet man has depraved and ruined these things. So in another sense, we are strangers in this world. We are strangers insofar as sin reigns, insofar as corruption is there, unrighteousness, uncleanness, wickedness, greed and ugliness. We realize only too acutely that these things are still in ourselves, too, and we weep for the fact and long for the redemption of the body. Blessed are those who weep, those who know that they are not strong in themselves, those who hunger and thirst for righteousness (beginning in their own lives), this is what Christ told us in the Beatitudes.

So if we are called to keep ourselves from sin, keep ourselves clean, it means that we must understand what the world is. If we think we can keep away from the world by living the life of a hermit, we are mistaken. 'For from within, out of the heart of man, come evil thoughts, fornication, theft, murder, adultery, coveting, wickedness . . .' [5] Nor can walls of legalism or 'do's and don'ts' be our fortress, for the Lord must be our fortress; and our enemy is the spiritual power of wickedness and the spirit of our age. We are certainly not in any position to wash our hands of the whole sinful world, or complacently let it rot, or feel that we are too holy and spiritual to get involved. For we *are* involved: it is *our* sin that has helped to make the world the sinful place it is. We are responsible. If we are not acting as salt, even if we are not involved, or hungering and thirsting for righteousness, we are responsible.

Being a Christian means being clean in an unclean world. It is hopeless to try to be beyond contact with evil. Not only is it within, it is all around us. Much as we may look forward to 'a new heaven and a new earth', we cannot opt out of the world here and now. It is for us to be not only clean amidst its uncleanness, but joyful and compassionate amidst its sorrows. We must understand it to know what is of God, to know what is good and what is evil. But it is not for us to judge it or write it off, for it is for God to judge.

Jesus said, 'You are the salt of the earth . . .'

[5] Mark 7: 21, 22.

Christianity in art

What place should art have in all this? Can there be a Christian art bearing its witness alongside other art? Is there any such thing in fact as Christian art? Can art be used for Christian purposes? Here I must say emphatically: art must never be used to show the validity of Christianity. Rather the validity of art should be shown through Christianity.

In an earlier chapter I discussed the difficulty of portraying biblical themes in art. This does not mean that specifically Christian themes are impossible. It means only that Christian art is not art that uses biblical or other Christian themes. Picasso painted more than one Crucifixion; but they were curses rather than done in faith. Many biblical themes were handled in a Humanist spirit after the Renaissance. And, of course, almost all heresies have found some sort of expression in art.

No, what is Christian in art does not lie in the theme, but in the spirit of it, in its wisdom and the understanding of reality it reflects. Just as being a Christian does not mean going round singing hallelujah all day, but showing the renewal of one's life by Christ through true creativity, so a Christian painting is not one in which all the figures have haloes and (if we put our ears to the canvas) can be heard singing hallelujahs.

Christian art is nothing special. It is sound, healthy, good art. It is art that is in line with the God-given structures of art, one which has a loving and free view on reality, one which is good and true. In a way there is no specifically Christian art. One can distinguish only good and bad art, art which is sound and good from art which is false or weird in its insight into reality. This is so whether it is painting or drama or music. Christians, however full of faith they may be, can still make bad art. They may be sinful and weak, or they might not have much talent. On the other hand a non-Christian can make a thing of beauty, a joy for ever— provided that he remains within the scope of the norms for art, provided that he works out of the fullness of his humanity, and does not glory in the depraved or in iniquity or glorify the devil.

So a work of art is not good when we know that the artist was a Christian: it is good when we perceive it to be good. Nor is a work bad if we know that the artist was a hater of God. It would be

possible to make an exhibition of beautiful Picassos. The exhibition would possibly not do justice to the spirit that drove Picasso on in his creativity, yet it would show us that the man is human. Human beings, even if they do not love God, do not thereby become devils.

This does not mean that art is neutral. Nothing is. Art is a human creation, and as such is closely bound to a particular person's humanity. Therefore it is his spirit, his insight, his feeling and his sense of beauty, his imagination and his subjectivity that the work of art will show.

Is it possible for 'beautiful' art to come out of an unholy, ungodly spirit? History has shown that it can. Yet, in the long run, death must show itself. If we walk through a gallery today, we can see this death. Sometimes art has gone the whole way: with John Cage's music, for example, or Fontana's pierced canvas. Yves Klein showed his 'freedom' by making a painting with a completely blue surface—and nothing else. Whether by showing a void like this we can make art is another question. In all these cases—often called by the artists themselves anti-art—we are dealing with borderline cases. Yet they show that, in the final analysis, with a completely anti-Christian and anti-Humanist spirit art is finished.

Christianity is about the renewal of life. Therefore it is also about the renewal of art. This is how art can be shown its validity through Christianity. It is an expression of Christian understanding, itself a fruit of the Spirit of God, including the emotion, the feeling, the sense of beauty that is bound up with it. It is for Christians to show what is meant by life and humanity; and to express what it means for them to have been 'made new' in Christ, in every aspect of their being.

The role of art

Art needs no justification. The mistake of many art theorists (and not only of Christian ones) is to try to give art a meaning or a sense by showing that it 'does something'. So art must open people's eyes, or serve as decoration, or prophesy, or praise, or have a social function, or express a particular philosophy. Art needs no such excuse. It has its own meaning that does not need

to be explained, just as marriage does, or man himself, or the existence of a particular bird or flower or mountain or sea or star. These all have meaning because God has made them. Their meaning is that they have been created by God and are sustained by Him. So art has a meaning as art because God thought it good to give art and beauty to humanity.

This does not mean that art cannot at times teach, praise, prophesy, decorate and help social relationships. It does so, often, just as a bird can be useful, or even as the life of a particular human being can be fruitful and important. But it would be false to say that art is only good if it promotes Christianity. This would be a perverted kind of utilitarianism. Art and singing can be used to promote worship—indeed, worship without good music is almost unthinkable—and art may be used in evangelism. But art does not need to be justified because it can be useful in this way. We must be careful here: if we are going to use art for these specifically Christian purposes—adorning a church, or attracting the unbeliever—then we must see that the art we use is really good. Cheap art means cheap worship or a cheap message. Perhaps I was overstating the case when I said that art should *never* be used to show the validity of Christianity. What I meant was that this is not art's primary function. But if it is going to be used, it must be really good for the purpose, and do the job well. But quite apart from the use to which it is put, art has its own validity.

Perhaps one of the main problems of art today has been the result of giving art the wrong function. Formerly art was 'an art', just as we still speak of arts and crafts. Art as a higher function of mankind, the work of the inspired lofty artist, comparable to that of the poet and the prophet, was the outcome of the Renaissance with its neo-platonic way of thinking. Yet the fatal conclusions were only drawn later: the modern division between the fine arts —drama, poetry, literature, music, painting and sculpture—and the applied arts such as pottery, tapestry and so on, is of fairly recent date. It was the outcome of a development in the theory of art at the end of the seventeenth century in academic and connoisseurs' circles. It was no accident that this coincided with the beginning of the 'closing of the box', the beginning of the Enlightenment. With the dichotomy of reality, the dualism

between the realm of the sciences and the higher realm of human freedom, 'cultural matters' and art were given a new task. Art became Art with a capital A, a high, exalted, more humanist than human endeavour. Yet precisely in that pseudo-religious function it became almost superfluous, something aside from reality and life, a luxury—fine, refined, but useless.

If we were able to break through this false duality, and see art again simply as art, with its own validity, art would regain its freedom, a part of human life, and acquire a renewed meaning in life. Neither art nor beauty needs to be justified or put on a pedestal. They are to be enjoyed and appreciated and practised, in love and freedom, as a joy for ever, accepted as a great gift of God.

Questions of aesthetics and morals

Some people feel that we ought to define the principle of art solely by the aesthetic. Is not this the core of art, the real heart of it? Is not this its true meaning? Very often, in the course of a discussion of modern art, it comes down to saying that its sole meaning is to be found in its lines and forms and colours, the aesthetic element as such.

Personally I have many doubts about this. First of all, this truly abstract art is very rare—much non-figurative art does have a meaning apart from its purely aesthetic appeal. The strange thing is that artists, almost without exception, do strive to express something in their art, and only rarely are happy with the aesthetic element alone. To me this is one of the proofs that any theory that goes too much in this direction is out of touch with real artistic practice. Of course, there exists artistic work done only with an eye to the aesthetic effect: fabrics, ornaments, some types of typography, and so on. But the problem does not really arise with the so-called applied arts. In fact, the beauty often found in good work of this sort is exactly the quality that the modern artist—pop, zero, and the like—seeks to destroy with his anti-art. Art, it is said, does not need beauty.

The whole argument is full of confusion. In searching for an art that is 'pure', people who stick to this theory tend to do away with everything that is not 'pure', not aesthetic: subject-matter,

reality, feelings, everything. Certainly this type of pure art would be abstract in its proper sense, because the aesthetic element is indeed an abstraction. But, as I have said, 'pure' art in this sense is very rare. But why should we look for such abstraction? Would it not deprive art of its concrete value and fullness of being? What is love (in a man-woman relationship) if there are not two specific people loving each other? If, as it is said, the most essential element of man is his rationality, his brain, would it not be better to cut people up and only leave the brain? But the person would be dead . . . People who say that money is what matters most in life are not happy with money alone: they want to have the concrete reality that their money can buy.

So in talking about art we are not just discussing aesthetics in an abstract way. We are dealing with the fullness of the phenomenon in the whole of life, in which, even if beauty, the aesthetic, is very important, there are many other elements. The aesthetic can never be realized in its fullness without these other elements, and the other elements only get their artistic meaning because they are brought together in an artistic way. Art is a complex structure (and there is no intention of trying to give a complete analysis of it in this book). As a complex structure, it exists in its realization in concrete works of a reality, a being, a meaning, composed of many elements; and even if it can exist without some of these elements, and sometimes does, yet it is more often than not poorer without them. A man can exist without his legs—but his being is fuller and in a way more meaningful if he has them. 'Pure art' is often poor art, even if it is beautiful.

Another question that is often raised is this. Should art be criticized on two levels, one aesthetic, the other moral? I think not. First, to use the term 'moral' here is too narrow. It is better to speak of content, or expression, or portrayal of reality. Indeed, real life is complex, and through sin, human shortcomings, and the fact that all human creations are less than perfect, there will always be inner conflicts. A man may have tremendous insight, deep understanding, and a great vision of what he wants to create: but if he is not able to realize it in an adequate form it will not be a good work of art. Another may be poor in vision and has almost nothing to say: yet he has a superb feeling for colour. He paints a picture that is excellent in that respect but poor in

content. Well then: his work of art is poor in content and beautiful in colour. When we study the really great works of art of history, we always find that their meaning is a unity: a beautiful idea is expressed and realized in a beautiful way. Each line, each colour, the whole composition is conceived in order to make the idea clear, and the idea would never have been made clearer than precisely by means of this particular composition with its colour scheme and so on. Every brushstroke 'carries' the meaning of the picture.

The question is in fact related to the old philosophical problem of form and content. Without trying to go into it here, I can only say that form can never be without content nor content without form. For, as McLuhan has shown, the meaning is in the medium —that is, in the artistic way of expression itself. So the question poses a false problem. A work of art is much more complex in structure than can be analysed by these two concepts of the aesthetic and the moral: if it is a great work of art, it is a unity in which very many elements can be discovered.

But there may have been another question underlying the old formulation of the problem: is it possible for a horrible thought to be realized in a beautiful form? The form may not be beautiful, but if the artist has the greatness, the talent and the strength of character he will certainly make a very powerful and clear work that expresses his thoughts in an overwhelming way. This is true of Picasso, as we have seen. The work may be really horrible: when it repels us it is because of its high quality. Or, if the form really is beautiful, then the evil expressed by it can make the beauty horrifying. The evil queen in the fairy tale should really be ugly; but if she is beautiful her evil becomes more evil, and the whole concept that much more horrifying.[6]

We can ask the same question in another way. Can there be a beautiful work of art which has as subject-matter something horrible and ugly? The answer is yes, of course, for there are abundant examples. Does Bach in his Passions portray something attractive and beautiful? The subject-matter of Michelangelo's Last Judgment or of Rembrandt's etching of the Fall is not exactly sweet and lovely and enjoyable—yet they belong to the great works of art. Rubens painted a magnificent battle of the

[6] Oscar Wilde dealt with this problem in his 'Picture of Dorian Gray'.

Amazons, Goya made etchings with human depravity as the subject, Kathe Kollwitz made lithos of suffering mankind, works considered to be of the highest quality. And what about Shakespeare's plays, or Marlowe's *Dr Faustus*—they talk about sin, crime, pride, all that is evil and ugly. Yet all these works are 'beautiful'—a beauty however which does not mean sweetness and sentimentality, nor a beauty in form or language alone, quite apart from content.

Beauty and truth are closely related. It is precisely in the truth of the portrayal of the demonic as demonic in, for instance, Grünewald's picture of the Temptation of St Anthony, or of despair as real despair in Roger van der Weyden's Last Judgment, that we appreciate beauty. To truth belongs insight into the greatness and goodness of God's creation, but also the understanding that this world is marred by sin, and that apart from God's grace there is also the curse, the terrible inevitability of eternal separation from Him. Christ *is* the truth—a fact which is seldom sufficiently considered or appreciated. Truth is more than conceptual truth, for truth in the last analysis is personal. Christ as the truth is the Lamb of God, the agent of God's grace and of the renewal of creation, yet also the one who is to rule all the nations with a rod of iron.[7]

What is the difference between the beauty of these 'horrible' works and the horrible we find in modern art? Again, it is a matter of truth. Modern art often speaks of (or rather swears at) the ugliness of God's creation, or of despair without hope or of the meaninglessness of the meaningful: insofar as these things are lies they are never beautiful. A horrible thought can never be truly beautiful, for a lie is not truth; but truth is beautiful, when shown in its depth and fullness. Here we are not dealing with easy formulae or cheap criteria (see the section on surreality and Christian reality in chapter six for further discussion of the problem). For the question of truth and beauty is after all as deep and many-sided as real life, and as complex.

Norms and structures in art

If we are going to create a work of art we must follow the norms for

[7] Revelation 12:5.

art, its structure. How can we compose music, for example, unless we use organized noise (to use the lowest definition possible)? To do a painting we must use the particular qualities of colour and line, realize their potential to represent something in a kind of pictorial language, and put them in a relationship that is pleasing to the eye, powerful and rhythmic and with an aesthetic economy. Then the picture can be 'beautiful' even if it depicts something ugly. It may be moving, like van Gogh's old shoes, or Dürer's wonderful drawing of his old, ugly mother. The subject-matter became beautiful in their hands because of their love for it. Love and beauty are closely related, just as love and freedom belong together—a forced love is no love, as many works of literature and poetry (if not life itself) have shown.

But if we are seeking as Christians to understand the structures and norms for art, should we not go to the Bible for them? Certainly, but we will not expect to see them explained in detail. Obviously the modern system of the arts did not exist in biblical times and they were simply not discussed. In the same way we will not find a long discourse on the art of shoe-making or of weaving cloth in the Bible. Of course, people then appreciated beauty; the psalms are superbly beautiful, and elsewhere in the Bible we have descriptions of the beauties of the temple with its cherubim, pillars of gold and so on. One of the first times the Holy Spirit is mentioned is in relation to a man who was filled 'with the Spirit of God, with ability and intelligence, with knowledge and all craftsmanship, to devise artistic designs . . .'[8]

But God did not give specific laws concerning the arts, nor for any other cultural element. These things belong to human 'possibilities': God created them, and made and structured man in such a way that he could discover these possibilities, and gave man the freedom and the task to realize and fulfil them. God left man to use all his possibilities in freedom.

This does not mean that there are no norms for art. Some of them are obvious, as the examples we have been discussing. If you are going to paint a sombre picture to express despair, you are not going to use gay colours, nor a light rhythmic line. A picture for a specific purpose must be visualized with the specific demands in mind, or else it will fail. If you are an architect designing a private

[8]Exodus 31 : 3, 4.

bungalow you will not use heavy masses appropriate to a splen-diferous public building. If an artist is not sensitive to this he will simply not be a good artist. Of course with less blatant examples I appreciate that this is not always easy. But good art is always the result of hard work. No great art has ever been achieved without the artist not only having talent and imagination but also the character, the energy to keep on working and thinking and toiling in order to achieve his aims. It is the artist's character which is really all-important.

The norms for art are in fact basically no different from the norms for the whole of life. Art belongs to human life, is part of it, and obeys the same rules. The fact that the artist must keep in mind the specific structures of art is the same as anyone else in other human activities must do: the government has to work within the structures of the state, the motorist within the struc-tures of the way the car works and of the rules of the road. But whether you are an artist, a politician or a motorist you must apply not only the specialized structures of your own field of operations but also the structure of the whole of life, the fact that, being human, man is designed to work in a particular way, and that only by being wholly true to humanity will each activity really fulfil its purpose.

The mental attitude involved in being essentially human, expressing the true humanity which Christ came to restore, is summed up by Paul in a passage in his letter to the Philippians (4 : 8). Paul exhorted his readers to think about whatever is true, honourable, just, pure, lovely, gracious, excellent, worthy of praise. If these are norms for man, whether Christian or not, they are also norms for the artist. How do they apply?

What does *truth* mean in art? It certainly does not mean that art has to be a copy of reality—in fact, art is never a copy of reality, and cannot be. Art always gives an interpretation of reality, of the thing seen, the relationships, the human reality experienced emotionally, rationally, and in many other human ways. Art always shows what man—the artist and the group to which he belongs, the time in which he lives—sees and exper-iences as relevant, as important, as worthwhile. For otherwise he will never try to depict it. For mediaeval man landscape was not important, even if he lived in it; that is why he never tried to

represent it. For a seventeenth-century Dutchman even a silver pitcher could be important, or a broken glass, just because of its beauty, or the effect of the light as it played over the surface. So, for him, the still-life was important. Of course good artists in other periods might just as well have done the same: but they did not do so, because the ability here is of a 'spiritual' nature. The artist who made the magnificent series of statues in the cathedral at Naumburg, with their very individual appearance, was certainly able to make portraits, even though the statues were not portraits, but representations of important figures who lived long before. Yet neither this artist nor any other at that time made portraits as such for 'spiritually' the times were not yet ripe, and we have to wait about half a century before man slowly and hesitantly made the first portraits. To represent something means that one thinks it to be of importance, and that one is spiritually open and free to do so. Art is always an interpretation, a certain view on reality. To the contemporary, art sometimes seems to be so true to nature that he thinks that it is a copy in an almost exact way; but later periods will see the choice, the emphasis, the particular view and understanding. Nineteenth-century naturalism may seem to be almost photographically true—but, as I have shown in an earlier chapter, this type of art belongs to a particular spiritual stream and shows a particular kind of understanding of reality.

Truth in art does not mean doing accurate copies, but that the artist's insight is rich and full, that he really has a good view of reality, that he does justice to the different elements of the aspect of reality he is representing. Truth has to do with the fullness of reality, its scope and meaning. So we can find works not only in a naturalistic style but also in the romanesque style, or gothic, or baroque, or expressionistic, that are true, showing in truth at least some aspects of the reality represented.

So for the same reason truth in art does not mean that every detail has to be true in a physical, historical, theological, scientific or any other non-artistic way. It is artistic truth! Hamlet may never have lived—but Shakespeare's Hamlet is true insofar as Shakespeare has been able to make the figure he created true to reality, to human character and potential. If you are going to criticize Hamlet you must show inconsistencies in his character or

in the way he is acted. You cannot object that Hamlet was probably never really like this historically. Not only is he no more than a stage figure, acting in keeping with the structure of the play, he is also a figure belonging to Shakespeare's time, not the period in which he is supposed to have lived. So too fairy tales can be true, if they show human action and behaviour in keeping with human character—within the framework of fairy tale reality.

In our relativistic times it is often said that we cannot speak of truth in art, but that we must speak of honesty. The artist has to be honest. Certainly: this is the minimum requirement. If an artist tries to conceal his true intentions, if he tries to show off, if there is the sort of make-believe (as in many of the Salon pictures) which gives the impression that a work is in the seventeenth-century tradition, while in fact the values contained in it are dead to him, this is dishonesty. These things show in a work of art. Honesty can be called subjective truth. An artist must show his own insight, his own vision, his own understanding. And all good works of art will do this. Picasso gives a clear and consistent statement of his nihilistic view on reality. He is honest to this extent: but does he really show reality in truth? Truth does not mean to be conceptually in accordance with reality—this is a rationalistic view of truth. The Bible speaks of *doing* the truth, acting in love and freedom, according to the relationships God wants for man. So in a way art *does* the truth often more than it *is* true in the sense that it portrays reality according to its conceptual reality. Art does the truth in its own artistic way. Doing the truth in this sense is closely related to the other qualities we must now go on to duscuss.

Honour in art suggests to me what was formerly called *decorum*. A work of art has to be in keeping with the place or occasion for which it is made, or the function it has to fulfil. You are not going to paint Christ on the cross in the style of a cartoon. Indeed, some 'Christian' art is at fault here: certain religious magazines sometimes portray Christ and biblical scenes in a way that is below standard, with a style that is too cheap. What is acceptable in a brochure for a new vacuum cleaner is wrong for such subjects, unless we are going to reduce Christianity to the level of commerciality and profit.

It is almost impossible to judge what is 'honourable' in art

without specific examples. For instance, it is possible that some types of jazz could be very suitable as music in church, but we can never give a final evaluation without weighing up factors such as the connotations of jazz for the particular people who will be there. It depends on how people will react to it in a particular situation. The artist must bear this in mind carefully. A biblical figure can be represented in a sculpture of straw or other 'strange' material: but if this means for the person looking (a person of a particular time and culture) that the figure is debased and so of no import-ance, reducing it to the level of a souvenir, then this cannot be done with 'honour'.

Righteousness in art does not mean that, in fiction or on the stage, for instance, everyone must be upright and good. That would be against truth. Reality is different. The Bible includes plenty of descriptions of wickedness and evil.

To be righteous means to be right to the situation, to give each element its due: to create a right balance, a harmonious whole. Righteous is a biblical term with many overtones, including mercy and grace, and the term never means a hard judgment only with an eye to the letter of the law. It must be seen in the artist's knowledge and insight and right portrayal of reality expressed in his painting. So 'righteousness' can be expressed in details of colour, composition, even a brushstroke, as well as in a character in a novel, a situation in a play, even in a modulation in music.

Purity in art is the same as that of which Christ speaks when He said, 'Blessed are the pure in heart'. It is a mentality that cannot stand the evil, the lovelessness which does harm to others. Purity in art means helping those who read or listen or see to have pure thoughts. It does not titillate, does not play on people's wrong desires, it does not seduce. It helps man to see the good and the beautiful. It shows iniquity, it protests, but in a protest of love against the unjust and the debased and evil.

It is in this framework that I must consider the question of nudity in art. Art does not copy reality, and it is possible to show things in art that cannot be shown in social reality. Nudity is found in the art of every period. In some periods, and among some artists, for instance Rembrandt and (sometimes) Dürer, the nude means man in his nakedness, his weakness—quite the opposite of

the heroic nude often found in Renaissance art, for instance, where it was a symbol of man's greatness. In both cases, however, there was nothing pornographic about it—neither by intention nor in the way it influences the onlooker. In fact lightly clothed figures are often much more erotic.

The erotic and the sexual have a place in art, as they have in life. As such they are not dirty nor impure. They are a gift from God, and belong to humanity itself. But man has often focused his attention on sex and carnal love in a sinful way. Yet the physical relationship between the sexes can be beautiful when it is an expression of true love. The female body can be beautiful, and this beauty is not a thing to be ashamed of: though in our society a woman is not expected to show her body without clothes, in other cultures this is quite possible without any immorality. Modesty in fact is a moral quality, and its expression is different in different cultures and society. Even where the body can be shown without clothes one can still speak of modesty and immodesty. Behaviour is the expression of an attitude.

So we cannot simply say that the nude in art is impure. This is against all experience. Look at Jan van Eyck's Eve in his great 'Lamb of God' altar-piece in Ghent—there is no purer woman ever painted. And look at the clothed Maya of Goya—she is more immodest than the nude Maya, showing the same woman in the same attitude. Purity is a norm, but not an easy rule that can be applied indiscriminately. We have to exercise our human judgment, with all our wisdom, understanding and prudence. For to the artist purity is an intention. It might be appropriate to use the nude in his art, whether it is in literature or in the visual arts, and even to speak of intercourse, with completely pure motives; while avoiding them does not mean that the intention or the work itself is automatically pure and clean.

Nudity in films and on the stage, permissiveness in books and in fashion and advertising, all this is partly a reaction against Victorian prudishness (itself a sign of an unhealthy view of sex, as we have seen), partly a sign of increasing lawlessness as all conventions and norms are thrown out. As customs change so fast, it is often difficult to know exactly what the intention is in a particular instance of nudity. But it is not always impossible, and we should judge with care rather than hastily. This is even more

so when dealing with art from the past or from other cultures. We have to take into account the mores and customs, the prevailing moral rules, if we want to avoid gross mistakes and injustice. However, there is often no need to give a final verdict. As Christians we may often (even must) leave the judgment in God's hands.[9] What is more important is that we can each exercise our own personal responsibility (which may be different for each of us).

In all this it is vital to realize that it is not what goes into us that makes us impure, but what is already within us, or goes out of us, as Jesus showed so trenchantly.[10] It is not when we see or hear or read something that we are wrong and commit sin, but when our thoughts are impure or our imagination adulterous. So every one must exercise his own Christian responsibility. What one can experience may lead another to sin—and what one cannot stand may not be harmful to another. This is Christian freedom, not a freedom for licence but a Christian responsibility to keep oneself clean from sin. And it is important to be aware of the fact that these things are not only, not even specifically, related to the sexual sphere. What we have been saying applies just as much to other aspects of our daily living.

What is *loveliness* in art? Obviously loveliness and beauty do not just belong to the arts. They belong to life, in two ways (leaving the beauty of nature aside). First, beauty and loveliness can be expressed in man's character, in inner harmony, in activities that are adequate and good. What we are asked to show and to search for is an inner beauty expressing itself in a 'beautiful' life. This is what Peter meant in his first letter when he said we must keep our tongue from evil and do good. Second, beauty and loveliness should be seen in the things we make and the things we have around us. In the 'applied' arts, for instance, loveliness can be expressed in the design, fitness for purpose and attractiveness of utensils, furniture, in everything we have around us. No-one is going to make his environment deliberately ugly, dirty or unpleasant unless the person himself is inwardly ugly or out of keeping with his inner self. I do not mean here that beauty is the final norm, nor the most important value. If I did, I would be no more than an aestheticist. And I certainly do not mean that we

[9] See Romans 12:19; 1 Corinthians 5:13. [10] Matthew 15:11.

must all possess expensive works of art—taste and a feeling for beauty are not to be bought with money. Loveliness is a 'norm' insofar as it belongs to the whole of life, and is held alongside all the other norms.

When thinking of beauty as applied to the arts, many people use the standard of classicism or of artists of the high Renaissance such as Raphael. But the beauty in Raphael's pictures is only a certain type of beauty. Rembrandt often did paintings that would be ugly by this standard—perhaps they are more human and more beautiful for that very reason. And if it is a norm that we should keep our lives clean and pure and beautiful as well as our surroundings, this does not mean that in art nothing that is bad or ugly or negative can be portrayed, as we have seen in our discussion of the 'horrible' in art. Beauty is expressed in line and colour, shape and form, rhythm and sound, rhyme and the relationship of words and composition, unity and diversity. It is through these very things that beauty is realized: it is not found abstractly in them. Truth, honour and purity are made visible by these means, are expressed by them. Without them beauty cannot be realized, yet the means cannot be said to be the end, the aim, the final value. A certain shape that is beautiful and completely right for its particular position within the context of a specific work of art, carrying a particular meaning, can be valueless and even out of place elsewhere.

Excellence and praise in art are again an obvious norm. Which artist would make a work of art that is bad, valueless, disgusting? It is true that today we may often encounter these things, for these are the signs of a strong inner tension, of a crisis, of despair, of revolution, of disgust. But even then their value and effectiveness depend on the fact that the norm is really held to be the norm. They can only break the rules where there are rules. Indeed we can say that if such a work was considered beautiful, or 'normal', it would have lost its meaning, and we should have thrown away the key to understanding it. Dada's black humour can only live in the negation of, or in play with, these norms. The revolt is the anarchy of denial.

So truth, honour, righteousness, loveliness, excellence and praise are as much norms for art as they are for life. And in all of them we feel that to bypass them is to do wrong to the beholder,

to fall short of being truly loving. For basically these norms are all aspects of the great command to love. Love is the great norm, in art as well. Love is to make things that are right and fitting, to help our fellow-man, to make this world more beautiful, more harmonious, more suitable for human living, more suitable for expressing that inner beauty and love for which all men are searching—even if, in despair, mankind often breaks it down, even if, in sin, we often destroy beauty and create ugliness. Beauty, as it were, is a by-product of love, of life in its full sense, of life in love and freedom. The artist, with his special gifts, has a specific task, a very special and wonderful calling. It is not to play the prophet, nor to be a teacher, nor to be a preacher, nor to evangelize. It is to make life better, more worthwhile, to create the sound, the shape, the tale, the decoration, the environment that is meaningful and lovely and a joy to mankind.

The Christian artist

How is the Christian artist to fulfil this role, and to work out these norms? Can he really create the lovely and beautiful in a loving way for his fellow-men? It is a calling to promote good and to fight evil, ugliness, the negative; to hunger and thirst for right-eousness; to search for the right 'finishing touch', the right tone, the right word in the right place.

The Christian artist has to create in an open and positive relationship to the structure of the world in which he was created by God; he has to act, on the foundation of Christ as His Lord and Saviour, in love and freedom.

He must have love for the people for whom the work is meant, for the material he uses, for the subject he chooses, for the truth he is going to express, for the Lord he is serving.

He must know freedom by not being bound wrongly to man-made rules. In his art he is free from the past, the present and the future. He can be traditional if he chooses and feels that to be right, he can search for new ways, new materials, new subject-matter, new techniques if he feels he needs them in order to achieve his goals.

Love and freedom belong closely together, just as sin and slavery belong together. If Christians feel that they have to make

all kinds of rules in a legalistic way, even if they do so with the best intentions and aim only to preserve the good, yet they kill freedom, and in the end love is gone, and beauty has fled. God gave His children freedom and we should not try to know better. Freedom is only truly possible, as we have seen, within the norms and structures and laws within which God has made us. It is for the Christian to distinguish between a false legalism and a true freedom to be what God intends us to be, for without this freedom art will wither.

Love and freedom are never cheap, and they are weakened by sin, pride, selfishness, greed and hate. Love and freedom belong to normal human life as given by God to man, but now, after the Fall, they are hard to achieve, to create, to realize. Christ came to make them possible. He died in order that we might be truly human, to have love, freedom and beauty and all the good things.

Beauty of course is something given by God as a gift to all to create. It is not limited to Christians. But because Christians have been made new in Christ, they are now in a position to appreciate God's true intention for man and the world, and create beauty in art as a result. So we will pray as we work. We will pray to the Lord for help—to open our eyes to the real possibilities, to open our eyes to see how we can achieve the best for our fellow human beings, to help us in creating according to the best that is in us. Our art, as everything else, must be from Him, through Him and to Him.

If I am walking round an art gallery and see a beautiful painting, it may be good to praise the Lord, and to thank Him for that great gift. The thing is beautiful, and therefore a joy and spiritually rich, perhaps just because the artist was in tune with reality, or because he loved the woman he painted, the landscape he lived in, the people he was working for. It is possible that the artist had prayed to the Lord to help him in his work—and then our thanksgiving to God is really thanking God for his answered prayers. We do not usually know. But more than likely it will not even occur to us, for we place the arts out of the context of life, making them something autonomous; or say that the gift is just 'natural', so opposing nature to grace, forgetting that there is no 'nature' that is out of God's creation. No: let us give praise to God for every manifestation of His gifts. And let the Christian

artist look to the inspiration of the Holy Spirit and the renewal of his life in Christ, not only to acknowledge the source of the gift he has but also in order to have the love and freedom that will enable him to create the good and the beautiful himself.

But however much we look to God to help us to remain free, we cannot make art apart from the time in which we live. We must know what is going on, and understand our environment if we want to achieve anything of relevance to our times. We must also know the spirit of our times in order to know where it is wrong and should be challenged and fought. We may look for inspiration to the arts of the past—but we may never be slaves of the past. And we can never just follow the past: the battle and the means of creativity were theirs, for their own situation. And God, in placing us in another period, has given us our own calling: to be 'salting salt' today, to hunger and thirst for righteousness in the here and now. Our world has changed, for better or worse. It is for us to find truth and beauty for today, constantly re-applying the truth of God's Word to our own time and to our own contemporary situation.

Only if we live in this way shall we be 'salting salt' and the fruit of the Holy Spirit seen in our work. The way will not be easy if we really want to show something of the richness and truth of created reality in our art. We shall soon find that we will have to find a way back to it. It can easily be that our first attempts will be poor and second-rate. I only trust that our fellow-Christians who stand beside us and watch our efforts will be helpful and encouraging, so that a new bud will not be frozen by coldness and lack of interest or understanding. The way may be long and hard. And an artist is virtually never able to succeed alone. He needs a community to back him up: if he fails it may be his fellow-Christians who are at fault, failing to give him the positive response he needs. But without this creativity we shall not be able to show the real validity of an art and life based on Christ our Lord.

Christian art does not come cheaply and easily. It can never be the first and direct fruit of the work of somebody who is just starting, even if he is a real Christian. We have lost so much in our civilization (and we Christians are also responsible for the fact) that the way will be long and tiring. But perhaps we can lay a foundation for the next generation, who may build on what we

have done to create something really great and fine. Or perhaps our small evidence of the fruit of the Spirit will have its own influence, helping to stop the rising tide of absurdity and ugly meaninglessness (or even beautiful meaninglessness).

Whether God will give us this or not, whether we shall have time to do it or not, whether as artists we are good or bad, as long as we can stand before Him saying that we have fought our battle and followed our calling, we can be confident. We do not need to be afraid, for nothing can divide us from His love.

The Christian in a changing world

What is the Christian's calling in the world of today that we have seen so clearly in its art? Can we really take a full part in its arts, plays, literature, philosophy, its revolutionary activity? Can we be people of our times in this sense?

The world has changed in the last decades. We have seen the crumbling of a culture. Increasingly we see ourselves living in a world that is post-Christian and even post-humanist, a neo-pagan world, one which is nihilist, or anarchist, or mystic. Whatever the signature of the day, however, it must be clear that every day we come nearer to the situation of the early Christians. Every time we read Peter's letters we can understand what he was saying better. For his letters were sent to Christians who were a small minority. We cannot now expect people to follow our rules, our insights, our morals automatically. We shall be more and more pilgrims and strangers in the world.

What is our calling? Of course first of all each of us has the calling to be a Christian and to live as one. This, sometimes, in a world full of all kinds of temptations, in advertising, films, TV and so on, is not so easy. But, in general, if we have the chance of doing something, or of saying something because we are in a position to do so, because we are on a committee or have some other responsible position, what should we be doing and saying? What in fact is our calling?

First, we must stand for freedom. Of course the world around us is full of the cry of freedom. But, as Peter writes, 'they promise them freedom, but they themselves are slaves of corruption.' The revolutionaries speak of freedom, yet we find that if you are not

for their kind of freedom, you have no right to say so. The revolution is totalitarian. It leads to dictatorship in the name of freedom. Here we are called never to compromise, but to fight for true freedom. We must defend the freedom even of those that we do not like, even of movements we feel to be wrong. We may never be totalitarian in that sense. We shall stand for freedom for many reasons: because humanity is lost if freedom is gone; because love has no place in a world without freedom, and certainly too because in a world without freedom we shall not have the liberty to be Christians, to tell out the good news, to invite others to our meetings. The Bible teaches us to pray for good government, so that we may live in peace, and so that others may have the opportunity of hearing the gospel.

We shall stand for freedom. In love, and with responsibility, we must see that in many different ways the people around us are not being deprived of their inner freedom. If young people are ostracized when they do not want to participate in 'free love' we must fight for their freedom. If people are almost forced to take up the status symbols, we must stand for the freedom to be different. We must stand against the pressures of man in the mass towards conformity or bad morals. We must stand against everything that takes away personal freedom of choice. We shall hunger and thirst for righteousness, for we know that sin always takes away freedom and makes men and women into slaves. Where sin is made 'normal', and people are asked to participate or else . . ., we always shall stand for freedom against tyranny, against the forces that dehumanize.

Freedom in this sense can never be a simple slogan. It is always something specific. It is never cheap, and always demands responsibility, involvement, loving our neighbour even if that is going to take our time, our energy, even our life.

Of course, we must begin to live freedom ourselves. We must show the inner freedom of those who have been made 'truly free' by Jesus Christ. We must show that we are free from greed, sin, hate, the need to dominate, free to do good, free to fight the evils of the day and to protest in love. Freedom is not just negative, freedom *from* something: on the contrary, freedom opens up possibilities, freedom is *for*, *towards* something. Christian freedom is positive, dynamic.

But we must not only stand for freedom. We must also stand for humanity. Personality is a great gift, and we shall stand against forces that try to take it away by making people conform or by making people behave 'normally', which means just like everyone else. Humanity is a great asset, a great gift from God, and we shall do all we can to withhold the dehumanizing forces of today which would turn human beings into little wheels in the big machine, into numbers in the computer. Of course, what we ask for may be less efficient or less profitable economically. But efficiency and profitability, though right and important in their place, are not primary values. Humanity comes first. Seek first God's kingdom, Jesus said, 'and all these things shall be yours as well'—yes, perhaps in the long run a stand for humanity will mean more efficiency and more profit, though that is not going to be the reason why we are taking it.

It is for the sake of humanity that we stand against every pressure that would drag the woman down to the level of an object of lust. For that same reason we are against all kinds of manipulation, in advertising, in the mass communication media, in the policy in the field of the arts that would promote only one stream (however 'contemporary' or 'modern' it may be called). Humanity, involving manhood and womanhood, is something of too great a worth to be deprived of its value and meaning.

Again, humanity is not cheap. It is worth our lives, and it is for us to make something creatively of our lives, to realize the given possibilities, the potential of humanity. And we shall stand for it so that others can enter into the same possibilities if they wish. Here too this means that we must show first of all in our own lives that we have this humanity, that we live openly and creatively; above all, that we show that we are new men and women, a new humanity in Christ.

Our calling is also to be critical of our times. Christians are called to speak prophetically. To hunger and thirst for righteousness means that we shall never just defend the established order of the day. It might be the easiest way; taking new paths, or paths that may be different from the traditional ones, means taking risks and giving energy, time, involvement. But even if defending the establishment is often easy, it cheapens us, and leads away from our calling to fight for what is right, for justice, love, beauty,

truth. Christians should never be conservative simply for the sake of conformity, of conserving the established order for its own sake. We must be critical.

We may be called to protest, too. Perhaps the strong protest movement of today is a result of the fact that the existing order was too much taken for granted, and was left free to become over-confident and too static. We should have protested before others have shown us the need to do so. Christians should have been aware, not just of the current undermining of sexual morality, but of the wrong sort of prudishness that caused it, the playing down of the fact that the gift of sex is from God and good and to be rejoiced in. We must be constantly aware of any growing lack of freedom, of the authoritarianism of petty bureaucracy which treats people as things, of any forces which dehumanize. We should have protested, and protested in love, not in hate and anarchy, because we care for freedom and humanity, and hate all sin and all unrighteousness.

Protest in love is just another way of saying that we should always hunger and thirst for righteousness. This means that we shall never compromise, never accept the status quo because that is the easiest thing to do or seems inevitable. For Jesus told us to watch that we do not try to gain the world at the expense of our true selves.

To take this stand, to respond to our calling today means that we shall not be afraid to show that we are Christians; not only in saying that we have been saved by Christ, but also in our stand, in our way of life, in our prophetic analysis of the situation. It means to be radical, to go back to the roots, to the very found-ation, which is Christ. To be Christian involves all our work and activity, understanding that there is nothing neutral, nothing apart from Christ's reign. Our very humanity, our everyday human life, including both the intellectual and the emotional, is something we shall thank Him for, and something that we shall have to defend against the attacks of the spirit of our age, and also something we must develop in a creative way, realizing all our possibilities, our potentials. And we shall not be afraid to be seen and to act as Christians because we know that our Christian life does not depend on ourselves, nor on the fact that we are perfect: '. . . we have confidence before God; and we receive from him

whatever we ask, because we keep his commandments and do what pleases him.'[11]

Our calling is to live in freedom and love, to fight against sin; to stand for freedom and humanity. It is to show love and compassion not only towards those we love and those who love us, but for modern man who has lost the track, who has become enslaved, who cries out for humanity, for love and freedom and truth, without ever finding them. It is not for us to condemn, for God is the judge, but to pray and work for them, meeting them openly and without reproach, accepting their ways and customs in the same way as Paul told us to be both Greek to the Greeks and Jew to the Jews. This means that we will have to study their problems, their ideas, know their language—what words mean to them—in order to be able to communicate. We must realize that the 'world' is not simply something remote—it is more often than not very near to us, in our very beings—but that the 'world' means people, human beings, personalities. We must help them, each of them, in their particular and very specific problems and needs.

As Christians today we realize that we are living in hard times. It is hard to keep to the right path; temptations are legion. And as we look around, it is hard to see a great culture breaking down around us, even though, as we have seen, it is not really based on Christian principles, but on those of the Enlightenment.

But for that very reason, these are exciting times. God has called us to bear witness to Him at a critical point of history. It is not only exciting and interesting to be a Christian now, it is a great privilege and responsibility. And it is vital.

Perhaps the most fitting conclusion would be to adapt Psalm 136 to express the greatness and wonder of all that we have seen God do in history—and in our own times:

Give thanks to Him that created this great cosmos, this earth, and all the structures that make creative work possible for man in love and freedom,

His mercy endures for ever.

[11] 1 John 3: 21, 22.

He did great things in the times of Moses and the beginnings of the written revelation when He spoke to His chosen people from Mount Sinai,

His mercy endures for ever.

He was great, so great that He inspired the psalmist to sing this psalm in His own time, a time of sorrow and trial, a time of triumph and victory,

His mercy endures for ever.

He sent His prophets, and they spoke of His mercy; they spoke against a people that walked in their own ways, following strange gods; they warned against wars, droughts and captivity to come— and these came indeed, yet a remnant would remain, for

His mercy endures for ever.

He sent His Son, who spoke of judgment and mercy, who spoke against those that could see and yet were blind, while opening the blind man's eyes; who said He saw the evil one falling out from heaven; who died for our sin and evil, and rose from the dead, for

His mercy endures for ever.

And He spoke again, against a church that was lukewarm; He gave great promises for those that would overcome, and showed His servant John all the plagues and wars that were to come, how His people would be sealed with His own seal, and how their prayers would be heard, for

His mercy endures for ever.

He built and led His church, sent teachers and prophets to warn the church of its complacency and self-sufficiency, sent reformers to lead His church back to the truth, helped His servants and His children, as

His mercy endures for ever.

He is great in our days, when His hand is heavy on a world that despises Him and looks for strange new ideas and new gods, when the culture once given is crumbling even though man has great technological means at his disposal, when the mode of the music

changes, when the times are changing, when things happen and people do not know what they are; when yet many look for humanity, or renewal, or even reformation, for it is still true that He loves us and hears our prayers in order to help His children; so that our song can be,

His mercy endures for ever.

BIBLIOGRAPHY

H. H. ARNASON, *A History of Modern Art*, Thames and Hudson, London, 1969.

W. BARRETT, *Irrational Man—a study in existential philosophy*, Heinemann, London, 1961.

B. BETTELHEIM, 'Obsolete Youth' in *Encounter*, September 1969.

H. BLAMIRES, *The Christian Mind*, SPCK, London, 1963.

C. BOOKER, *The Neophiliacs*, Collins, London, 1969.

D. J. BOORSTIN, *The Image*, Penguin Books, Harmondsworth, 1963.

M. BRION, *Romantic Art*, Thames and Hudson, London, 1960.

H. BUTTERFIELD, *Christianity and History*, Fontana, London, 1957.

J. CANADAY, *Mainstreams of Modern Art*, Thames and Hudson, London, 1959.

CHRISTIAN PERSPECTIVES, Essays by H. L. Runner, S. U. Zuidema, H. van Riessen and others, Guardian Publishing Co., Hamilton, Ontario, 1960, 1961, 1962.

J. DILLENBERGER, *Style and Content in Christian Art*, Abingdon Press, Nashville, 1965.

H. DOOYEWEERD, *A New Critique of Theoretical Thought*, I-IV, Amsterdam, 1955.

H. DOOYEWEERD, *Transcendental Problems of Philosophical Thought*, Eerdmans, Grand Rapids, Michigan, 1948.

M. ESSLIN, *The Theatre of the Absurd*, Anchor Books, Doubleday, New York, 1961.

R. ETCHELLS, *Unafraid to Be:* A Christian study of contemporary English writing, Inter-Varsity Press, London, 1969.

F. EVERSOLE (Ed.), *Christian Faith and the Contemporary Arts*, Abingdon Press, Nashville, 1962.

E. F. FRY, *Cubism*, Thames and Hudson, London, 1966.

E. H. GOMBRICH, *The Story of Art*, The Phaidon Press, London, 1966.

W. HOFMANN, *The Earthly Paradise, Art in the nineteenth century*, Faber, London, 1961.

HOLBROOK JACKSON, *The Eighteen Nineties*, Penguin Books, Harmondsworth, 1950 (first ed. 1913).

H. L. C. JAFFÉ, *De Stijl* 1917–1931, Meulenhoff, Amsterdam, 1956 (English Language edition, Thames and Hudson, London, 1970).

KENNETH KENISTON, *The Uncommitted*, Harvest Books, New York, 1965.

KENNETH KENISTON, *Young Radicals*, Harvest Books, New York, 1968.

O. KRISTELLER, 'The Modern System of the Arts' in the *Journal of the History of Ideas*, XII, 1951.

S. LÖVGREN, *The Genesis of Modernism* (Seurat, Gauguin, van Gogh and French Symbolism in the 1880s), Stockholm, 1959.

L. LOWENTHAL, *Literature, Popular Culture and Society*, Prentice-Hall, New Jersey, 1961.

H. MARCUSE, *One Dimensional Man*, Beacon Press, Boston, Mass., 1966.

G. MELLY, *Revolt into Style – the Pop Arts in Britain*, Allen Lane The Penguin Press, London, 1970.

B. S. MIJERS, *Expressionism: A Generation in Revolt*, Thames and Hudson, London, 1957.

H. R. NIEBUHR, *Christ and Culture*, Faber and Faber, London, 1952.

V. PACKARD, *The Hidden Persuaders*, Penguin Books, Harmondsworth, 1960.

V. PACKARD, *The Naked Society*, Penguin Books, Harmondsworth, 1964.

N. PEVSNER, *Pioneers of Modern Design, from William Morris to Walter Gropius*, Museum of Modern Art, New York, 1949.

M. PRAZ, *The Romantic Agony*, Fontana, London, 1960.

H. READ, *The Philosophy of Modern Art*, Meridian Books, London, 1955.

J. REWALD, *The History of Impressionism*, Museum of Modern Art, New York, 1946.

J. REWALD, *Post-Impressionism*, Museum of Modern Art, New York, 1956.

H. R. ROOKMAAKER, *Art and the Public Today*, L'Abri Fellowship, Huémoz, Switzerland, 1968.

H. R. ROOKMAAKER, *Synthetist Art Theories*, Swets and Zeitlinger, Amsterdam, 1959.

H. R. ROOKMAAKER, 'The Christian and Art', in *The Encyclopedia of Christianity*, s.v. Art, Wilmington, Delaware, 1964.

DOROTHY SAYERS, *Christian Letters to a Post-Christian World*, Eerdmans, Grand Rapids, Michigan, 1969.

DOROTHY SAYERS, *The Mind of the Maker*, Harcourt, New York, 1942.

F. A. SCHAEFFER, *The Church at the End of the 20th Century*, Norfolk Press, London, 1970.

F. A. SCHAEFFER, *Death in the City*, Inter-Varsity Press, London, 1969.

F. A. SCHAEFFER, *Escape from Reason*, Inter-Varsity Press, London, 1968.

F. A. SCHAEFFER, *The God Who is There*, Hodder and Stoughton, London, 1968.

C. SEERVELD, *A Christian Critique of Art and Literature*, Guardian Publishing Co., Hamilton, Ontario, 1968.

J. SEZNEC, *The Survival of the Pagan Gods:* The mythological tradition and its place in renaissance Humanism and Art, Harper Torchbooks, New York, 1961.

A. SHAW, *The Rock Revolution*, Paperback Library, New York, 1971.

W. HEBDON TAYLOR, *The Christian Philosophy of Law, Politics and the State*, Craig Press, Nutley, N.J., 1966.

H. R. VAN TIL, *The Calvinistic Concept of Culture*, Presbyterian and Reformed Publishing Co., Philadelphia, 1959.

CALVIN TOMKINS, *Ahead of the Game:* Four versions of Avant Garde: John Cage, Marcel Duchamp, Jean Tinguely, Robert Rauschenberg, Penguin Books, Harmondsworth, 1955.

A. N. TRITON, *Whose World?* Inter-Varsity Press, London, 1970.

ELLIS WATERHOUSE, *Italian Baroque Painting*, The Phaidon Press, London, 1962.

H. ZIJLSTRA, *Testament of Vision*, Eerdmans, Grand Rapids, Michigan, 1961.

INDEX

of main artists and ideas referred to